Gardens in Art

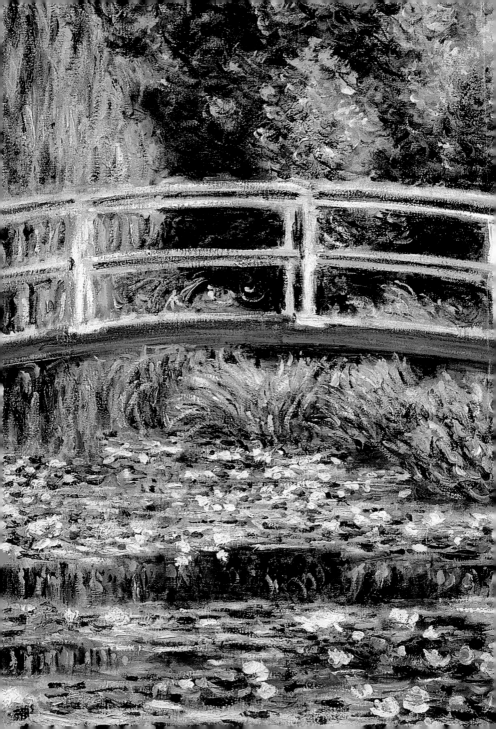

Lucia Impelluso

Gardens in Art

Translated by Stephen Sartarelli

The J. Paul Getty Museum
Los Angeles

A Guide to Imagery

Italian edition © 2005 Mondadori Electa S.p.A, Milan
All rights reserved. www.electaweb.it

Series editor: Stefano Zuffi
Original Graphic Design: Anna Piccarreta
Original Layout: Paola Fiorini
Original Editing: Carla Ferrucci
Original Image Research: Carla Ingicco
Original Technical Coordinator: Andrea Panozzo
Original Quality Control: Giancarlo Betti

English translation © 2007 J. Paul Getty Trust

First published in the United States of America
in 2007 by the J. Paul Getty Museum

Getty Publications
1200 Getty Center Drive, Suite 500
Los Angeles, California 90049-1682
www.getty.edu

Mark Greenberg, *Editor in Chief*

Ann Lucke, *Managing Editor*
Mollie Holtman, *Editor*
Robin H. Ray, *Copy Editor*
Pamela Heath, *Production Coordinator*
Hespenheide Design, *Designer and Typesetter*

Printed in Hong Kong

Library of Congress Cataloging-in-Publication Data
Impelluso, Lucia.
 [Giardini, orti e labirinti. English]
 Gardens in art / Lucia Impelluso ; translated by Stephen Sartarelli.
 p. cm.—(A guide to imagery)
 Includes bibliographical references and index.
 ISBN 978-0-89236-885-3 (pbk.)
1. Gardens in art. 2. Painting, European. 3. Gardens. I. Title.
 ND1460.G37I4713 2007
 758–dc22
 2006032199

Page 2: Claude Monet, *White Water Lilies*, 1899. Moscow,
Pushkin Museum.

Contents

6 Introduction

9 Sacred and Profane Gardens

31 Gardens of Popes and Lords

57 Gardens of Kings

87 The Liberated Garden

111 The Garden Goes Public

123 Elements of the Garden

233 Life in the Garden

293 Symbolic Gardens

343 Literary Gardens

Appendixes

375 Index of Subjects

376 Index of Artists

378 Bibliography

Introduction

Those who study gardens usually do so from an architectural or historical point of view, looking upon them as examples of "living architecture" and neglecting their semantic aspects. In reality, a garden speaks to the visitor through its various components, which are in turn linked to the style in which it expresses itself.

Whether it is a place of pleasure in which we find peace and serenity, or a setting for festivities and social events, the garden always comprises a certain set of elements. These elements appear consistently throughout the ages but are used differently each time, according to the needs of the day. We always find water, in its countless forms, as well as statues, and a garden always has lanes or paths running through it. Sometimes these elements establish a geometrical structure and conform to artificial strictures; sometimes they are given free rein and blend in with the surrounding landscape. Changes in tastes and aesthetics are thus accompanied by new forms of gardens. As it evolved from its humbler form as enclosed cloister—an image of Eden, oasis of peace, and refuge from outside dangers—

the garden ended up reflecting the concept of man as "the measure of all things" and finally became a magnificent celebration of the power of the absolute sovereign, a sumptuous stage-set exalting the ruler's glory and triumph.

With the advent of the Enlightenment, the French Revolution, the Industrial Revolution, and Rousseau's social contract, the garden became a symbol of the new liberal political system. It broke free of the artifice in which it had been bound and became part of nature itself, free to express itself in full. With a continual conversation between geometrical artifice and the "picturesque" natural element, the art of gardens evolved in a variety of forms, each proper to its own historical era. Yet unlike architecture in bricks and marble, which is less vulnerable to the ravages of time, the garden is a juxtaposition of fragile materials in a state of perennial transformation and is therefore difficult to maintain in its original form. The memory of a garden, however, can be preserved in a poet's verse, in a writer's impassioned description, or in a painting or drawing. The subject of this

book, then, is the garden as represented in painting and a range of other art mediums, and we will analyze the different levels of interpretation contained in such images.

Often relegated to the background of a painting, the garden has generally played the role of décor to the main scene taking place in the foreground. But in fact that green microcosm has a life of its own, made up of symbols and meanings reflecting the tastes and aesthetics of successive centuries. The aim of this book is to analyze and decipher the constituent elements of the garden itself and the symbolic meanings that underlie them. The volume has two principal sections, subdivided into many chapters, which are organized chronologically and range from antiquity to the 19th century.

The first five chapters outline the main typologies of garden for which we have direct testimony in painting, and their related symbolic meanings. The second part examines the different levels of symbolism that recur within these typologies: these involve the garden's compositional elements and the different ways to use and approach it, as well as its many hidden representa-tions of symbolic, religious, philosophical, or esoteric messages, and even "quotations" from literature. The latter are particularly important in giving rise to certain garden typologies, most of which have a literary text as their source of inspiration.

The book's two parts thus interact iconographically, juxtaposing and reflecting the interrelationships and symbolic echoes that make the garden what it is: a complex of signs and allegories too often overlooked.

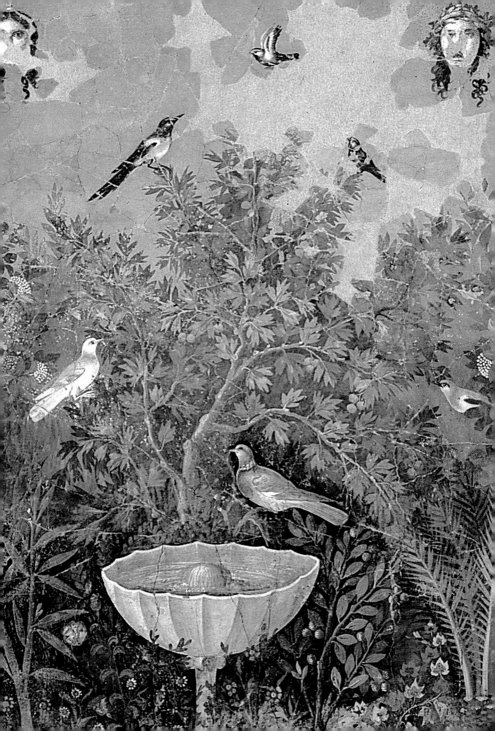

SACRED AND PROFANE GARDENS

Ancient Egypt
Ancient Greece
Ancient Rome
Islamic Gardens
Monastic Gardens
Secular Gardens

◀ *Garden with Herms and Fountain*
(detail), A.D. 25–50. Pompeii, House of
the Golden Bracelet.

The frescoes in Egyptian tombs constitute some of the most ancient pictorial documentation of gardens, predating even the mythic hanging gardens of Babylon.

Ancient Egypt

Characteristics
High defensive walls, one or more rectangular pools, trees arranged in a regular pattern

Symbology
The quest for a secluded, private, or sacred environment, sheltered and protected from the outside world

Related Entries
Walls

The allure of ancient Egyptian culture is reflected in that special art form that is the garden. The earliest evidence we have of Egyptian gardens is from miniature models discovered in tombs, in which the space devoted to the garden is far more extensive than that occupied by the house, usually represented by a simple portico. These little models were intended to accompany the souls of the dead on their journey to the afterlife. The Egyptian garden reached the height of its splendor during the New Kingdom, in the period from the 18th Dynasty to ca. 1200 B.C. The many fresco fragments recovered from other tombs, such as that of Ineni, architect for Thutmose I (ca. 1504–1492 B.C.), or that of the nobleman Nebamun (ca. 1400 B.C.), have allowed us to reconstruct the Egyptian garden, which was designed for recreation but also for food production. The garden was laid out according to a rather simple plan that remained unchanged for centuries: one or more rectangular pools of water; rows of trees planted in regular patterns; and a high wall that protected it against desert sands, intruders, and the Nile in flood. This type of garden was conceived as a space isolated from its surroundings, and it developed along those lines. It made desert land fertile, creating a green, orderly environment organized around a pool with fish and lotus flowers, symbols of birth and rebirth. In this protected haven, where water and shade were key elements, plant species were arranged in precise geometrical order. The garden's perimeter walls separated an inner, defined, and orderly world from an outer, chaotic, and unpredictable world.

▼ Fragment of a wall painting from the tomb of Nebamun, ca. 1400 B.C. London, British Museum.

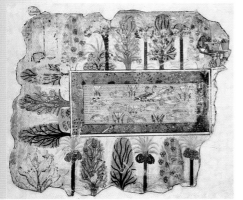

In the Greek world, where nature was seen as a manifestation of the gods, the garden was considered a sacred grove, rich in mystical, symbolic, and religious significance.

Ancient Greece

While we cannot precisely enumerate the typical features of the Greek garden, we know that the Greeks believed that every place was endowed with certain inherent qualities and constituted an expression of multiple vital forces and a manifestation of divinity. The use of nature for agriculture was balanced with the idea of nature as a religious place, consecrated for the gods and watched over by the *genius loci*, that is, the "spirit of the place." Similar concepts lay behind the selection of sites for the construction of religious buildings or theaters, where the site provided natural protection and magnificent views, and where the trees, also divine manifestations, were an integral part of the surroundings. The few images of gardens that survive, most of them dating from the Minoan-Cycladic era, do not show the garden as an enclosed space in which nature is domesticated; rather, they represent nature as wild, something to be respected and feared, but rendered more human by the reduced scale. Flowers and plants are often depicted in domestic wall paintings, for both ornamental and ritual or magical purposes. For Greek culture, and later for the Romans, the painted image of the garden became a way of translating and transforming nature in its uncorrupted state—nature as sacred to the gods, realm of the *genius loci*, nature as a *locus amoenus* in which man rediscovers a dimension in touch with the supernatural world.

Characteristics
Until the Classical period, a sacred place located near a sanctuary

Symbology
A religious place devoted to the gods and guarded by a *genius loci*, or "spirit of the place"

Related Entries
Sacred Woods; The Garden of the Hesperides; The Garden of Venus,

▼ Fragment of funerary stela with relief, known as *The Exaltation of the Flower*, 470–460 B.C. Paris, Louvre.

This fresco is a rare depiction of a domestic garden with specifically ritual aspects.

Red lilies of the Lilium chalcedonium *(scarlet turkscap) family grow spontaneously on the rocks. The lily alludes to the love between Apollo and Hyacinth but also evokes the idea of death, since Persephone was abducted by Hades as she was picking a lily (or narcissus).*

According to Ovid's account, Hyacinth was turned into a flower "like lilies with their silver changed to crimson" (Metamorphoses 10.213).

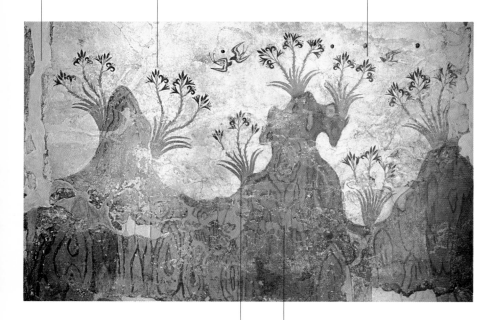

Simultaneously evoking love (the pistil) and death (the lily) in a garden devoted to the gods confirms the sacred ritual linking love and death.

The presence of mountains suggests a wild, rocky environment with an arid climate.

▲ *Spring*, ca. 1500 B.C. Athens, National Archaeological Museum.

In its many manifestations, the Roman garden could serve as hortus (vegetable garden), as a space intended for recreation, or as a place of study and conversation.

Ancient Rome

Between the end of the republican era and the first decades of the empire, the garden became a prestigious ornament of sumptuous private residences. The *hortus*, a garden intended for vegetables and other useful plants, gave way to the *viridarium*, with ornamental plants, sculptures, and fountains. Fresco decorations began to appear on the interior walls of homes, depicting lush gardens with trees and flowering plants against blue skies. At the center of these compositions, there is often a gushing fountain, while *stilopinakia*—marble pictures on colonettes believed to ward off evil spirits—stand out against the foliage. On the trellises marking the boundary between real space and painted space, mythical creatures such as sileni, maenads, and hermaphrodites appear. A direct descendant of the Greek garden, the Roman garden was above all a sacred place. Priapus, god of fertility (later supplanted by the Greek Dionysus),

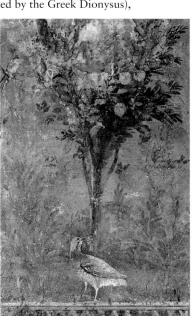

appeared in orchards as well as funerary monuments. The garden of the *domus* (home) featured *lararia*—sanctuaries to the *lares*, or household gods—as well as plants for celebrating their rites. The gods and the dead formed part of a holistic idea of nature that was reflected in the continuity between the real garden and the one depicted on the walls of homes.

Characteristics
It is generally surrounded by a peristyle, geometrically divided by rectilinear pathways, and adorned with benches, statues, vases, fountains, canals, and pools

Symbology
The utilitarian and religious aspects of republican-era gardens are supplemented in the imperial era by philosophical and literary aspects

Related Entries
Hortus; Topiary; Sacred Woods; The Garden of Flora; The Garden of Pomona

◄ Fragment of a wall painting, A.D. 20–40. Naples, National Archaeological Museum.

13

The trees behind the buildings establish a perfect harmony between the architecture, the garden, and the surrounding landscape.

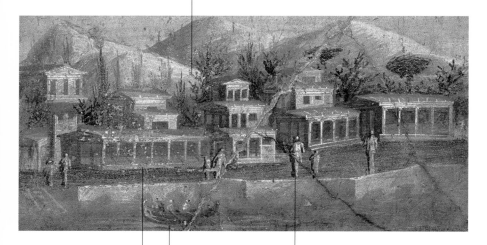

As it evolved, the Roman house tended increasingly to open up onto the garden.

The image shows how the great pleasure gardens strove to make full use of their natural settings, integrating the architecture into the site.

The herms were placed along boundaries of the garden to elicit divine protection.

▲ *Villa with Porticoes* (Third Style). Pompeii, House of Marcus Lucretius Fronto.

This laurel grove was supposed to have sprung up following a miracle in which Livia herself was involved.

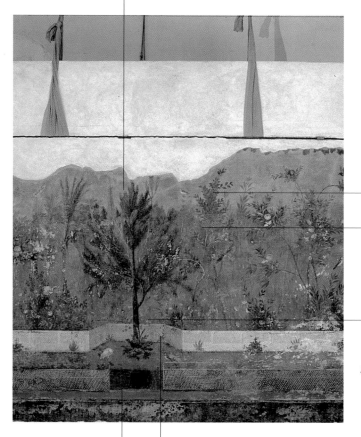

The presence of laurel may serve to support the assertions of certain Latin writers that the laurel branches destined to celebrate the triumphs of the Caesars came from the laurel grove around the Villa of Livia at Prima Porta.

The image of the evergreen garden, always verdant, can be interpreted as a good omen for the reign of Augustus.

According to legend, at the wedding of Livia and Augustus, a white eagle dropped a white hen with a laurel sprig in her beak onto the bride's lap. From this alleged event derives the name of the villa—often called ad gallinas albas, "of the white hen"—and the planting of the laurel grove.

The garden scene covering all four walls of the room seems to have been painted to "dissolve" them, as it were, creating an illusory extension of real space.

The garden as painted is organized by means of a double enclosure that runs along the entire frescoed wall. The foreground features a fence made of reeds or willow branches, with a marble barrier behind it.

▲ Fresco from the Villa of Livia at Prima Porta (detail), ca. 40–20 B.C. Rome, Museo Nazionale Romano.

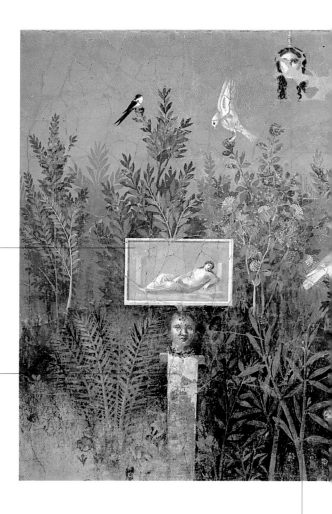

The stilopinakia, *small marble pictures atop colonettes, bear images of reclining, half-naked women, probably maenads.*

The two small columns are crowned by herms, a male and a female. The facial features are so personalized that some have thought them to be portraits.

▲ *Garden with Herms and Fountain*, A.D. 25–50. Pompeii, House of the Golden Bracelet.

Oleander, a poisonous plant, is a symbol of death.

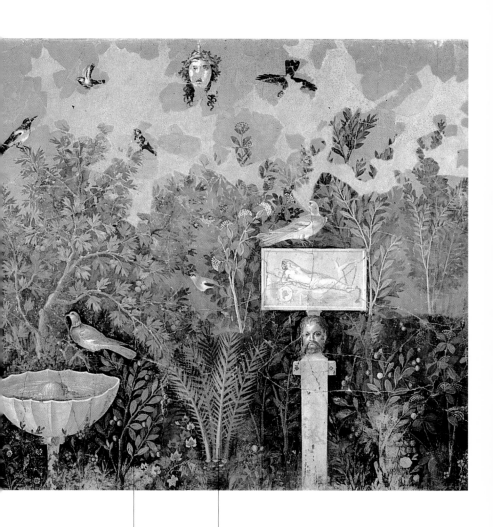

The cane apple or strawberry tree (Arbutus unedo L.), an evergreen, alludes to eternity.

The vegetation, depicted in fine detail, has an allegorical meaning: the transcendence of the condition of life and death through the attainment of immortality, symbolized by the palm.

As a place of pleasure and happiness, the Islamic garden is indivisibly linked with Paradise, which it foreshadows.

Islamic Gardens

Characteristics
Geometrical, strictly rectangular layout, enclosed by high walls and divided into four parts by two perpendicular, intersecting canals, with a pool of water at the center

Symbology
Paradise; the four parts of the world, the four rivers of Paradise; the center of the world

The sultans and emperors loved gardens and devoted great effort and care to their maintenance. It was their aim to re-create on earth an image of Paradise as described in the Koran: a splendid garden whose equal could not be created on earth. The Islamic garden is a place from which all negative symbols are banished, and where all elements conform to a specific symbology. It is regular in form and divided into four parts—corresponding to the parts of the world—by two perpendicular canals that intersect at a basin of water: the *umbilicus mundi* (navel of the world), font of life, gift from God. This image derives from the fountain that gives rise to the four rivers of Paradise, flowing out to the four cardinal points. It represents fertility and eternal life. The central pool is sometimes embellished, covered by a bower, or built as a pavilion at the center of an island. The geometrical layout conveys a sense of order, unity, and serenity in an enclosed space where water plays a dominant role. These gardens are found in lordly palaces and humble abodes, in mosques as well as Koranic

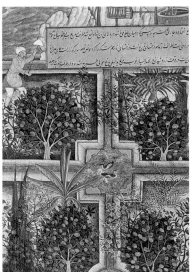

▶ *The Garden of Fidelity, from* Baburname *(1597).*

schools. The importance of the garden in Islamic culture also derives from the ancient Persian tradition of offering the king, on the tenth day of February each year, a painted wax miniature of a garden, a gift that mirrors the monarch's benediction of nature and bears witness to the strong bond between the sovereign and his people.

The rigorously geometrical garden is divided into four parts. The symbolism of the number four is very ancient in origin: Genesis speaks of the river of Paradise dividing into four branches; for the ancient Persians, the world was divided into four parts, with a spring at the center.

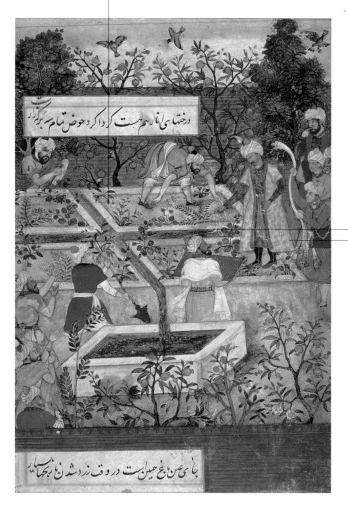

The four canals allude to the four rivers of Paradise, in which flow water, milk, wine, and honey.

In the arid climate of the eastern desert, the garden becomes a sign of civilization. The emperors themselves were passionate gardeners. This miniature shows the young prince Babur giving orders to his gardeners.

▲ *The Emperor Babur Oversees the Planting of the Garden of Fidelity*, illuminated manuscript, 16th century. London, Victoria and Albert Museum.

Islamic Gardens

According to tradition, in the 4th century, still some time before the Arab conquest, the Sassanid rulers were already having rugs woven with images of gardens, so they could enjoy their colors even in winter. This custom would live on for over twelve centuries.

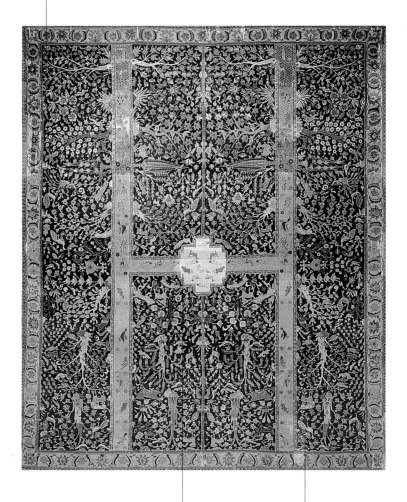

▲ Persian school, Garden Rug, ca. 1610.
Glasgow, Burrell Collection.

Although the geometrical layout typical of the Islamic garden is slightly modified here, the rug still displays the classic division into four parts, with the pool of water at the center.

The rug has an important magical and symbolic significance. It allowed the king to keep his garden—a symbol of the universe and his power over nature— perpetually alive.

The rich mystical symbolism that informs medieval culture includes the garden, which becomes one of its most resonant manifestations.

Monastic Gardens

Medieval monasteries helped preserve the arts and sciences and also became repositories of the secret arts of agricultural and ornamental gardens. The monks' profound feeling for nature was also influenced by the traditional image of Paradise. Devoting themselves to their gardens, religious hermits fortified their souls with an earthly vision of the lost promised land of Eden. The wall surrounding the monastic complex marked the boundary between cultivated and wild vegetation, order and chaos. Cultivated land inside the complex was used for many purposes, including food gardens (*horti*), herbaria, and orchards. The cloister, locus of religious meditation and prayer, was often square in form, divided into four parts by paths that form a cross at their point of intersection, usually marked by a fountain or tree. The number four was thus central to this garden as it was in the Islamic garden, evoking a variety of meanings: the four rivers of Paradise, the four cardinal virtues, the four evangelists. The allusion to Eden is also reflected in the central fountain, symbol of the font from which the rivers of Paradise spring as well as an image of Christ, origin of life and salvation. Sometimes a tree was planted at the center of the cloister, symbolizing the wood of the cross or the Tree of the Knowledge of Good and Evil, to warn against disobeying God's commandments. Certain plants cultivated within the monasteries' food gardens and catalogued in the herbaria had healing properties but also bore mythical and allegorical meanings. Many species of plant or flower corresponded to specific powers and symbologies, often connected to the figure of the Virgin Mary.

Characteristics
Cruciform plan with a fountain or tree at the center

Symbology
Paradise

Related Entries
Walls; The Gardens of Christ; The Garden of Mary

▼ Gherardo Starnina, *The Thebaid* (detail), ca. 1410. Florence, Uffizi.

Monastic Gardens

The outer wall of the monastic complex marks the sharp separation between the inner order and outer chaos. Protected from external danger, nature is channeled to re-create an image of the garden of Eden.

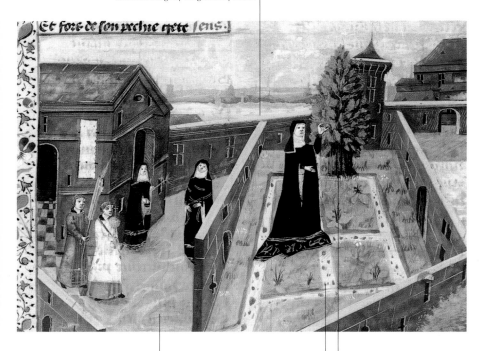

Et fors de son pselne eyete sens.

The image illustrates one of the tales from Lives of the Fathers, which was widely read in the 13th century. It tells of a nun succumbing to the devil, who succeeded in tempting her with a leaf of fresh cabbage.

The nun portrayed near the tree, picking the forbidden fruit, evokes the image of Eve being tempted by the serpent in Eden. This miniature, however, also shows holly, a toxic plant, growing, rather than cabbage. This was due to a mistake on the part of the manuscript's copyist, who wrote the word houx (holly) instead of choux (cabbage).

Walkways divide the garden into four sections. In the middle there was often a fountain or a tree. In the story illustrated here, however, a garden is possessed by evil, inverting the usual image of the monastic garden as a model of Eden.

▲ Master of the Maréchal de Brosse, *Monastery Garden*, ca. 1475. Paris, Bibliothèque de l'Arsenal.

The image of the central cloister, divided in four and featuring an obelisk in the middle, dominates the scene. Like the fountain or tree, the obelisk is an object with strong symbolic significance, evoking the cosmic axis linking earth and sky.

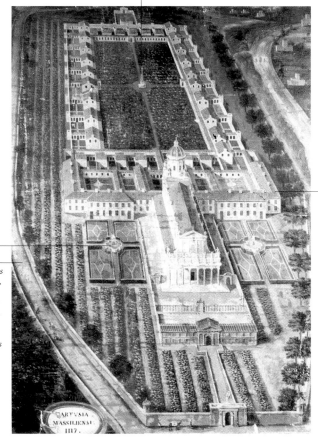

The fountain at the center of the quadripartite garden alludes to Christ, origin of life and salvation.

The charterhouse is organized according to a system of division by four, which reflects the principles of ideal beauty deriving from the divine order.

The outer wall cuts into the landscape, creating a kind of break between the disorderly outside, full of peril and uncertainty, and the inside, which is orderly, safe, and organized.

▲ *The Charterhouse of Marseille*, ca. 1680. Grenoble, Grande Chartreuse.

A direct descendant of the garden of Eden and the hortus conclusus, *the lay medieval garden is walled and protected from hostile, threatening nature.*

Secular Gardens

Characteristics
Geometric garden artic-
ulated in progressive
sequences, with no breaks
in the perspective

Symbology
Image of the heavenly
Jerusalem on earth; the
garden of courtly love;
safe haven; slice of the
domesticated nature

Related Entries
Walls; Labyrinths; Love
in the Garden; The Garden
of Paradise; The Garden
of Mary; *Le Roman de la
Rose*

The secular medieval garden was a slice of domesticated nature, a place of intimacy and retreat, protected by high walls. In it, religious motifs mingled with themes from courtly litera-ture. The garden thus became a secluded, enchanted place, as in Chrétien de Troyes's *Erec et Enide*, or the realm of courtly love, as in *Le Roman de la rose*. Boccaccio, for his part, evokes this sort of garden among the festive *verzieri* (greeneries) in his *Decameron*. The garden's internal space was divided by walk-ways into simple geometric forms by wooden enclosures flank-ing the walkways or surrounding the plant beds. There were often bowers, either simple or arched, covered with vegetation, usually vines. The truly indispensable element was water, which alluded to the source of life in Paradise, the pool of Narcissus, and the fountain of youth. We know from texts that medieval gardens sometimes had labyrinths of greenery, known as *maisons Dédalus*, of which there is no extant iconographic testimony. The medieval garden was an ordered universe, mod-est in dimension, with space dedicated to the cultivation of dye plants, vegetables, herbs, and fruit trees. Nature—viewed as chaotic and dangerous in a Europe still thick with wolves, bears, and bandits—here assumed a graphic, geometric, and reassuring form. In art, the garden was perceived sequentially, and there were no tricks of perspec-tive or openings onto infinite horizons.

▶ Lombard school, *Lady in a Garden*, 15th century. Oreno, Casino Borromeo.

A woman is weaving a crown of flowers, a typical courtly activity for women, and usually a token of love for a beloved man or woman, or for the Virgin Mary. The crown could be made of roses and carnations, marigolds, or periwinkles, but also of aromatic herbs such as mint, artemisia, and rue.

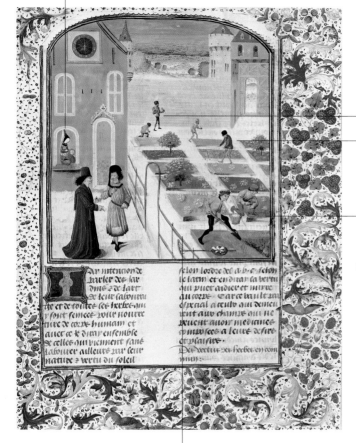

Two gardeners are fencing the square beds, which have just been planted, with a trellis of rushes.

Another gardener surrounds the perimeter of a plant bed with a high partition of rush shoots woven into lozenges.

The garden is divided into square sections representing the different stages of plant growth. Each section is in turn demarcated and raised by wooden planks that act as retainers. This method yields optimum drainage.

Inside the garden, delicate wooden barriers flank the walkways or surround plant beds, creating simple geometric forms.

▲ Master of the Fitzwilliam MS. 268, *Herbarium*, from Pietro de Crescenzi, *Livre des Prouffis Champestres et Ruraux* (1465–75). New York, Morgan Library and Museum.

A cluster of red carnations is enclosed inside a belfry-shaped structure with a cross at the top.

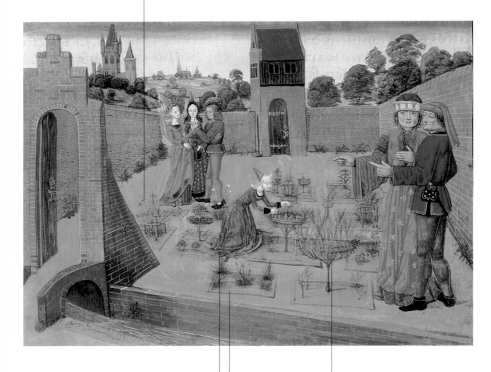

A young woman tends a small tree that is cut into a disk shape and supported by a metal ring. This sort of shaping was rather common in medieval gardens.

The painter of these miniatures emphasizes not so much the structure of the garden, which is suggested by the squared partitions, as the kinds of plants cultivated, particularly the variety of grafts and the forms of the vegetation.

The modeling of the trees and shrubs did not follow the rules of the ars topiaria, *which involves cutting the branches directly; one merely guided their growth with special supports that enabled them to assume extravagant forms.*

▲ Bruges school, *Ladies and Gentlemen in a Garden*, ca. 1485. London, British Library.

► Jean Le Tavernier, *René d'Anjou in His Study*, ca. 1485. Brussels, Bibliothèque Royale Albert Ier.

The garden paths are paved with white and blue tiles, between square plant beds raised within low masonry walls.

The tree is pruned not according to the ars topiaria, *but into superimposed disks. By means of this technique—rather widespread in the late Middle Ages—the plants' branches had to grow over wooden or metal wheels placed one on top of the other in diminishing size, forcing the foliage to grow out horizontally.*

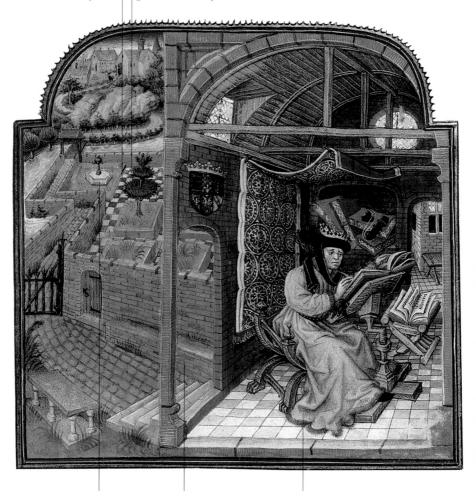

The beneficial presence of water is an indispensable element in a garden.

The garden is surrounded by a high, crenellated wall that establishes a sharp boundary between inside and outside.

René d'Anjou is busy writing in his study, while the garden behind him evokes the king's love for gardens and botany. In fact he created a great many gardens at his various residences and tended them himself.

Secular Gardens

The arched bower is usually covered with grapevines.

In the medieval garden, the internal structure is formed by light wooden barriers, the most common of which was a lozenge grid with roses climbing up it. The structure here serves, moreover, as a support for a bench covered by a carpet of grass.

In the Teseida, Boccaccio describes the interior of the castle of Thebes, where there is a little "garden of love." This is a typical example of a secular medieval garden drawn from life.

▶ Barthélemy d'Eyck (attr.), *Emilia in Her Garden*, from Boccaccio's *Teseida*, ca. 1465. Vienna, Österreichische Nationalbibliothek.

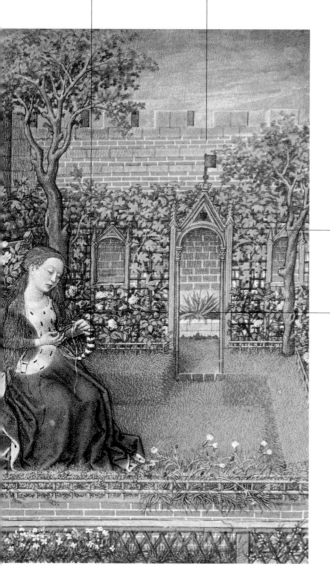

Young Emilia weaves a crown of flowers, a typical courtly activity for women.

A high, impenetrable defensive wall, made of brick and stone, protects the medieval garden.

This image is probably a faithful rendering of the garden at one of René d'Anjou's residences. He was well versed in agronomy and agriculture and had a passion for gardens.

The flowers are depicted in very fine detail and almost all are identifiable. In the background, an aloe plant seems to be reaching its leaves up toward the sun.

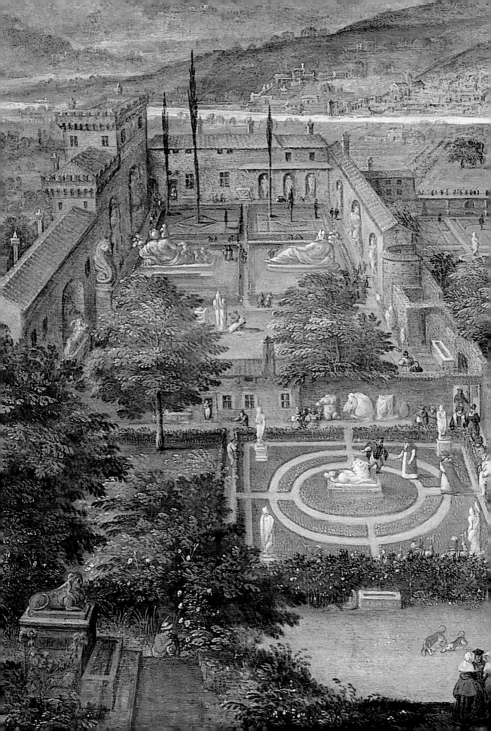

GARDENS OF POPES AND LORDS

Renaissance Gardens
Renaissance Treatises
Medici Gardens
Urban Residences
Gardens outside City Walls
The Papal Garden: Belvedere
Villa d'Este
The Cardinal's Barco
Bomarzo

◀ Hendrick van Cleve III, *View of the Vatican Gardens* (detail), 1587. Paris, Galerie de Jonckheere.

Based on readings of the classical authors, the Renaissance garden became a place of retreat for admiring the beauty of creation and devoting oneself to study and meditation.

Renaissance Gardens

Characteristics
Renewed interest in antiquity; secularization of systems of symbols and allegories; close attention given to the garden's architectural aspects

Symbology
The Renaissance garden reflects man's new attitude toward nature; it contains hidden iconographical programs aimed at celebrating the greatness of its owner

Related Entries
Walls; Secret Gardens; Grottoes; Mountains; The Garden of Wonders; Petrarch's Gardens; The Gardens of Poliphilo

The Renaissance garden was considered an integral part of life, an opening onto the outside world organized according to precise architectural rules. Taking the structure of the medieval monastic garden in a different direction, the Renaissance garden was based on a regular, geometrical plan in which low internal barriers divided the garden into sectors, breaking up the visual perspectives and creating a more closed space with genuine chambers of clipped greenery to which one could retreat to read, think, or converse. The paths were not meant to offer a visual perspective of the villa or house but rather to link the garden's different "rooms." Even the central lane was seldom broad and hardly ever gave onto the villa's main facade, which was sometimes on the side of the building. In addition to lavishing greater care on the garden's architectural aspects, the Renaissance garden also reflected a renewed interest in antiquity, along with a secularization of the symbolic and allegorical repertory of the medieval garden. As homage to and evocation of the classical world, we find ancient statues and fragments of reliefs. Although these may not have been selected according to any particular criterion, they were not merely formal ornaments but rather presences that transformed the sites into gymnasia, academies, dens of the Muses, or sacred groves. While still sometimes alluding to the garden of Paradise, the Renaissance garden's symbology above all reflected modern life.

▶ Paolo Zucchi, *View of the Villa Medici*, 1564–75. Rome, Villa Medici.

The garden is organized according to a very simple plan, oriented along a main axis running parallel to the villa's facade, probably to create a greater sense of seclusion.

In the Renaissance, one witnesses a gradual abandonment of the fortified castle prototype, and the birth, indeed rebirth, of the suburban villa, directly derived from ancient Roman models.

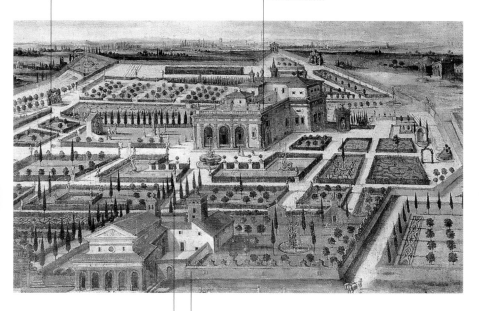

The Renaissance garden is still enclosed by a wall, but this loses its symbolic value and becomes a sort of exhortation to solitude and seclusion.

The Renaissance garden embodies a new relationship between man and nature. Finally free, man no longer opposes nature but moves about within it, fully aware that he can control it through reason.

▲ *The Villa Mattei in Rome*, 17th century. Florence, Acton Collection.

The Renaissance garden's architectural structure is emphasized by its "living architecture," such as this portico supported by caryatids and covered by a barrel-vaulted bower of vegetation, in accordance with ancient precedents.

The labyrinth of hedges in concentric circles, with a May tree in the middle, reflects the typology of the labyrinth of love.

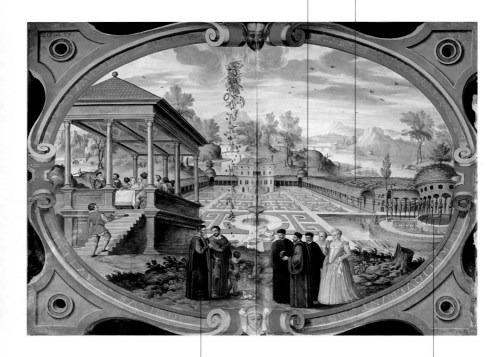

The garden's paths, which follow a well-defined geometrical structure, are designed to provide a direct perspectival view of the villa.

A place of fantasy and mystery derived from ancient sources, the island is an image of a garden within a garden where the optimum living conditions for man and vegetation are created. A place of refuge and meditation, it also has a more playful side and acts as a favorite destination for trysts.

▲ *Lunch in the Garden*, plate from *The Voyage of Charles Magnus*, *1568–1573*, 16th century. Paris, Bibliothèque Nationale.

Renaissance treatise-writers considered the art of gardening to be part of the architectural discipline, in that the garden was seen as an extension of the edifice.

Renaissance Treatises

In his mid-15th-century treatise *De re aedificatoria*, Leon Battista Alberti set out the guidelines for the construction of the suburban villa. Drawing inspiration from classical authors such as Vitruvius and Pliny, Alberti asserted that the choice of site—exposed to the sun and wind, and not too far from the city—was fundamental. As an essential component of the dwelling, the garden should be plotted according to a symmetrical plan integrated with that of the building and should reflect the ideals of unity and harmony underlying the architectural structures. The Florentine architect spared no detail in describing the garden's composition, where the paths were defined by the regular arrangement of plants, preferably evergreens. Francesco di Giorgio Martini, the famous Sienese artist who also specialized in military architecture, similarly advises in his *Trattato di architettura* that the garden's site be articulated according to a geometrical plan adapted to the features of the site. More fanciful suggestions are made in Filarete's tract dedicated to Francesco Sforza, in which he recounts the construction of an ideal city (obsequiously called Sforzinda). Filarete describes a labyrinth garden at the center of which stands a garden palace. Splendid hanging gardens adorn the palace's terraces, which feature, alongside lush vegetation, a wealth of allegorical statues representing mythological deities. Filarete's garden, however, is not laid out in the traditional manner along one side of the building but is directly integrated into the palace's architecture, thus assuming equal rank, as though the fusion of architecture and garden had become, in the author's mind, a new cultural project for Renaissance man.

▼ Filarete, *Garden Palace at the Center of the Labyrinth Garden*, 1460–65. Florence, Biblioteca Nazionale.

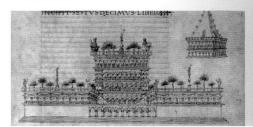

Filarete illustrates a garden labyrinth situated outside the city of Sforzinda. At the center of the garden he schematically represents a palace with abundant hanging gardens.

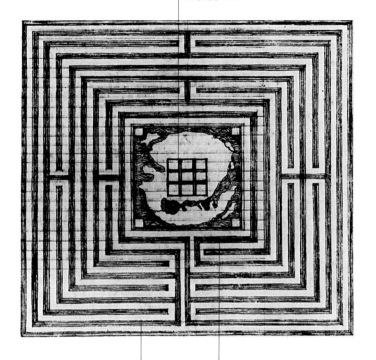

The image of garden labyrinth is apotropaic—that is, it is believed to ward off evil.

The square-plan garden is surrounded by a broad moat and a high defensive wall. Inside is a labyrinth with seven corridors, each delimited on both sides by moats filled with water.

▲ Filarete, *Garden Labyrinth*, ca. 1464.
Florence, Biblioteca Nazionale.

The hilltop is adorned with a circular garden, with paths that unfold "in the manner of a snail" and are embellished with trees and arbors.

On the little rise in the middle, which is surrounded by a moat, stands a circular-plan villa with a ground-floor portico and loggias on the upper stories.

The innovation of this design is that it also studies the possibilities of controlling a natural environment.

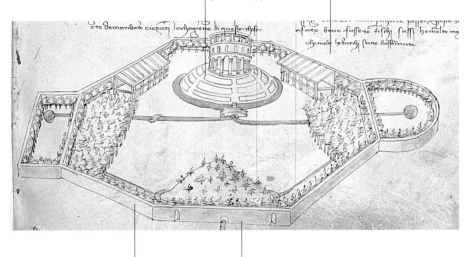

The garden's organization is connected and subordinate to the geometrical, polygonal structure of the walls.

The garden is still situated inside a closed space protected by high walls.

▲ Francesco di Giorgio Martini, *Drawing of a Park with Octagonal Wall*, 1470–90. Turin, Biblioteca Reale.

In the most hidden part of the villa, a secret garden has been created, a private space intended for the lord and designed according to the model of the hortus conclusus.

The Medici villa of Fiesole was constructed according to the directions given by Leon Battista Alberti in De re aedificatoria.

In keeping with Alberti's recommendations, the garden unfolds in descending terraces looking out onto the surrounding landscape.

The two broad terraces cut into the hillside are supported by powerful retaining walls and linked by stairs and ramps. The disposition and orientation of the gardens follow Alberti's prescriptions.

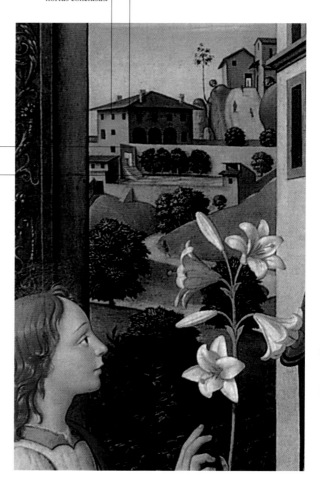

▲ Biagio d'Antonio, *The Annunciation* (detail), second half of 15th century. Rome, Accademia di San Luca.

The Medici gardens rose up as the family did, manifesting the political designs implicit in this variety of ascent to power.

Medici Gardens

From the rule of Cosimo the Elder (1389–1464) to the arts patronage of Lorenzo the Magnificent (1449–1492), the territorial expansion of the Grand Duchy under Cosimo I (1519–1574), and the princeship of Francesco I (1541–1587), the garden constantly figured in the governing plans of the Medici family, becoming a kind of propaganda of power. It was with the rise of Cosimo I, at the start of a period of economic and social prosperity, that the most famous villas were built. Either bought or expropriated, these estates are spread across the territory and by the end of the 16th century constituted a significant economic and political structure unto themselves. Despite some basic similarities, the villas and gardens present an array of typologies and tend to correspond, in their layouts, to the specific symbologies demanded by their owners. In the villa at Castello, for example, the garden plan reflects the political program of Cosimo I's government, while the ensemble of fountains—arranged to mimic the Medici family's heraldic emblem—symbolizes the prominent localities in the Grand Duchy of Tuscany. Most innovative, perhaps, is the cultural use to which the gardens were put. Starting under the rule of Cosimo I, philosophers, artists, and intellectuals would gather in these gardens, which were supposed to reproduce the ambience of Classical Athens. Places such as Careggi and Poggio a Caiano became centers of Neoplatonist teaching. The San Marco gardens in Florence proper were used as a kind of drawing school for the study of the ancients, which, after centuries of laudatory publicity, became famous as an important academy of the fine arts.

Characteristics
They display the evolution of the garden's structure from the beginning to the end of the Renaissance

Symbology
Each garden expresses the nature and symbolic demands of its owner; they range from cultural allusions to outright symbols of power

Related Entries
Mountains; Statues; The Garden of Wonders

▼ *View of Villa Medici,* 19th century. Fiesole, private collection.

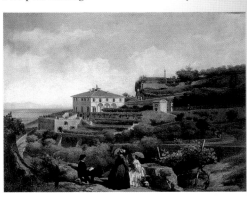

Medici Gardens

The garden does not contrast with the surrounding landscape but is integrated into it. Thanks to progress in farming technology, in fact, the countryside was no longer considered a hostile environment and thus gained new vitality.

In the humanistic conception of the villa and garden, the landscape is an integral part of the whole and considered one of the primary components of its design.

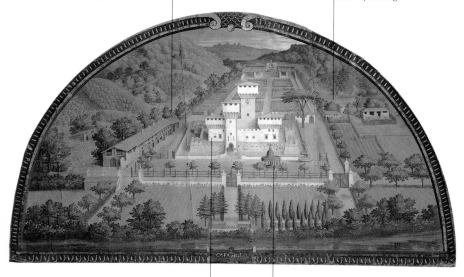

Cafaggiolo was a fortified villa that had belonged to the Medici since the 14th century. Cosimo the Elder had it renovated in the mid-15th century by the architect Michelangelo Michelozzo.

In the foreground, we see a pavilion of greenery, made up of plants carefully pruned to form a circular roof with a bench underneath.

▲ Giusto Utens, *The Villa at Cafaggiolo*, ca. 1599. Florence, Museo Storico Topographico "Firenze Com'era."

Lorenzo the Magnificent commis-
sioned the architect Giuliano da
Sangallo to build the villa at Poggio a
Caiano in the late 1400s.

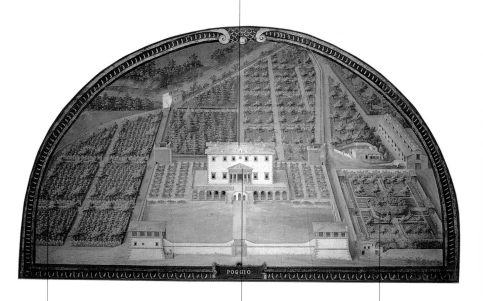

The garden at Poggio a Caiano, seat of the
Platonic Academy, is no longer the "paradise
of learning" of Careggi that Marsilio Ficino
and other philosophers dreamed up. Rather, it
represents the stage on which the human
spirit, during the brief span of its earthly exis-
tence, lives out its days, inevitably drawn
toward the path of good or that of evil, before
it is born again.

A glazed terracotta
frieze, bearing mytholog-
ical figures that alluded
to the Medicis' good
government, adorns the
tympanum of the villa.

The small, octagonal
green space sheltered
by a grove of holm
oaks was executed at
a later date.

▲ Giusto Utens, *The Villa at Poggio
a Caiano*, ca. 1599. Florence, Museo
Storico Topographico "Firenze
Com'era."

The Medici gardens are places that reflect the humanist view of antiquity by means of statues and reliefs with allegorical meanings, as in the case of the garden at Via Larga.

The statue of Marsyas, who made the mistake of challenging Apollo to a musical competition, served as a kind of warning to all those who would dare offend the hosts' tastes with bad music.

Ancient statues representing the punishment of Marsyas greeted visitors to the garden at Via Larga.

Apparently Donatello's statues David *and* Judith *were* also part of the sculptural and iconographical program of the garden at Via Larga.

▶ *Marsyas Hanging.*
Florence, Uffizi.

The structure of the urban aristocratic garden is documented only by a few rare paintings, mostly depicting open-air banquet scenes.

Urban Residences

In *De re aedificatoria*, Alberti conceives of the urban garden as a means of reintroducing into the city the models of *otium* (leisure) developed for the suburban villa. Gardens, which the aristocracy had long cultivated outside the city, now also graced their urban residences. The scant documentation of these gardens suffices to give us a sense of the importance accorded the garden and its relationship with the house. Most striking in the few surviving paintings is the close connection between the banqueting space—usually a splendidly decorated courtyard or hall—and the garden, which assumes the role of a stage on which the guests might enjoy domesticated nature, as well as each other's company. In these depictions, we get glimpses of the urban garden with its inevitable fountain, which is often finely worked and precious. The garden is usually ringed by high walls, and its pergolas and trellises are twined with flowers, normally roses. Where there is no garden, or the banquet hall is close to the entrance, nature is evoked by means of tapestries hung on the walls, featuring flowers and lush, imperishable vegetation: the millefleur tapestries, a sign of wealth and high social standing.

Related Entries
The Artificial Garden

▼ Filippino Lippi, *The Presentation of the Virgins to King Ahasuerus*, 1480. Chantilly, Musée Condé.

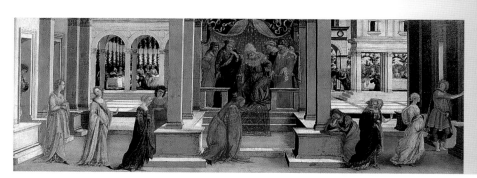

The area chosen for the banquet is partially covered by an arbor entwined with grapevines.

The real garden lies beyond the triple archway. Through its openings, one sees a high wall with a raised plant bed at its base, containing some sapling trees.

The fountain, a key element of the garden, is finely carved. It looks like a product of Rossellino's workshop and reflects the refined taste of the hosts.

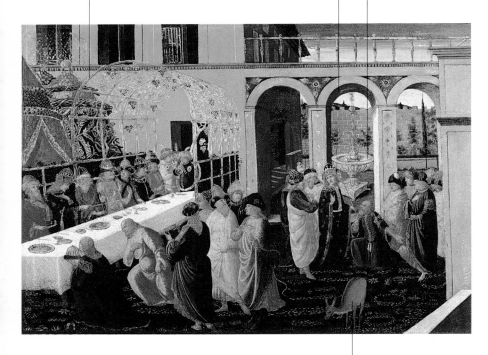

The space in which the banquet is being held is decorated to look like a meadow, as demonstrated by the presence of this grazing fawn.

▲ Jacopo del Sellaio, *The Banquet of Ahasuerus*, ca. 1490. Florence, Uffizi.

In the Renaissance garden, a new relationship is established between man and the natural world, which is no longer walled off in fear.

Gardens outside City Walls

The high enclosure wall, typical of the medieval garden, which excludes the outside world in toto, fell out of use over the course of the Renaissance. The garden began to integrate the surrounding landscape, which was now considered a fundamental element of its design. Alberti recommended that when choosing a site on which to build one's villa, one should take into account the view of the landscape. Particularly in Tuscany, the organization of the rural areas in the 15th century restored to the countryside the beautiful nooks and breathtaking vistas that were glorified by the writers of the time. Thanks to this partial ordering of outdoor space, Renaissance gardens are exceptionally well married to their environs. The garden thus played an important role in the rebirth of countryside that also gained a new vitality from improved farming techniques. The nature surrounding the Renaissance park, moreover, found a new sense of order. The garden was usually separated from the outdoor space allocated to residential buildings, orchards, kitchen gardens, and walkways. Over time, this functional part of the estate, with its irregular configuration, became part of the garden itself. Some scholars view these sorts of peculiarities in the Renaissance landscape as a sort of foreshadowing of what, a few centuries later, would become the landscape garden.

Related Entries
Landscape Gardens;
Nature as Model: Chiswick

▼ Benozzo Gozzoli, *The Journey of the Magi* (detail), 1450. Florence, Palazzo Medici Ricciardi, Chapel of the Magi.

Gardens outside City Walls

Although the city walls create a barrier between inside and outside, the countryside, now well ordered, is no longer seen as a terrifying place from which one must seek shelter, as it was in the Middle Ages. These three tiny figures are strolling peacefully.

The landscape outside the defensive walls is divided into fields, which are plowed and planted in different ways, creating a heterogeneous but orderly fabric.

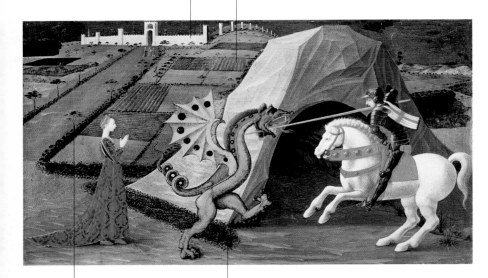

The road leading to the fortified town is lined on both sides by regular rows of trees.

The painting shows wild nature brought to order by man's "rational" mind.

▲ Paolo Uccello, *Saint George and the Dragon*, ca. 1460. Paris, Musée Jacquemart-André.

Created by Donato Bramante in 1503–4, the Belvedere Garden at the Vatican stands as the principal model for garden architecture up to the Baroque age.

The Papal Garden: Belvedere

The idea for the Belvedere Garden arose from the need to connect the pontifical palace with the villa that Pope Innocent VIII had erected as his summer residence. The requirement that the two complexes be unified aesthetically led Bramante to structure the connecting space in a stately manner inspired by models from imperial Rome, such as the Domus Aurea and the sanctuary of Fortuna Primigenia at Palestrina. The grand dimensions of the complex also reflected the wishes of Julius II, who with this ambitious work of renovation sought to assert the political prestige of the Papal States and the integrity of their territories. With this magnificent project, Bramante practically constructed a new landscape. Exploiting the natural configuration of the site, which was on a slight incline, the architect subdivided the courtyard into three different levels enclosed by long walkways consisting of arcaded corridors that established a better, more convenient connection between the two edifices. The three terraces were linked by means of staircases, while the space of the lower courtyard, intended for performances and spectacles, was equipped with a stepped seating area for spectators. The new arrangement also created a worthy space for Julius II's great collection of ancient art. Considered the first permanent, open-air theater built since antiquity, the first museum, and above all the first project integrating garden and architecture, the Belvedere's great courtyard embodies a further affirmation of man's reason, which was now able to control nature itself, reducing it to architectural form.

THE BELVEDERE GARDEN

Related Entries
Statues

▼ Hendrick van Cleve III, *View of the Vatican Gardens*, 1587. Paris, Galerie de Jonckheere.

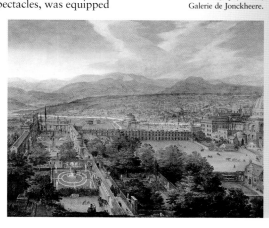

The Papal Garden: Belvedere

The Belvedere was the first garden directly integrated into an architectural complex.

The system of terraces linked by stairways was an original solution, inasmuch as it increased the sense of depth, breadth, and height of the entire garden. The design became an important reference point in later garden planning.

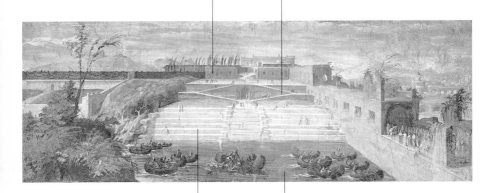

The original layout of the garden was destroyed by the later intervention of Domenico Fontana, following the construction of the library, which cut through Bramante's courtyard and irreparably ruined the view of the whole.

This fresco, executed in the ancient manner, depicts the Belvedere courtyard in the early phases of its construction. Here the lower courtyard is equipped for a naumachia, or staged naval battle.

▲ Perino del Vaga, *Naumachia in the Belvedere Courtyard*, 1545–47. Rome, Castel Sant'Angelo.

The gardens of the Villa d'Este in Tivoli, the most spectacular of the entire Renaissance, were begun in 1550 at the behest of Cardinal Ippolito II d'Este and completed thirty years later.

Villa d'Este

This majestic garden covers a vast area known as the *valle gaudente* (valley of pleasure), which was entirely reorganized in relation to the palace, an ancient Benedictine monastery transformed and rebuilt by Pirro Ligorio. The garden is divided into a wooded part on a hillside—which is wilder, nearer the palace, and crossed with long diagonal paths—and a level part, which is divided into geometrically regular sections. The two zones are separated by a canal. Indeed, the garden's central theme is water in all its many forms: fountains, pools, and sprays, the arrangement of which contains a complex allegorical meaning. The moral significance of Villa d'Este is taken from the mythic choice of Hercules, who, in the guise of the patron or well-informed visitor, comes to a fork in the road and must choose between the path to vice and the path to virtue. Superimposed upon this logical itinerary—which is echoed by the garden's architectural and spatial elements and easily recognized by visitors—is an esoteric itinerary accessible to only a few initiates. This is a path into the unknown, toward the deepest secrets of nature and history, that leads to a knowledge of nature and the psyche. It passes through three stages: the first concerns the *genius loci* and the Orphic mysteries; the second, an understanding of chthonian and marine forces from the perspective of Hesiod's cosmogony; and the third, the investigation of the psyche. In the latter, the garden's four labyrinths represent the doubt inherent in the ongoing quests of science and culture, with the cross of faith, represented by a cruciform pergola with a dome over the crossing, superimposed on top.

▼ Jean-Baptiste-Camille Corot, *The Gardens of the Villa d'Este*, 1843. Paris, Louvre.

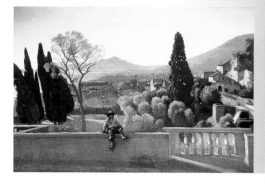

Villa d'Este

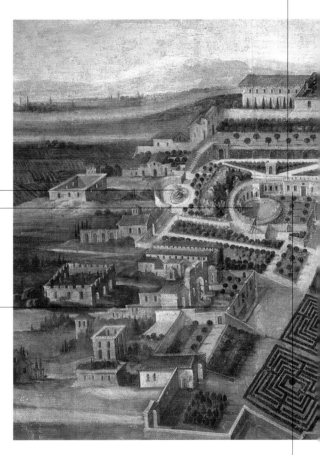

The figures of Venus, the Tiburtine Sibyl Albunea, and Diana of Ephesus are all in the eastern part of the garden, the one dedicated to virtue.

The statue of Pegasus in the Fountain of the Ovato is yet another allusion to virtue.

The Fountain of the Organ, with a statue of Diana of Ephesus.

The grotto of Venus is identified as a symbol of vice, a place of perdition, and therefore as the final destination of one of the two paths from which Hercules was supposed to choose.

▲ *The Villa d'Este at Tivoli,* 17th century. Florence, Villa La Pietra.

The palace has a second entrance in back, which can be thought of as the start of the itinerary from the known to the unknown. A kind of *descensus ad inferos, or descent into the Underworld*, it is accessible only to a chosen few, such as the heroes of legend.

The western sector of the garden contains the Fountain of Rome (the Rometta), a spectacular stage set that alludes to vice.

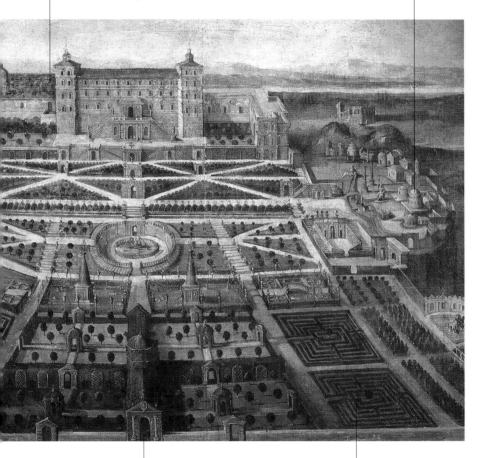

The garden's entrance used to be approached by a lane from which one could view the dizzying climb up to the terraces. The visitor was led through a complex series of allegorical allusions, most of them mythological in origin. This itinerary suggested the image of Hercules' choice, a difficult, intriguing path that ends with the virtuous deservedly attaining the top of the steep hill.

The labyrinth represents the quest, the impetus toward the final destination, just as in Hercules' quest.

Villa d'Este

The painting depicts part of the Villa d'Este complex, specifically the area around the Fountain of the Dragon, the heart of the garden, now isolated by vegetation.

The uncontrolled growth of the shrubs and trees is one sign of the crisis that was facing this late-Renaissance garden. The original configuration of Villa d'Este, with its ordered geometry, has been lost here.

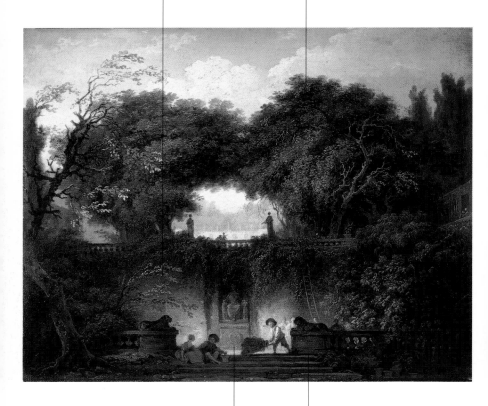

Deprived of their original context and freed from prior visual interrelationships, the statues are immersed in the natural surroundings and perfectly integrated into them.

The state of abandonment in which Villa d'Este was languishing when Fragonard painted it is borne out by the direct testimony of visitors.

▲ Jean-Honoré Fragonard, *Le Petit Parc*, ca. 1765. London, Wallace Collection.

The history of Villa Lante in Viterbo begins in the early Renaissance, when Cardinal Raffaele Riario created a barco *(park or hunting preserve) at Bagnaia.*

The Cardinal's Barco

The garden that replaced the old *barco* was created for Cardinal Francesco Gambara, who was given the Bagnaia estate when elected bishop of Viterbo in 1566. The design is most often attributed to Giacomo Barozzi da Vignola. The garden's rigorously geometrical layout unfolds along a hillside, whose slope is resolved through the creation of several terraces, skillfully arranged in perspectival sequence. Next to the geometrical garden is a vast wooded area, left wild though crossed by paths and punctuated with fountains of obviously allegorical significance. The garden, in fact, was conceived as an itinerary leading from the natural world to the world of art. As one enters the wood, one finds the Fountain of Pegasus surrounded by the Muses, designating the entire hill as Mount Parnassus. Furthermore, the so-called Fountain of Acorns (acorns were sacred to Jupiter) and the Fountain of Bacchus (a possible allusion to the wines that flowed like water in the golden age described by Virgil) seem to refer to that happy time when nature lavished on man the things he needed to live. The wood may therefore allude to a world of unspoiled nature, considered in juxtaposition with the age of Jupiter, represented by the geometrical garden, in which man's art imposes itself on nature. The second allegorical itinerary begins at the Grotto of the Deluge, at the garden's highest point, marking the transition from the Iron Age to the age of Jupiter, in which man must labor in order to live. Water, the life-giving element, after plunging from the grotto through a series of intermediate levels, finally arrives peacefully in the Fountain of the Moors, which stands at the center of the square garden, in which nature is subdued by art.

VILLA LANTE

▼ Detail of the Fountain of the Moors. Bagnaia, Villa Lante.

Starting at the Fountain of the Deluge, the water passes through several stages and is channeled into the catena d'acqua *(water chain), bearing the image of the Shrimp (*gambero, in Italian), *an allusion to Cardinal Gambara, who was responsible for transforming nature into art.*

The Fountain of the Deluge, located at the top of the geometrical garden, represents the dramatic final moment of the golden age and the beginning of the new age under the sign of Jupiter, when man puts into practice the art he has learned through his gradual civilization.

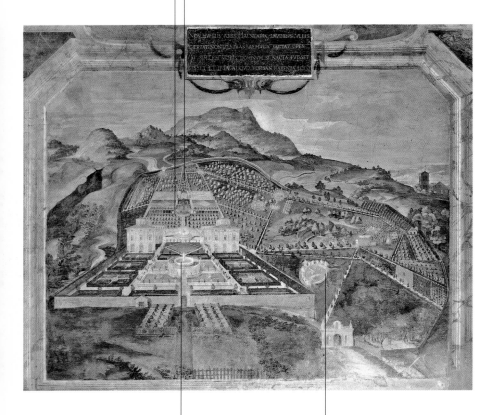

▲ Raffaellino da Reggio, *View of Villa Lante,* ca. 1575. Bagnaia, Villa Lante.

The fountain is linked by four bridges to four quadrangular pools that are surrounded by plant beds divided into regular squares that were originally enclosed by wooden fences and had small fountains in the middle.

The wooded area dominated by the Fountain of Parnassus, symbol of the garden of the Muses, alludes to the golden age, characterized by uncontaminated nature.

The gardens of Bomarzo, with their Sacro Bosco, *or "sacred wood," were elaborated for Prince Vicino Orsini around 1560.*

Bomarzo

Thanks to an inscription in the garden, we know the initial date of construction, 1552, and the name of its owner. The inscription also contains the motto *Solo per sfogar il core* (Just to unburden the heart), which seems to reflect a desire to create a garden that expresses one's inner world. The site appears to be a sort of garden of wonders, with stoneworks among its many attractions. The numerous sculptures in a great variety of forms appear amid the disorderly natural setting of the wood: one finds wrestling giants, river gods, and sea gods, Ceres and Pegasus, but also an elephant, a dolphin, an enormous tortoise with a female figure on top, Cerberus, the Furies, and many other beings. According to some scholars, the supernatural quality of the site is underscored by the presence of the ancient necropolis of Polimartum, where an Etruscan tomb with sea horses, demons, and serpents was once discovered and where, according to the Greek geographer Strabo, a giant tortoise was once found. This garden of Vicino Orsini, an imaginative, highly cultivated man, draws its inspiration from many sources and remains a mystery to this day. In one interpretation, the layout of the garden is thought to be informed by a philosophical allegory, expressing the prince's notions of life, death, and the afterlife. Others see it as a path to initiation or spiritual growth along which man separates from his primordial bestiality. Whatever its meaning, the sacred wood expresses a rejection or transcendence of the geometrical canons of the Renaissance garden; its main purpose is to surprise and astonish, and in this sense it anticipates the Baroque.

▼ Gardens of Bomarzo, Ogre's Head Grotto, 1552–53.

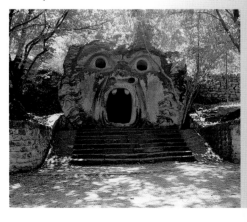

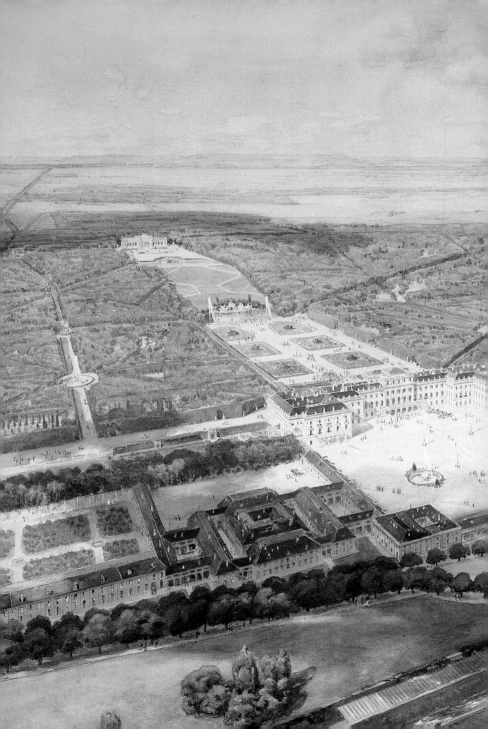

GARDENS OF KINGS

Baroque Gardens
The Garden of Defiance
Versailles
Hortus Palatinus
Schönbrunn
The Royal Palace at Caserta
The Garden of the Czar
Democratic Holland
Tulipomania
Rococo Gardens

◄ Robert Raschka, *View of the Palace of Schönbrunn* (detail), second half of 19th century. Vienna, Schönbrunn.

The political absolutism established in 17th-century Europe affected not only social and economic institutions but also the highest expressions of culture and art.

Baroque Gardens

Characteristics
Perspectival structuring of space; monumental transformation of vegetation

Symbology
Generally dictated by the need for grandiose celebrations

Related Entries
Topiary; Grottoes; Water; The Garden Stage; Parterres; Love in the Garden; Festivities in the Garden

▼ Pieter Schenck, *Perspective of the Château of Het Loo*, late 17th century. Het Loo (The Netherlands), museum.

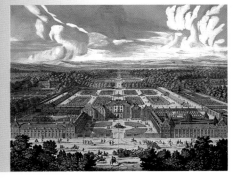

The Baroque garden was a symbol of power that found expression in the radical transformation of the natural environment. Gardens became an indispensable element of the prince's palace as a show of pomp and spectacle. Their huge expanses stretched almost to the vanishing point along rectilinear avenues that created vast geometric grids as they intersected. A single park could take up a whole valley, the main intention being to "capture infinity." Just as the Italian garden had done during the Renaissance, it was the garden of French Classicism that now set the rules with its new aesthetic principles, which would spread to all the courts of Europe. The new gardens used long, broad avenues to open up grandiose perspectives giving onto and leading away from the palace. Every aspect of the landscape that might offer dramatic panoramas was exploited to this end. This great incursion onto the land demanded that more attention be paid to the natural element, which assumed a determinant role in the Baroque garden. Artificial grottoes, reefs, and rocks were created; fountains and nymphaea became much larger, while broad bodies of water, sometimes called *parterres d'eau*, functioned as mirrors for expanding space. Gardens were designed to accommodate great numbers of people, fireworks displays, musical and theatrical performances, and every sort of *fête galante* typical of courtly life. The Baroque garden has often been considered the expression of man's total domination over nature. In reality, the regularity of the garden's dimensions, in keeping with the philosophical precepts of the age, reflected the regularity of nature itself, as well as its submission to the principles of Newtonian physics and Cartesian rationalism.

In 1767, Louis XIV surveyed the domains of Marly and commissioned Mansart to do the work, which began three years later.

On either side of the central palace of the king, symbol of the sun, Mansart designed six pavilions, lined up across the main pool and representing the twelve signs of the zodiac.

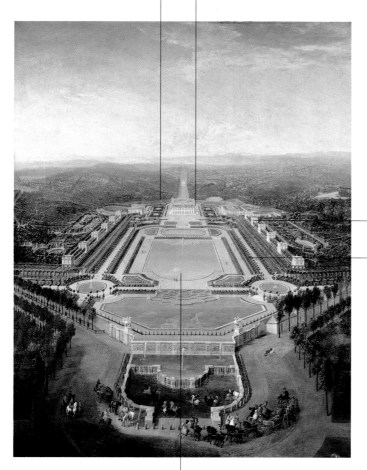

The closer a pavilion was to the main palace, the more its guests enjoyed the king's favor.

Mansart succeeded in regularizing wild nature by imposing a rigorous symmetry on it. The garden becomes a grandiose work of art in which every detail is controlled by the human hand. It is an expression of man's total dominion over nature.

▲ Pierre-Denis Martin, *The Young Louis XV in a Carriage, with Drinking Trough and Château de Marly in View*, 1724. Versailles, Musée des Châteaux de Versailles et de Trianon.

The vast reflecting pools of water tend to expand the new representative space of the garden as much as possible.

André Le Nôtre worked on the Chantilly garden complex of the Count of Condé, cousin of Louis XIV, for almost twenty years.

The Grande Parterre is made up of large pools that reflect the sky and have fountains in the middle.

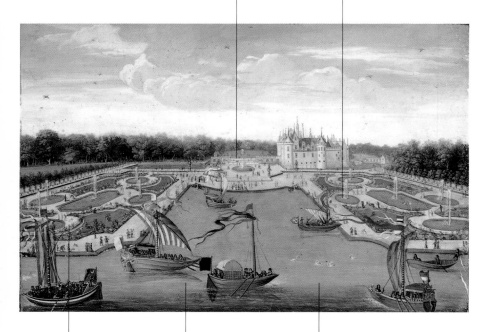

Le Nôtre has placed plates-bandes of flowers around the parterres.

The canal opens onto the park in a large basin where the boats for sport and recreation could be docked. These boats often assumed the most fanciful and varied shapes.

One of the two principal axes of the park of Chantilly runs east–west along the Grand Canal. It was constructed between 1761 and 1763 for recreational navigation and is about two and a half kilometers long.

▲ *View of the Château de Chantilly*, late 17th century. Chantilly, Musée Condé.

The Vaux-le-Vicomte garden symbolized a challenge to the king's supremacy. Designed for Louis XIV's superintendent of finance, it anticipated the grandeurs of Versailles.

The Garden of Defiance

The château and garden of Vaux-le-Vicomte are the fruit of a collaboration among three artists working together for the first time: the painter André Le Brun, the architect Louis Le Vaux, and the landscape architect André Le Nôtre. Work on this vast project, commissioned by Nicolas Fouquet, began in 1656. The château stands on an artificial prominence, which is located at the center of a garden that unfolds over three huge terraces created to modulate the slight inclination of the land. A long perspectival axis begins at the palace and extends for the entire length of the garden—with alternating rhythms of *parterres de broderies* (embroidered flower beds) and pools with fountains—leading the eye all the way up a hill. At its summit stands an enormous statue of Hercules (a copy of the Farnese *Hercules*), which directs its gaze back at the château. This mythological symbol of strength represents the great power of Fouquet, a successful financier but also a man of culture and a patron of the arts. It was the first garden where the main concern was the effect of the perspectival views. In fact, Le Nôtre, in order to create a planar effect, eschewed Renaissance precepts of perspective to create his own brilliant system for highlighting certain dramatic views and hiding or correcting certain imperfections in the whole. These expedients cause the perspectives to expand, assuming greater visual dimensions. Upon completion, the stately project was unveiled for the king as part of a sumptuous reception in August 1661. The finance officer's megalomania aroused the king's envy and suspicion, however. Within weeks, Fouquet was arrested and thrown in prison, where he remained for the rest of his life.

THE GARDEN OF
VAUX-LE-VICOMTE

▼ Israël Silvestre,
*Perspective View of the
Garden of Vaux-le-
Vicomte*, 17th century.
Paris, Bibliothèque
Nationale.

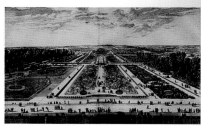

The Garden of Defiance

The central view of the château is accentuated by the arrangements of trees that rise up behind the constantly pruned "walls" of greenery called palissades.

The use of broad avenues and perspectives leading both toward and away from the château is a fundamental feature of the Baroque garden.

The broad perspective of the central avenue, over parterres and pools, leads the eye directly to the château.

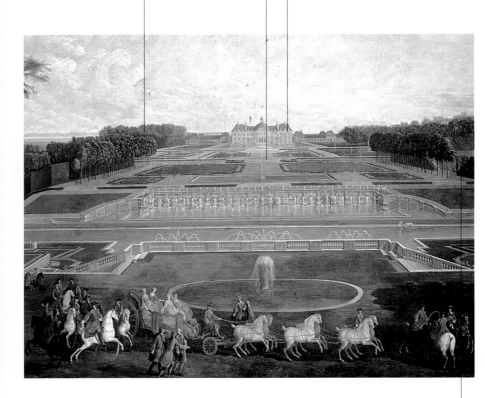

Outside the geometrically defined, celebratory space of the garden are wooded areas with a more secluded atmosphere, propitious for confidential meetings and conversations, far from the magnificence and pomp of the central part.

▲ *Visit of Queen Maria Leszczyńska at Vaux*, 1728. Private collection.

André Le Nôtre's masterpiece, the garden of Versailles, is the very symbol of 17th-century Europe, an emblem of man's sovereignty over nature and the world, and a testament to royal splendor.

Versailles

Work on Versailles took over thirty years to complete, even though Le Nôtre's first design, executed in 1662–68, included nearly all of the most important elements. The gardens unfold along two main axes set to the compass points. The primary axis begins at the royal palace and continues as far as the eye can see, passing through an endless sequence of parterres, groves, fountains, canals, and avenues. Versailles's iconographic system revolves around the symbol of the sun, the king's emblem. Every ornament—from the "green rooms" enclosed by tall hedges to the sculptural, architectural, and urbanistic elements—relates to the image of Apollo, king of the sun and the universe. The meaning of the flower garden to the south, for example, was conveyed by the statues of Flora, Zephyr, Hyacinth, and Clitia, who were turned into flowers by Apollo. His legend is embodied in statues representing the seasons, day and night, the four continents, and the four elements. The Apollo fountain at the base of the Grand Canal shows the god rising out of the sea with his chariot. The god's return after his daily itinerary is symbolized in the grotto of the Basin of Apollo.

VERSAILLES

Characteristics
Versailles is conceived as a vast stage articulated on three different levels: the town, the château, and the park, which are united by the triumphal central axis that leads to the château and continues into the park

Symbology
The entire arrangement of Versailles revolves around the glorification of Apollo, god of the sun, an explicit reference to Louis, the Sun King

Related Entries
Topiary; Grottoes; Statues; Labyrinths; Water; Technology in the Garden; Fashionable Promenades

◄ French school, *Perspective View of the Basin of Apollo and the Grand Canal*, ca. 1705. Versailles, Musée des Châteaux de Versailles et de Trianon.

Broad avenues and perspectives, leading toward and away from the château, stretch out to infinity. The king "tyrannized" nature, making his garden an image of his dominion not only over his territories but also over his court and his kingdom.

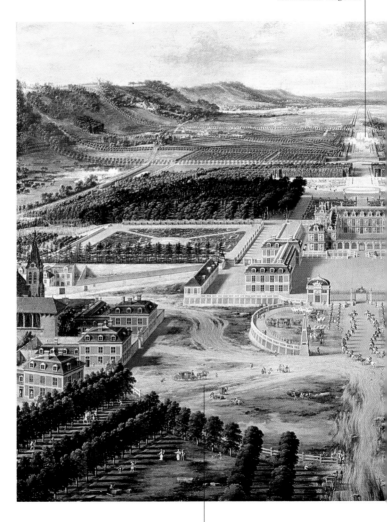

The solar symbolism is evident even in the sunburst pattern of paths fanning out from a single center. The shining sun, with the king's palace as its center, sheds its rays onto the historical world, through the radial pattern of streets that constitute the principal axes around which the town is organized, and onto nature, through the avenues that radiate out into the park. The very layout of the complex seems to express the expansionist designs of Louis XIV.

The avenues radiating from a single center like a sunburst not only recall the solar symbolism but also serve a practical purpose, in that they allow broader visual perspectives.

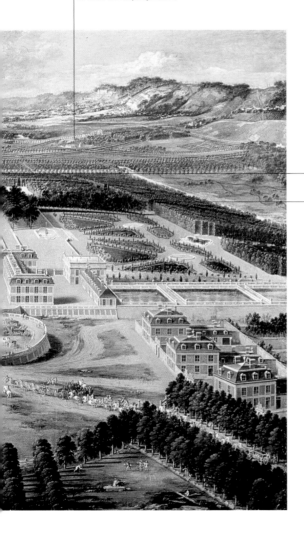

Rectilinear avenues, open spaces, and pools are cut into the thickets growing in areas left empty by the intersection of various axes. The main problem arising from this system of organization is that of keeping the principal axes of the squares and rondeaux unencumbered and preventing the arboreal walls from invading the open spaces.

There are two different scales of intervention in the Baroque garden. On one hand, we have the solemn stage set of infinite spaces destined for ceremonial processions and arranged in accordance with a celebratory or moralizing program; on the other hand, there is a more modest scale, more sensual in nature, that involves the small wooded areas, where the lush background of trees creates an intimate atmosphere propitious to fleeting pleasures.

▲ Pierre Antoine Patel, *Perspective View of the Château and Gardens of Versailles*, 17th century. Versailles, Musée des Châteaux de Versailles et de Trianon.

A latticework pavilion is the focal point of the rectilinear path at the entrance to the labyrinth.

Water and vegetation alternate in the décor of the great "green theater" of Versailles, a genuine stage set that serves as backdrop for social events and worldly gatherings.

The paths in the labyrinth of Versailles are adorned with sculptures and gushing fountains representing Aesop's fables. Here at the entrance we see two fountains illustrating the story of the fox and the crane.

▲ Jean Cotelle, *View inside the Grove of the Labyrinth in the Gardens of Versailles*, late 17th century. Versailles, Musée des Châteaux de Versailles et de Trianon.

The banks of vegetation must be constantly kept in check by barriers, pruned hedges, palissades, *and trellises.*

Within the park, the space is subdivided into bosquets *(thickets or groves), which stand apart from the grandiose language of the rest and offer a more secluded atmosphere lending itself to more intimate encounters.*

The bosquets *and open spaces exist in a state of tension, not of submission of one to the other.*

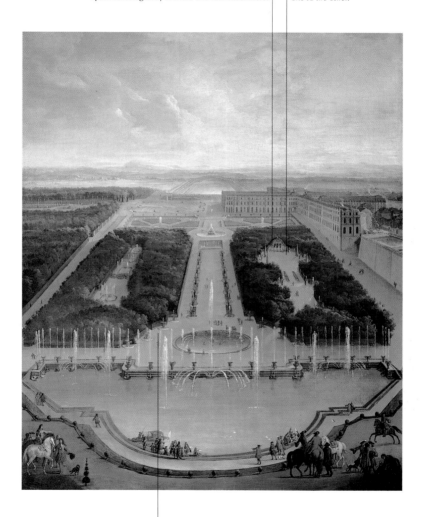

▲ Jean-Baptiste Martin, *View of the Château de Versailles from the Basin of the Dragon*, late 17th century. Versailles, Musée des Châteaux de Versailles et de Trianon.

The garden, especially the French garden, thrives on the juxtaposition between positive and negative space, between transparent perspective views and surrounding masses of trees. It is thus the result of a subtle, precarious balance that requires constant, meticulous maintenance.

In 1620, Prince Elector Frederick V commissioned the architect and littérateur *Salomon de Caus to create the Hortus Palatinus, considered by some the eighth wonder of the world.*

Hortus Palatinus

Characteristics
The garden was divided along two terraces perpendicular to each other

Symbology
The glorification of the natural elements; the celebration of the reign of Frederick V

Related Entries
The Garden of Wonders; The Garden of Pomona

▼ Salomon de Caus, *Orangerie of the Garden of Heidelberg,* from *Hortus Palatinus a Friderico rege Boemiae* (Frankfurt, 1620).

The garden was divided into two long, terraced stretches of land that were perpendicular to each other and followed the incline of the hill, atop which sat the castle. The *hortus* was given pools and fountains adorned with statues and rock compositions. The design also included artificial grottoes that were supposed to have animated scenes and talking statues, accompanied by music generated from mechanical fountains. The iconography of the Hortus Palatinus followed two principal themes: the glorification of nature and the celebration of the sovereign. The natural elements were embodied in the statues and bas-reliefs of river gods and such deities as Ceres and Pomona, while the parterre of the seasons was dedicated to Vertumnus, the Roman god of the seasons. The allegorical aspects of the sovereign's image were less well represented. A statue of the prince stood in a corner of the uppermost terrace, overlooking the garden from its highest point. The prince also reappeared in the guise of Neptune—a god who, according to Virgil, could placate a people in revolt against their earthly sovereign—and of Apollo, Hercules, and Vertumnus. The statues of the gods of the Rhine River and its tributaries the Main and the Neckar alluded to the prince's territories.

Unfortunately, after the start of the Thirty Years' War, Frederick's plans to create a zone of tolerance between Protestants and Catholics in central Europe were shattered. All that remains of his garden is a book by Salomon de Caus, an important document that allows us to reconstruct the original layout of the garden, which was never completed.

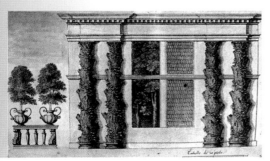

From a formal perspective, the garden is designed according to two principles: on the one hand, the surfaces are as flat and broad as possible, and on the other, the terraces are organized in declining order, as in Italian gardens.

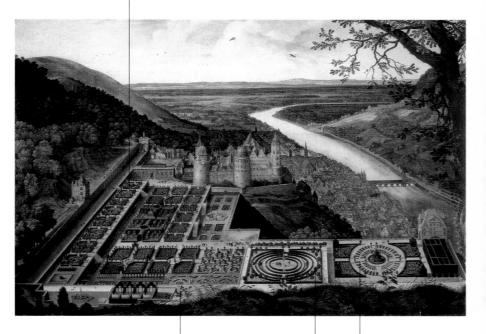

The Fountain of the Rhine is on the main terrace, while those of the Main and the Neckar are on a lower one, in keeping with a strict hierarchical structure.

The labyrinth may allude to a statement that Pope Paul V made after Frederick's coronation as king of Bohemia, in which he warned that the sovereign would get lost in a filthy labyrinth with no hope for salvation.

The circular flower beds were organized according to periods of bloom, so that the blossoming and wilting of each species of flower would occur in clockwise order.

▲ Jacques Fouquières, *Hortus Palatinus*, ca. 1620. Heidelberg, Kurpfälzisches Museum.

Schönbrunn rises up in a game preserve that Maximilian II created in the late 16th century on land that had once featured a fortified mill surrounded by farmland.

Schönbrunn

The place got its name, which means "lovely wellspring," some time after its creation, when Emperor Matthias discovered a spring in the preserve during a hunting party in 1612. In the late 16th century, having defeated the Turks, Emperor Leopold I wanted to make Schönbrunn a symbol of his power and build a royal palace to rival Versailles for his son. The project was entrusted to the architect Johann Bernhard Fischer von Erlach, who conceived a rather ambitious initial design that was replaced by one that was equally celebratory but more modest in size. In its simpler dimensions, the royal palace became the focal point of the inevitable central prospect. At the end of this avenue, on the top of a hill, the Austrian architect envisioned a loggia reminiscent of the Vatican Belvedere. Work on the garden, which stopped and restarted a number of times, was finally completed by Empress Maria Theresa of Austria, who modified its design, and especially its aesthetic conception. The poetics of limitless expanse were abandoned, and the garden was divided into sections enclosed by trees and hedgerows. Heterogeneous in their geometry and not visible from the main avenues of the palace, they were secluded spots full of surprises and apparitions, often adorned with mythological statues. Having abandoned the unitary, large-scale plan, as well as the heroic, triumphal accents of French pomp, the garden adapted its forms to a sober, enlightened monarchy unaccustomed to the cult of personality and more attentive to the bureaucratic aspects of the institution.

▼ Robert Raschka, *View of the Schönbrunn Palace*, second half of 19th century. Vienna, Schönbrunn.

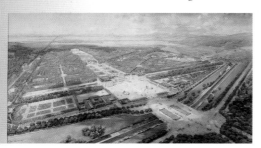

In 1773, well after Bellotto finished this painting, a row of statues was placed in front of the tall hedgerows, at the behest of Maria Theresa. These simple effigies, drawn from mythology and history, were supposed to stand in contrast to the emphatic system of symbols still identifying the glories of the House of Habsburg with the triumphs of the Caesars.

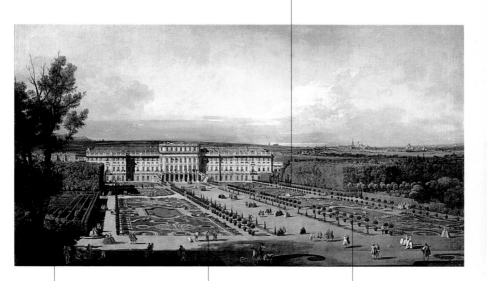

The labyrinth is made out of tall hedges, in keeping with the model of the Irrgarten, that is, a maze of paths in which one can easily lose one's way. The structure was dismantled in 1892, precisely because its particular configuration lent itself to being used for purposes "forbidden in public places."

The presence of men at work emphasizes how essential it was to provide continual upkeep for a garden of this sort.

The potted trees, generally citrus, were brought outside during the warm seasons after being kept in hothouses during the winter.

▲ Bernardo Bellotto, *Schönbrunn Castle, Vienna*, ca. 1750. Vienna, Kunsthistorisches Museum.

In the park of the royal palace at Caserta, one encounters both Renaissance and Baroque traditions, as well as an English-style garden, created many years later.

The Royal Palace at Caserta

Characteristics
Structured around a
single longitudinal axis;
the palace is a full three
kilometers from the tall
cascades

Symbology
Myths and allegories evok-
ing nature, the hunt, and
the power of the Bourbons
over the Kingdom of the
Two Sicilies

Related Entries
Landscape Gardens

Charles IV, Bourbon king of Naples (formerly Charles III of Spain), commissioned Luigi Vanvitelli to create the palace as well as the park in 1750. While remaining faithful to Vanvitelli's original design, the park's final structure was somewhat simplified. After Luigi died in 1773, his son Charles finished the work. The garden is structured around a vast longitudinal axis whose Canalone, or "Big Canal," features an alternating sequence of green lawns and fish pools. Water descends from the mountain and passes through a series of fountains, basins, stepped cascades, and simple pools before finally reaching the palace. The garden's symbolic theme, made explicit through its system of monumental fountains inspired by episodes from Ovid's *Metamorphoses*, is that of nature and the hunt, a favorite activity of the Bourbons. The allegorical journey begins at the Margherita Fountain, at the start of the perspectival axis leading toward the waterfall. The element of water is represented by the Fountain of the Dolphins, followed by the representation of air in Aeolus and the allegories of the winds. Then comes earth, symbolized by the statue of Ceres with her medallion of Trinacria, and the allegories of the hunt: the sculpture groups of Venus and Adonis, and Diana and Actaeon. This latter fountain, fed by a great waterfall, is the culmination and focal point of the entire garden. The English garden at Caserta, created at the behest of Maria Carolina of Austria, dates from the late 18th century and is entirely extraneous to the garden's original design.

► Jakob Philipp Hackert,
*The English Garden at
Caserta*, 1792. Caserta,
Royal Palace.

The water of the great cascade comes out of an artificial grotto, a kind of rustic little pavilion that was originally conceived as a belvedere.

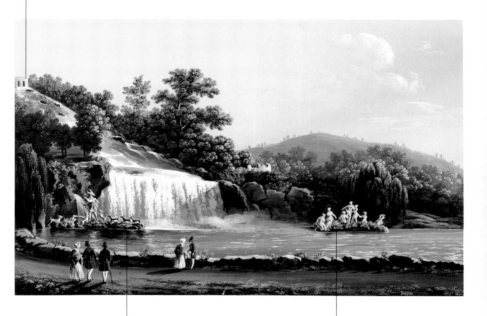

The Fountain of Diana and Actaeon, an allegory of the hunt, is the focal point of the garden.

The drama of Actaeon is divided into two distinct episodes: on the right, we see the group of Diana bathing with her nymphs; on the left, Actaeon, surrounded by his dogs, is about to be transformed into a stag.

▲ Neapolitan school, *The First Cascade at Caserta*, late 19th century. Private collection.

At Peterhof, Peter the Great succeeded in finding an original style to represent Russia's triumph when, after the victory over Sweden, his power extended to the Baltic Sea.

The Garden of the Czar

PETERHOF PARK

Characteristics
The garden structure is twofold, with an upper garden and a lower garden, and the palace serving as the link between the two

Symbology
Glorification of Russia's dominion over the sea, following its victory over Sweden

In 1715, Czar Peter the Great decided to build a château near his new city, St. Petersburg, on the southern shore of the Gulf of Finland. The complex, called Peterhof, was supposed to recall French models, especially Versailles, which had much impressed the czar during a journey to the court of Louis XIV. He brought the architect Jean-Baptiste Alexandre Le Blond, a pupil of Le Nôtre, to Russia from France. Le Blond built the palace on a terrace looking out onto the Gulf of Finland, while in the distance one could see the roofs of St. Petersburg, Russia's new capital, which Peter could now have perpetually in view. The palace's position allowed Le Blond to create two gardens, with the building serving as the link: the upper garden, which looked toward the Continent, and the lower garden, which sloped gracefully down to the sea. The upper park is rich with pools serving as reservoirs for the waterfalls and many fountains of the lower park. One particularly spectacular waterfall in the lower garden flows out from under the palace, down a marble staircase, and into a circular fountain sixteen meters below before continuing through a canal that finally flows into the sea. The circular fountain, called the Fountain of Samson, is one of the garden's main focal points. At its center is a small island, atop which a muscular Samson wrestles with a lion from whose open jaws streams a jet of water nearly twenty meters long. This sculpture represents the war with Sweden, from which Russia emerged triumphant, reconquering the territories along the Baltic Sea.

The upper garden is behind the palace and turned toward the mainland, while the lower garden looks out at the sea.

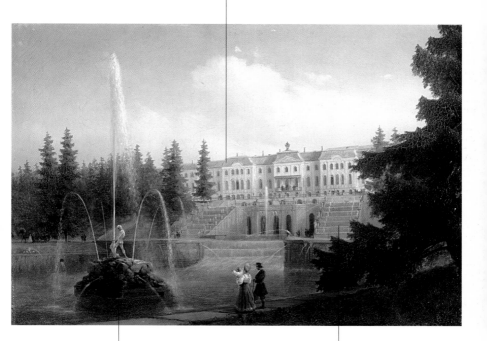

The sculpture of Samson wrestling with the lion symbolizes Russia's victory over Sweden and the reconquest of the territories on the Baltic Sea, which the palace looks out on, as though visually extending the power of the czar.

After descending a marble staircase, the water from the cascade in the lower garden flows into the large pool below.

◄ Vassily Ivanovich Bazhenov,
The Waterfall of the Dragon in Peterhof Park, 1796.
St. Petersburg, Peterhof Palace.

▲ Ivan Konstantinovich Ayvazovsky,
Peterhof, the Château, and the Great Waterfall, 1837. St. Petersburg, Peterhof Palace.

In Holland, the concept of the garden is inseparable from the Calvinist, republican spirit of its people and departs from the theatrical, celebratory pomp of the Baroque era.

Democratic Holland

Characteristics
Generally symmetrical design, with regular parterres and divisions of space; prominence of flowers

Symbology
The garden reflects the sober Calvinist spirit of the Dutch

Related Entries
Water; Parterres

▼ Jan van Kessel the Elder, *Garden with Fountain*, 16th century. London, Roy Miles Fine Paintings.

The Dutch garden, derived from the principles of the Renaissance garden and supported by considerable technical and scientific expertise, is shaped by a philosophical perspective on nature that is both utilitarian and mystical, viewing it as an instance of union between man and God. In a culture steeped in religiosity, evocations of pagan mythology in sculpture were not easy to justify. Thus in Holland the garden omitted such allusions and concentrated on Christian symbolism, ultimately creating, on a foundation of Renaissance principles, an original, autonomous language of its own. The Dutch garden was usually small, its design regular and symmetrical, and it was subdivided into numerous separate spaces, or "cabinets," that were generally square and separated by tall hedges. The garden was also usually enclosed by screens of vegetation or systems of canals, the latter especially in the low-lying polder areas. While water was certainly present in Dutch gardens, it did not have the same prominent role as in the Italian garden and usually appeared in the form of quiet pools and canals, which acted as mirrors. In gardens of regular design, the residence, not always in the center, was sometimes hidden by trees, creating an intimate, secluded atmosphere for those who ventured down the side paths. Another typical characteristic of the Dutch garden was the great abundance of flowers growing in flower beds as well as pots, especially tulips, whose popularity began to soar in the latter half of the 17th century. Around this same time, dramatic French models of garden décor began to spread in Holland, especially under William of Orange.

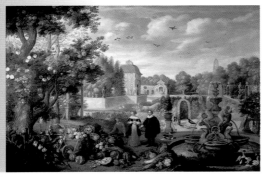

In ancient times, the night between April 30
and May 1 marked the transition to the
warm season and was celebrated as a kind of
New Year's Eve of springtime. Christian tra-
dition assimilated and transformed this myth
into Walpurgisnacht, a night when witches
and evil spirits convened but were banished
by the intercession of Saint Walpurga.

The rather small garden
in front of the residence
is subdivided into sym-
metrical plant beds.

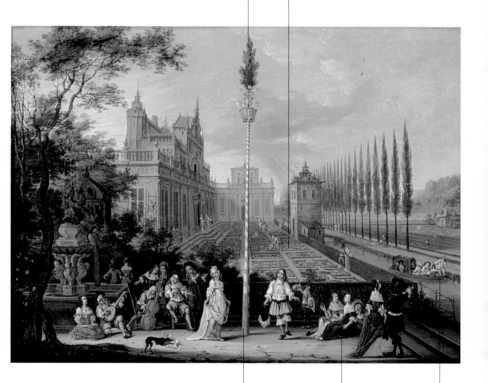

On the first of May, after the evil spirits
were banished, the people used to erect a
mast culled from the woods in the center of
town. This was the famous Maypole, or
"greasy pole," to which this painting makes
reference, while transposing the celebration
to a private scene.

▲ Peeter Gysels, *Elegant Figures Playing
Music around the Maypole*, second half
of 17th century. Private collection.

The space in the fore-
ground, along the side
of the palace, contrasts
with the space in front
of the residence, from
which it is separated
by hedges. Within this
small enclosure, a
group of men and
women are playing
and listening to music.

One side of the gar-
den gives onto a
canal. A small, deco-
rated barge is taking
a group of ladies and
gentlemen to cele-
brate under the
Maypole.

This garden, with its fanciful fruit-shaped flower beds, shows the great originality of the Dutch garden.

It is hard to identify the flowers, aside from a few tulips and the famous Corona imperialis major (*Imperial Crown lily*) standing erect on its support, a species of fritillaria that at the time was considered one the most beautiful ornaments of a garden.

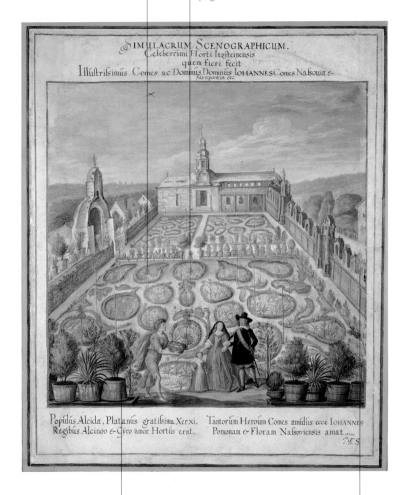

Delicate plant species were cultivated in pots to facilitate moving them to adjoining greenhouses during the cold months.

Closed to the outside world with its high wall, this garden still has the trappings of a medieval garden, a kind of Earthly Paradise isolated from a reality that still felt the threat of the Thirty Years' War.

▲ Johann Jakob Walther, *Dutch Garden*, 1650. London, Victoria and Albert Museum.

The tulip, imported from Turkey in the mid-16th century by the Austrian consul to Istanbul, quickly spread throughout Europe, enjoying particular success in Holland.

Tulipomania

Over the course of the 17th century, the tulip became the most cultivated flower in the Netherlands, where expert floriculturists used grafting techniques to create many varieties in different forms and colors. Interest in the tulip was not limited to botanists and florists, however, but became a force on the European horticultural market, making the flower a luxury commodity. Princes, nobles, and even wealthy commoners were attracted by the tulip's charm, in which nature seemed to express all her whimsy. Buyers sought out the strangest, rarest varieties to adorn their gardens. Images of tulips, moreover, became widespread, thanks to the proliferation of florilegia and the flower paintings that were so popular in Baroque Europe. In Holland, the passion for this bulbous plant grew into a true "tulipomania," one of the first speculative crazes in modern history. Until about 1630, acquisition of the flower had been the privilege of botanists and a limited number of enthusiasts. When it became accessible to small buyers as well, however, the demand became so feverish that a specialized exchange was created in Amsterdam, where one could wager on the color varieties of the new bulbs and lose or gain vast sums of money. When prices crashed in 1637, even the direct intervention of the Estates General could not mitigate the disaster. The phenomenon led to a public-education campaign and condemnation of tulipomania, spearheaded for the most part by anonymous magistrates in the affected cities.

▼ Jean-Baptiste Oudry, *Bed of Tulips and Vase of Flowers in Front of a Wall* (detail), 1744. Detroit Institute of Arts.

This image is taken from the frontispiece of Hortus Floridus *by Crispijn van de Passe, an herbal devoted to flowers, published in 1614.*

The garden is surrounded by a green, barrel-vaulted arcade, supported by caryatids.

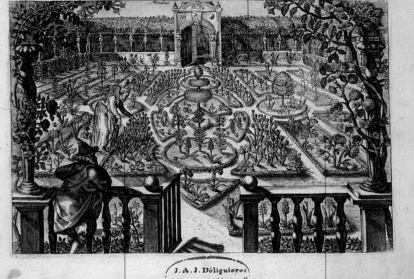

In this garden, a prominent role is given to tulips, which the woman here is tending.

This small Dutch flower garden is broken up into rather original flower beds in decorative geometrical shapes.

▲ Crispijn van de Passe I, *Garden in Spring*, from *Hortus Floridus* (1614). Private collection.

This painting condemns tulipo-
mania and denounces the dan-
gers created by this passion.

The goddess Flora is dressed like a courtesan and holds
a few of the most sought-after varieties of tulip. She is
surrounded by three faithful servants wearing minstrel's
caps. This is the so-called Flora's Wagon of Fools.

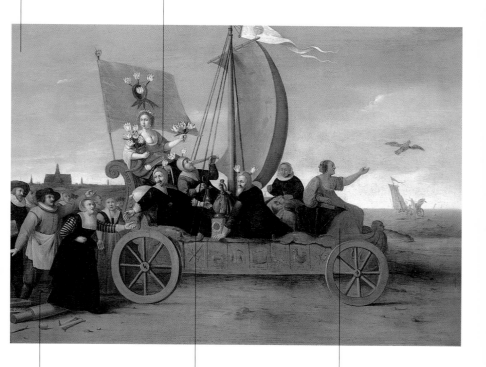

Behind the cart, several
distinguished citizens
beg to be taken on
board.

Gluttony toasts the dupes while
Greed shakes his moneybags and
unrestrained Discourse, with bell
in hand, tells licentious tales.

The two women seated in
front are called Forget
Everything, who is weigh-
ing bulbs, and Vain Hope,
who is freeing the bird of
vain hope.

▲ Hendrik Gerritsz. Pot, *Flora's
Wagon of Fools*, ca. 1637. Haarlem,
Frans Hals Museum.

The duel in the background and the image of the monkey weeping as it clutches a handful of tulips are clear reminders of the tragic aspects of the immoderate passion for the flower.

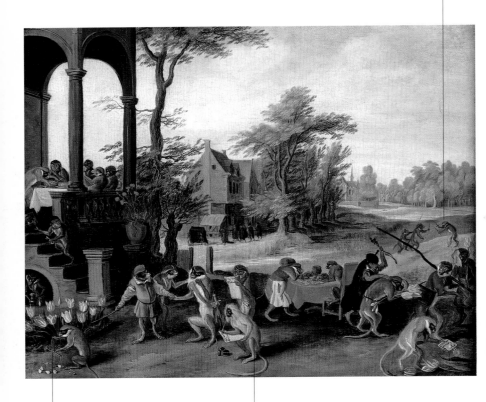

A careful analysis of the variety of the tulip is followed by the weighing of the bulb and payment with money or barter.

Symbols of man's dark, sinful side, the monkeys are portrayed in different activities related to the tulip business.

▲ Jan Brueghel the Younger, *Satire of Tulipomania*, 17th century. Private collection.

► François Boucher, *Cupid with a Cluster of Grapes*, 1765. Paris, Musée Carnavalet.

At the turn of the 18th century, the stately, triumphal French repertory begins to decline and give way to a more intimate, secluded sort of garden.

Rococo Gardens

The Rococo garden favored asymmetrical configurations defined by a deliberately prearranged disorder in which one could pursue one's desire for recreation and play in charming, intimate spaces. Gardens thus began once again to isolate themselves from the surrounding landscape and turn inward, acquiring a more meditative, comforting atmosphere into which one withdrew to pursue bucolic pleasures. The internal structure became increasingly fragmented, and the individual sections of the garden gained greater independence, until they began to look like autonomous places, united only, and in a fragmentary manner, by a system of lanes and a still-regular layout. The spaces, now more secluded, were no longer con-ceived in the grandiose context of court life but became venues for the festive gatherings of a worldly aristocracy and a rising bourgeoisie, offering a pleasant illusion of happy country life. Typical of this period are the themes of the idyll, the *fête galante*, bucolic sentiments, coquettishness, and whimsy. The aesthetic ideals of the age, moreover, tended toward a more human dimension, cultivating beauty as an interpretation of the charm and sensuality of life and finding expression in subjects relating to everyday life or a revived Arcadia. The garden's decorative elements aban-doned prior heroic and celebratory themes and became lighter, more lively, and more frivolous. Certain Rococo gardens began to feature eclectic structures inspired by diverse styles, including the wildly popular *chinoiseries*. Pagodas, Chinese pavilions, and buildings in the Oriental style begin to appear in different parts of the garden, to exotic effect.

Characteristics
Asymmetrical layouts; secluded spaces; light and frivolous decorative elements; predilection for *chinoiseries*

Symbology
The garden scales back to a more human dimen-sion; illusion of happy country life

Related Entries
The Garden Stage; Fabriques and Follies; The Orient in the Garden

Rococo Gardens

The Sanssouci complex was built at Potsdam at the behest of Frederick II of Prussia. Work began in 1744.

The very name of the complex—sans souci *means* "without worry"—*expresses the garden's purpose. It was conceived as a refuge for recreation, far from the oppressive ceremony of the court.*

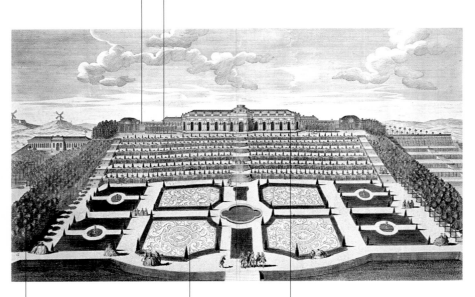

The garden is framed by lanes lined with five rows of chestnut and walnut trees.

The central parterre is divided into four compartments of broderie, *or* "embroidery."

The single-story building dominates the six terraces below. The terraces' retaining walls have niches where grapevines and small fig trees grow behind French doors.

▲ Johann David Schleuen, *View of the Vineyard-Style Terraces of the Château of Sanssouci*, 1748. Private collection.

The Indian House, with its unusual shapes, was built at a later date and is a clear example of the passion for Oriental forms that began to take hold of garden aesthetics.

The forms of the parterres, pools, and fountains became more complex in the Rococo garden. The straight line became less important, giving way to curved lines that were sometimes taken to extremes.

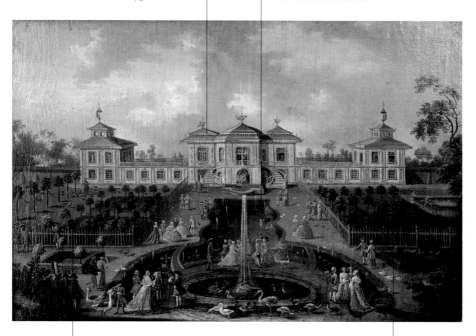

No longer dominated by propagandistic concerns and triumphal forms and messages, Rococo gardens become more graceful than their predecessors.

Conceived by the archbishop of Cologne as a summer residence, the Augustusburg complex was built in late 1720.

▲ François Rousseau, *The Indian House in the Augustusburg Garden*, 1755–80. Brühl (Germany), Augustusburg Castle.

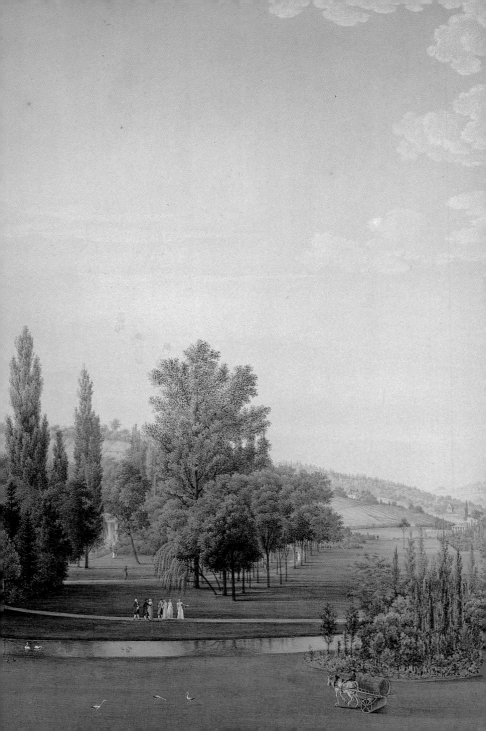

THE LIBERATED GARDEN

Landscape Gardens
Nature as Model: Chiswick
A Poet's Garden: Twickenham
Stourhead
The Political Garden: Stowe
Repton's Gardens
Ermenonville
Wilhelmshöhe
Malmaison
The "Sublime" Garden

◄ Anton Ignaz Melling, *The Park of Malmaison and the Bois-Préau* (detail), 1810. Rueil-Malmaison, Musée National des Châteaux de Malmaison et Bois-Préau.

The dialogue between nature and painting is the foundation of landscape gardening, which was born in democratic England in the 18th century.

Landscape Gardens

▼ Nicolas Poussin, *Landscape with Pyramus and Thisbe*, 1651. Frankfurt, Städelsches Kunstinstitut.

One of the main sources of inspiration for landscape gardening was landscape painting, particularly the depictions of the 17th-century Roman *campagna* by Nicolas Poussin, Claude Lorrain, and Salvator Rosa. Rather common in English collections, this genre of painting presented the Roman countryside with subtle plays of color, light, and shadow, soft hills covered with trees and shrubs and washed by rivers and streams, and scattered ruins. Such views became realities in the gardens conceived by a new generation of architects who by the early 18th century had abandoned the rigid schemata of the French garden. In Britain, this rejection of French artificiality took on a variety of meanings. The underlying concept was freedom from constriction: nature was seen as a medley of unevenness and disorder that should not be forced to follow the rigid laws of geometry. Thus if the French model reflected French absolutism, the English model reflected English liberalism. According to the latter vision, man no longer sought to dominate nature, but only to give it order. A relationship of continuity between garden and nature was thus created, blurring the former separation of the garden from the surrounding landscape. The landforms, trees, and broad grassy meadows of the garden spilled over into the countryside. The only difference between the two environments was that the countryside was a workplace with grazing animals and hay wagons, while the garden was graced with classical edifices and artificial ruins that evoked the paintings of the Roman *campagna* so beloved by the English.

Henry Hoare, proprietor of Stourhead Garden, owned a copy of this painting, and his garden reproduced, with some variants, the compositional sequence we see here: the circular-plan temple, the stone bridge, and the building with colonnade.

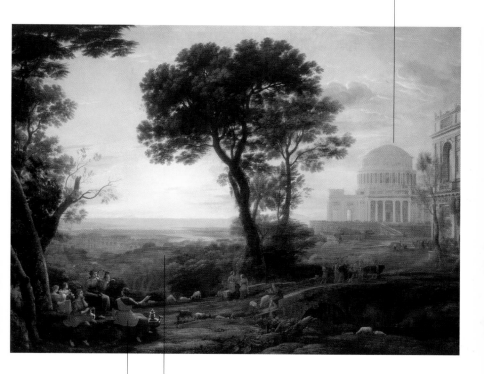

The Roman campagna, with its shepherds and ancient ruins, was one of the main sources of inspiration for the landscape garden.

Paintings of the Roman landscape offered an original vision of nature, which was no longer domesticated and could express itself in its finest forms.

▲ Claude Lorrain, *View of Delphi with Procession*, 1660–75. Rome, Galleria Doria Pamphilj.

The third Earl of Burlington and fourth Earl of Cork, Richard Boyle was an architect and patron of the arts. The garden was part of his ambitious program for Chiswick House.

Nature as Model: Chiswick

CHISWICK GARDEN

Characteristics
Coexistence of models derived from the formal garden with the new principles of the landscape garden

Symbology
Emblem of a new national style based on the spirit of liberty embodied by the new constitutional government of Great Britain

Chiswick Garden was the starting point along the path that would lead to the landscape garden. Its transformation came about in three basic stages, which reflect the general history of gardening in England. Before the Earl of Burlington's intervention, Chiswick Garden's design followed the Italian model. The renovations made between 1724 and 1733 featured a blend of Italian—or, more accurately, Neo-Palladian—motifs, such as classical buildings, exedra, and groves, and French motifs, such as avenues in trident formation and canals. Finally, between 1733 and 1736, the first intimations of a garden inspired by nature begin to emerge. A broad, grassy expanse, rolling over the soft terrain, leads to the banks of a meandering river, into which a small cascade pours. The transformation of Chiswick was part of a broader cultural change in the aristocratic circles of England. It is considered the very symbol of the sort of garden formulated by the "Palladian circle," men who saw in Palladio's harmonious architectural works and in the Classical style in general a synthesis of motifs that held universal truths. A freer view of nature, Neoclassical architecture, and the landscape garden came to be inseparable elements of a program for artistic rebirth, the result and expression of the prosperity of England's free society.

▼ William Hogarth, *View of Chiswick Garden*, 1741. Private collection.

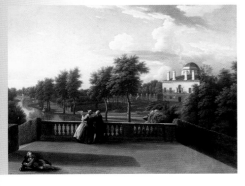

To the west of the main residence at Chiswick there once stood an amphitheater-shaped copse with numerous potted trees arranged around a small pond, at the center of which stood an obelisk.

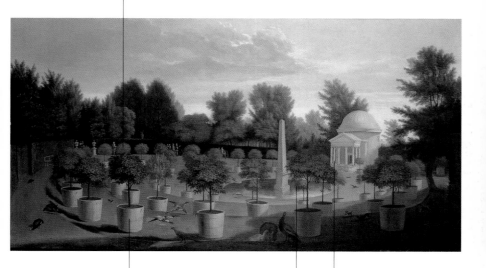

Arranged in three rows reminiscent of Enlightenment principles of order, the trees were sheltered in hothouses during the winter months.

This corner of the garden still shows the blend of Neo-Palladian and French motifs. Once the trees are removed, leaving only the architectural structures, one begins to see an environment conceived in such a way as to seem natural.

Early-18th-century England had a predilection for the Classical style, which is inevitably reflected in garden architecture and decoration.

▲ English school, *Chiswick Garden*, 18th century. London, Victoria and Albert Museum.

Twickenham Garden reflects the ideas of its owner, the poet Alexander Pope, one of the most passionate supporters of a return to nature.

A Poet's Garden: Twickenham

THE GARDEN AT
TWICKENHAM

Characteristics
Central structure organized
around a principal lane,
with more natural areas
to the sides

Symbology
The garden as landscape
painting

▼ Joseph Nickolls,
*Alexander Pope's Villa at
Twickenham,* ca. 1765.
New Haven, Yale Center
for British Art, Paul Mellon
Collection.

Landscape gardening was primarily a cultural movement among intellectuals, philosophers, poets, nobles, painters, and architects, who all contributed toward creating new and original ideas in the art of gardening. Their number included the poet Alexander Pope, who played an important role in determining the principles behind the new conception of the garden. Pope's writing bears witness to a deep feeling for nature. He believed that one must "consult the genius of the place" to discover the forms that the garden must take as the work proceeds. There was a new sense that one must respect the environmental particularities of the site, and at the same time one must conceive the garden not according to a prearranged model but by studying its setting. In creating a garden, Pope said, "you may distance things by darkening them and by narrowing the plantation more and more toward the end, in the same manner as they do in painting." This heralds a new relationship between painting and nature, which Pope summed up in the famous declaration, recorded in Joseph Spence's *Anecdotes,* that "all gardening is landscape-painting." At his Twickenham estate, Pope succeeded in creating an original garden, where the central area is crossed by a rectilinear lane with an obelisk at its end, commemorating his mother. The side areas were in a more natural state, with irregular paths running through them, a few thickets, and a small lake. The Neoclassical ornaments the poet situated in his park—a small temple, a statue, an urn—were accompanied by inscriptions, so that the garden would be perceived as a historical painting.

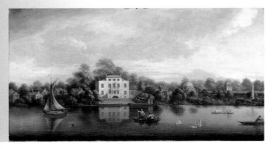

Stourhead is the most obvious example of how 17th-century landscape paintings, in this case the works of Claude Lorrain, served as models for gardens.

Stourhead

The construction of Stourhead Garden began in 1741, when the banker Henry Hoare II settled once and for all on his Wiltshire estate. The garden is organized around a lake with undulating shores and dotted with classicizing buildings: the Temple of Apollo, a circular-plan edifice with portico; the Temple of Flora or Ceres; and the Pantheon, which is on the shore opposite the first two. A bridge with Palladian echoes links the two shores at the lake's narrowest point. With this garden, Hoare created, for the first time, a landscape painting from the resources that nature offered him. The form of the Pantheon recalls the Temple of Apollo portrayed by Claude Lorrain in the painting entitled *Landscape with Aeneas at Delos I* (1672), today at the National Gallery in London. Like Hoare's building, it is a domed edifice with a hexastyle Corinthian portico on the facade. In front of the Temple of Apollo is the colonnade of a Doric-order temple whose forms and positioning recall the Temple of Flora at Stourhead. The banker did not own this painting by Lorrain, but he had a copy of the artist's *View of Delphi with Procession*, which also features the buildings in scenic sequence. At the time there were countless reproductions of Lorrain's most important drawings and paintings in circulation. The garden at Stourhead is conceived as a place of memory, an image of an ideal journey whose principal stops are marked by the buildings overlooking the lake. It is an idealized representation of the voyage of the Trojan hero Aeneas, where each building represents a place described by Virgil.

STOURHEAD GARDEN

Characteristics
The garden unfolds around a lake

Symbology
It marks the most important stops of the journey of Aeneas, the Virgilian hero who fled from Troy to become the legendary ancestor of the Romans

▼ Henry Flitcroft, *View of Stourhead*, ca. 1765. London, British Museum.

The Temple of Apollo repro-
duces the round Temple of
Baalbek, today in Lebanon.
It was the first copy built in
Europe.

The Pantheon, or Temple of Hercules, recalls
Aeneas's arrival at the court of Evander just as a
ceremony in honor of Hercules was being per-
formed. The building is copied from Lorrain's
painting Landscape with Aeneas on Delos.

The lake recalls the
Tiber River, which
appeared in a dream to
Aeneas as he was rest-
ing on the river's banks.

In the re-creation of Arcadian
nature, rich with ancient build-
ings and animals freely grazing,
the garden seems to have brought
Lorrain's paintings to life.

▲ Coplestone Warre Bampfylde,
View of Stourhead, ca. 1760.
London, private collection.

▲ Claude Lorrain, *Seascape with
Aeneas on Delos*, 1672. London,
National Gallery.

Stowe, the political and philosophical manifesto of Sir Richard Temple, an exponent of the Whig Party, is a place for contemplating the relationship between virtue and politics.

The Political Garden: Stowe

The garden at Stowe was remodeled from an original structure that was pentagonal in design and organized along long radial axes. Around 1735, Temple enlarged the park, annexing new land. He hired William Kent, one of the major figures in landscape gardening, to design the new areas. To the northwest, he built a hermitage and a temple to Venus; to the east, he designed an Arcadian landscape, the Elysian Fields, with multiple symbolic meanings. Through a series of "tableaux," and through the careful placement of classicizing architectural structures, the latter zone expressed the eternal struggle between politics and virtue. The buildings were linked by a kind of allegorical itinerary. The Temple of Ancient Virtue, imitating the Temple of the Sibyl at Tivoli, contained statues of the most important figures of ancient Greece. Juxtaposed with this was the Temple of Modern Virtue, a building in ruins, alluding to the decadence of contemporary customs. Inside was a headless bust of Robert Walpole, Temple's bitter political enemy, whom he considered the incarnation of corrupt power. Not far from this was the Temple of British Worthies, a broad exedra adorned with niches containing busts of sixteen famous Englishmen. The message conveyed by this place was clear: the England of the past, with its philosophers, scientists, enlightened sovereigns, and protectors of freedom, was not inferior to ancient Greek civilization in its quest for virtue. Today, however, British virtue, threatened by people like the hated Walpole, was reduced to a pile of ruins. The hope for reviving England's political future lay in the Temple of British Worthies, where the great men of the present live with those of the past.

The "ha-ha"—an artificial ditch at once marking and
dissembling the boundaries of the park—is an image
of the new freedom, in that it makes possible an unob-
structed view of infinity.

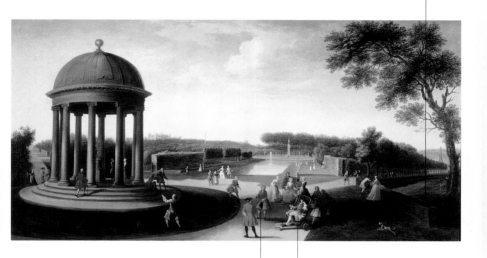

Though one of the first to
oppose the rigid schemata of
the formal garden, Charles
Bridgeman, royal gardener in
the service of King George II,
was nevertheless a conservative.

A seated Sir Richard (1st
Viscount Cobham) listens
as Charles Bridgeman
talks to him about the
great rotunda at Stowe.

▲ Jacques Rigaud, *The Rotunda and
Queen's Theatre at Stowe*, ca. 1740.
Private collection.

*The monument is surrounded by
a natural environment that is free
to grow as it likes, no longer con-
strained by geometrical schemes.*

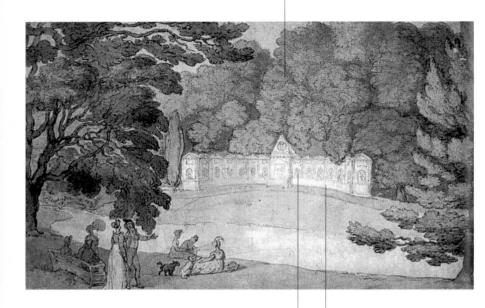

*Alongside the busts of the great men of the past are
portraits of men of the present, such as Alexander
Pope and politicians of great integrity such as the
democratic John Barnard, famous for taking on
Walpole. These men are the examples on which to
base one's hope for a better future for England.*

*The Temple of British Worthies
is the culminating point of the
political message of Viscount
Cobham's garden. It is an image
of faith and hope.*

▲ Thomas Rowlandson, *The Temple of
British Worthies*, late 18th century. San
Marino (California), The Huntington
Library, Art Collections and Botanical
Gardens.

The concept of the garden was broadened with the work of Humphry Repton, who became the greatest landscape gardener of his age and left ample written testimony of his works.

Repton's Gardens

In his *Red Books*, Humphry Repton, a landscape gardener, as he liked to define himself, created pages with overlays that allowed the reader to see the "before" and "after" of his projects. This method made garden design more comprehensible than it was in simple diagrams. The *Red Books* also reveal how much the art of gardening had changed in the space of a few decades. The watercolors show images of parks peopled with middle-class families strolling, playing sports, or sitting and talking in the shade of the trees. The classical elements on the facades of the buildings are barely hinted at, and the statues, herms, and cippi (inscribed pillars) have disappeared. The systems of cultural reference, rich in allusion and symbolism, expressing a precise ideology in such earlier parks as Stourhead and Stowe, became rather attenuated in Repton's gardens. The owners' choices were dictated no longer by cultural demands, but by the desire for immediate visual gratification. The choice of architectural styles was now determined by new constraints, such as the need to let clients select the style they like best, as well as by purely aesthetic considerations. Repton thus favored natural elements over cultural ones. He maintained, moreover, that the park and garden were destined to be "inhabited," and that civilized man could not live in the sort of nature represented in paintings. Nature must be tamed and made more comfortable. While not fully espousing either the ideas of French classicism or those of the landscape garden, he would take from each those elements most congenial to the creation of his own landscape.

Symbology
The garden is stripped of its symbolism to cater to purely visual gratification

Related Entries
Flowers

▼ Humphry Repton, *Water at Wentworth, Yorkshire,* transformation proposal from *Observations on the Theory and Practice of Landscape Gardening* (London, 1803).

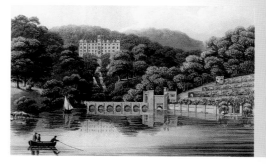

Repton became a spokesman for the demands of the new bourgeoisie that rose up on the great tide of the Industrial Revolution.

In this image, Repton portrays the garden before his intervention, when the hill was still hidden by a dense forest.

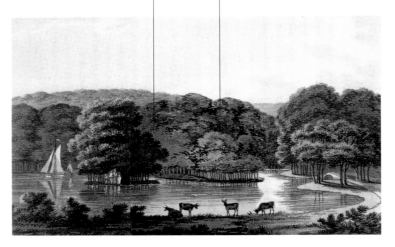

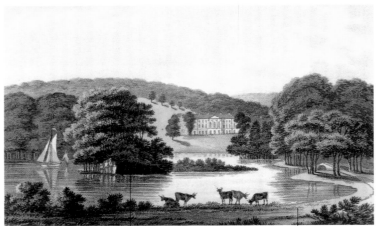

▲ Humphry Repton, West Wycombe, Buckinghamshire, "as is" and transformation proposal from Observations on the Theory and Practice of Landscape Gardening (London, 1803).

In the transformation proposal, Repton's project, though it entails clearing a section of trees at the center, presents itself as a new landscape garden, where the entire landscape is part of the garden's design.

It was Repton who conceived the term "landscape gardening" to designate the "English-style" garden—a garden that blends in with the landscape, even if it is aesthetically controlled by the human hand, as we see in these two drawings.

The garden of Ermenonville, first conceived by the marquis de Girardin and the architect Jean-Marie Morel in 1766, is one of the most successful examples of landscape gardening in Europe.

Ermenonville

The garden has three main zones: one to the south of the château, centered on a lake; one to the north, which used to have a small park; and the so-called Désert (Wilderness) to the west, a wild area where nature could grow freely. Girardin's brilliance lies in having intuited, like a true artist, what would become the park's principal décor. In the northern zone, he installed an artificial stream and erected along its course pavilions in the medieval and Italian styles. In the Désert zone, he built a hermitage, and a number of inscriptions were posted to accentuate the mood of solitude and meditation. The southern zone was organized around a small lake on whose shores more pavilions were built, including the Ice House and the Temple of Modern Philosophy. The tomb of Jean-Jacques Rousseau lies on an island of poplars in the middle of the lake. The great philosopher in fact resided at Ermenonville for several periods of his life and died there in 1778. Though his tomb remains on the island, his ashes were transferred to the Pantheon in Paris twenty years after his death. The park's primary source of inspiration was Rousseau himself, and it was intended to evoke his philosophy, especially the garden of Clarens in *La Nouvelle Héloïse*, which was supposed to harmonize natural sensations with rational behavior. The entire garden, in fact, was meant as a kind of moral and spiritual promenade, focused on meditation and feeling.

Characteristics
Organized into three main zones; it contains Rousseau's tomb

Symbology
Conceived as a spiritual and moral promenade; a new Arcadia

Related Entries
Gardens of the Dead

▼ Moreth, *View of the Garden of Ermenonville*, 1794. Versailles, Musée Lambinet.

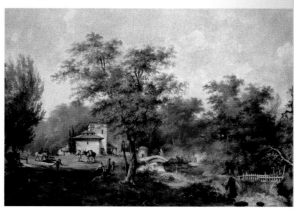

Apparently Hubert Robert also worked at Ermenonville, though this is hard to prove because the marquis de Girardin was very jealously protective of his garden and wanted to appear as its sole creator.

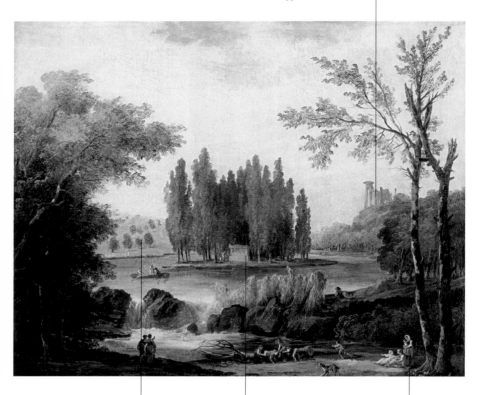

The composition of the gardens to the south and north represents two different conceptions of the landscape garden. The first garden is conceived as an Italian landscape, like those painted by Lorrain, while the second is a pastoral environment with a "melancholy stream" running through it.

It is now established that Rousseau's tomb was executed from a design by Hubert Robert.

Girardin allowed visitors from the nearby village to walk in the southern zone, depicted here. He thus supplemented the garden's natural look with the bucolic effect created by real peasants and commoners moving about in the landscape.

▲ Hubert Robert, *View of the Park of Ermenonville with the Isle of Poplars*, 1802. Private collection.

The Temple of Modern Philosophy, built in 1775 and copied from the Temple of the Sibyl at Tivoli, is unfinished, because "philosophy never attains her goals."

The temple's six columns are dedicated to six philosophers considered driving forces of humanity. Each philosopher has a corresponding motto inscribed at the base of the column.

The mottoes at the base of each column are "Lucem" for Newton; "Nil in rebus inane" for Descartes; "Humilitatem" for William Penn; "Justitiam" for Montesquieu; "Naturam" for Rousseau; "Ridiculum" for Voltaire.

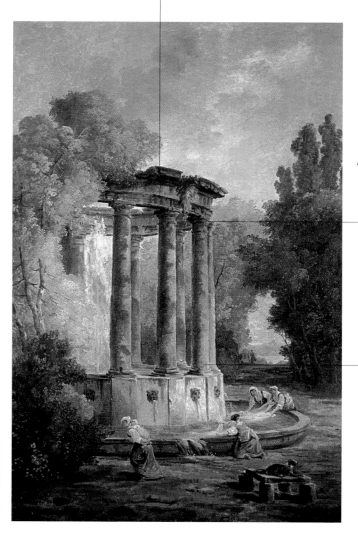

▲ Hubert Robert, *The Washerwomen*, 1792. Cincinnati Art Museum.

103

Wilhelmshöhe Bergpark has an important place in the world of landscape gardens, thanks to the structural morphology of the site, dominated by a long slope that looms above the royal palace.

Wilhelmshöhe

THE GARDEN AT
WILHELMSHÖHE

Characteristics
English garden super-
imposed on an original
Baroque design

Symbology
Manifestation of absolutist
pomp

▼ Jan Nickelen, *View of the Octagon*, 19th century. Kassel, Kunstsammlungen.

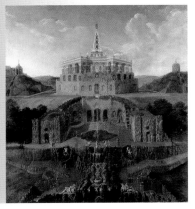

The garden at Wilhelmshöhe (Kassel) is the fruit of three different stages of planning in three different eras. It was given its definitive form in the 18th century by designer Giovanni Guernierno. Its original Baroque structure, inspired by Italian gardens, was later modified by new ideas imported from England and finally by Romantic notions. In the original design, a waterfall of imposing size with numerous terraces was created to descend from the mountain opposite the palace and into the valley near the royal residence. The waterfall is fed by a tank called the Octagon. Atop this imposing eight-sided structure rises a pyramid, at the summit of which stands a statue of Hercules, a copy of the Farnese *Hercules*. A natural geometrical axis linked the castle with the Octagon when the park still had its original function as a game preserve. The garden was then remodeled according to English principles at the suggestion of Princess Maria, daughter of King George II of England and wife of the new landgrave, Frederick II. It was finally completed in the late 18th century by Frederick's son Wilhelm and took on the name of Wilhelmshöhe. Along with the landscape aesthetic, the park was also supposed to reflect the absolutist conception of power that still reigned in central Europe. The landscape thus took on a heroic dimension, with artificial rocks jutting out, ravines, the faux ruins of a Roman aqueduct, and forceful cascades. Opposite the main body of the château Wilhelm added a ruined "medieval fortress" called the Löwenburg, or "lions' castle," recalling the feline on the Hesse coat of arms. The castle's park, the landscape garden, and the original Baroque structure were well integrated with one another, creating a harmonious ensemble.

Across from the main château were the
artificial ruins of a Neo-Gothic castle: the
Löwenburg, or "lions' castle," which
recalled the coat of arms of Hesse.

In front of the château, Wilhelm erected
a fountain that could shoot water more
than thirty meters into the air, thanks to
the pressure of the water flowing down
from the reservoir at the mountaintop.

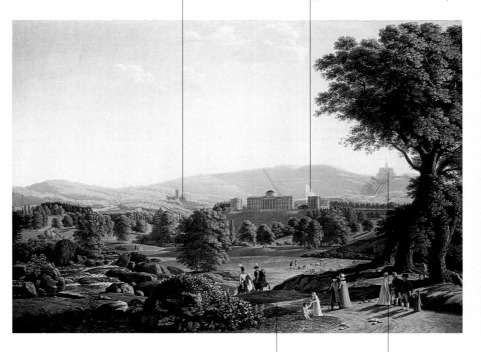

This painting shows the
Wilhelmshöhe park in
the early 19th century. It
is the product of a har-
monious synthesis of the
transformations made
over three consecutive
generations.

The Octagon gets its
craggy look from its con-
stituent stone, basalt. The
statue of Hercules on top
is almost ten meters high
and embodies the land-
grave's absolutist rule
over the territory, the
Weissenstein.

▲ Johann Erdmann Hummel, *View
of Wilhelmshöhe*, ca. 1800. Kassel,
Staatliche Kunstsammlungen.

In France, the principles of the landscape garden began to be adopted in the early 19th century, under the emperor Napoleon.

Malmaison

THE GARDEN OF
MALMAISON

Characteristics
One of the finest examples
of the landscape garden in
continental Europe

Symbology
The park reflects the
empress's great dedication
to botany and zoology

Related Entries
Greenhouses; The Portrait
in the Garden

The garden at Malmaison is one of the most interesting examples of how the landscape garden philosophy was adopted by the French. In the late 18th century, Joséphine Bonaparte acquired the estate of Malmaison. From 1800 to 1802 it acted as the seat of the French government, where the ministers of the Counsel met. After an initial restructuring by architects Charles Percier and Pierre Fontaine, the park was turned into a landscape garden by Louis-Martin Berthault. The Malmaison garden was a sequence of broad lawns dotted with small thickets and crossed by a sinuous waterway that opened up into a small, navigable lake before continuing its course toward the great greenhouse. Its fame is associated mostly with the empress's passion for botany and zoology. Indeed, Joséphine managed to cultivate rare and exotic plants that she imported not only from other parts of Europe but from all over the world, with the aid of nurserymen, botanists, and scholars from the museum of natural history. Some two hundred plants were grown for the first time in France at Malmaison. But the greatest protagonists were the roses. Some 250 species grew in beds throughout the park or were planted in vases and brought outside for the warm months. The empress managed to import specimens even during the years of the blockade against Napoleonic France, because the English shared and gladly supported her passion for plants. Nearly 170 species of Joséphine's roses were depicted in the volume *Les Roses*, by plant illustrator Pierre-Joseph Redouté, who achieved great fame with this book. His watercolors combined botanical precision with the delicacy of the new language of Romanticism, which was beginning to spread throughout Europe.

Seventeenth-century gardening
models were abandoned in
France after the Revolution, as
they had become symbols of the
ancien régime.

The garden of Malmaison was famous above all
for the enormous collection of roses immortalized
by Pierre-Joseph Redouté in his highly successful
volume, Les Roses.

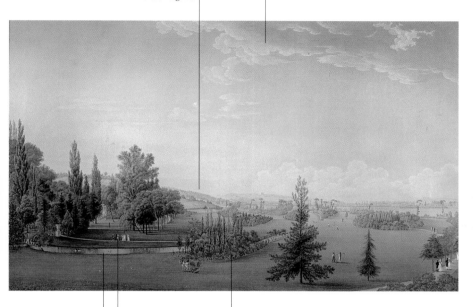

The winding stream
runs through the
entire park and flows
into a navigable lake.

The English-style
park unfolds along
circular pathways
that offer unusual
views.

Joséphine incurred
enormous expenses in
making her park and
stocking it with rare
animals.

◄ Pierre-Joseph Redouté, *Bengal Rose*,
1817–24. Rueil-Malmaison, Musée
National des Châteaux de Malmaison
et Bois-Préau.

▲ Anton Ignaz Melling, *The Park of
Malmaison and the Bois-Préau*, 1810.
Rueil-Malmaison, Musée National des
Châteaux de Malmaison et Bois-Préau.

Malmaison

The empress faced numerous difficulties in trying to raise exotic animals, not the least of which was finding trained keepers. For this reason, and her financial overreach, many of the animals were transferred to the natural history museum in Paris in the early 19th century. Thereafter Joséphine concentrated her energies on botany.

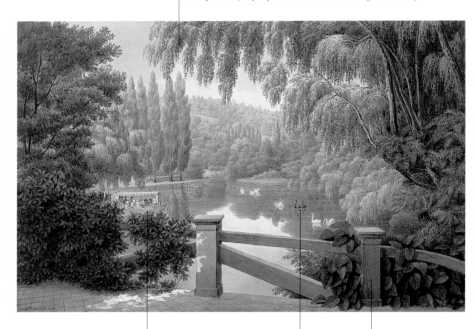

Little is left today of the original garden. The lake is gone, and even Joséphine's renowned greenhouses have been absorbed into the local housing.

These Australian black swans were among the exotic species that thrived at Malmaison.

The artificial lake was spanned by a bridge in the Oriental style, in keeping with the fashion of the time.

▲ Auguste Garneray, *View of the Lake of Malmaison*, early 19th century. Rueil-Malmaison, Musée National des Châteaux de Malmaison et Bois-Préau.

In the last few decades of the 18th century, a new approach to gardens emerged in England, one that privileged their most natural, wild aspects.

The "Sublime" Garden

A new kind of garden was born of the rejection of artifice and formalism. In these spaces, a sense of the sublime predominates, and it is difficult to trace the boundary between garden and wild nature. The aspiration is to enjoy nature in its original state, with steep crags, dark caves, and breathtaking vistas onto ravines. Here man's intervention is very limited. We are a long way from the feeling of tranquil solitude that inspired the gardens of the Restoration, where a mastery of geometry and a rigor of design resulted in secluded, intimate spaces that sought to provide an escape from the passions. The "sublime" garden, by contrast, evokes emotional agitation, sudden fear, or a sense of dismay at the dizzying perspectives. Hafod Park, in Dyfed County (Wales), is one example of this new approach to nature. The park was intended to arouse profound, intense sensations in the visitor. The harsh landscape of the Hafod estate lent itself particularly well to sensations of "horror." Itineraries and specific lookout points were selected as the work was being carried out, using the craggy Welsh landscape to evoke the mythical Celtic origins of the region. When the park was first being built in the 1780s, Celtic legends tied to this land were also being revived in the popular literary genre of "legends of the bards," of which the much-debated *Fragments of Ancient Poetry* "discovered" by James Macpherson are the most famous example. Hafod Park was affected by this ferment, and a number of clear references to the bardic origins of the place were incorporated at several points.

▼ John Smith, *Cavern Cascade*, from *Fifteen Views Illustrative of a Tour to Hafod*, by James E. Smith (London, 1810). Aberystwyth (Cardiganshire), National Library of Wales.

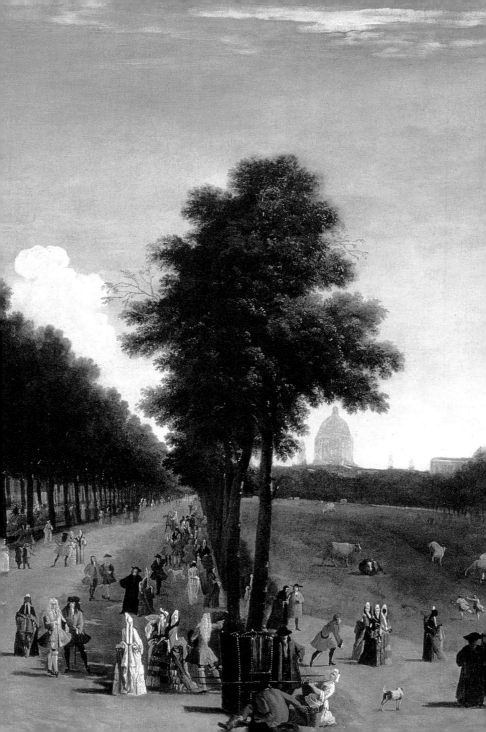

THE GARDEN GOES PUBLIC

The Public Park in Paris
The Public Park in London
Viktoriapark in Berlin
New York's Central Park

During the 1789 Revolution, numerous domains of the clergy and aristocracy were confiscated, some of which were turned into public parks.

The Public Park in Paris

Characteristics
The new parks were designed for the most part according to the precepts of the landscape garden

Symbology
The need for better hygiene and social control of urban growth

Related Entries
Games, Sports, and Activities; Fashionable Promenades

▼ Jean-Baptiste Leprince (attr.), *The Entrance to the Tuileries from Place Louis XV*, ca. 1775. Besançon, Musée des Beaux-Arts.

Paris was one of the first cities to offer the use of its green spaces, including such well-known temples of the promenade as the Palais Royal and the Tuileries, to its citizens. But it was during the reign of Napoleon III that Paris undertook the most important programs of public parks, integrated into a general plan of urban renewal that was to eradicate its medieval plan. To give France a more modern look, Louis Napoleon assigned Georges-Eugène Haussmann, prefect of the Seine, the task of making the capital into a model city and symbol of progress. Haussmann created new, tree-lined avenues, a sewage system, and a series of public gardens and promenades. The parks in particular were supposed to define the geographical organization of the city. The Bois de Boulogne to the west would have its counterpart in the Bois de Vincennes to the east, while the park of Buttes-Chaumont to the north had its corresponding space in the park of Montsouris to the south. Corresponding to the layout of these four parks, twenty-four public squares, outfitted as gardens, were inserted into the urban fabric. These were modeled on the English square and offered the public a place for relaxation and recreation. Napoleon III was well

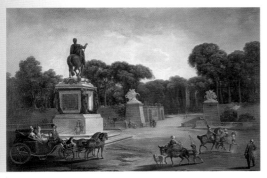

aware, however, that creating "green lungs" for the people's amusement in the city of Paris also had political implications. The parks indeed helped reinstate an image, albeit illusory, of social harmony. It was hoped that recreation and diversion might serve a counter-revolutionary purpose, channeling some of the daily tensions of urban life into harmless activities.

Le Nôtre created a uniform grid of lanes fanning out from the central avenue and alternating with decorative plant beds and clusters of trees.

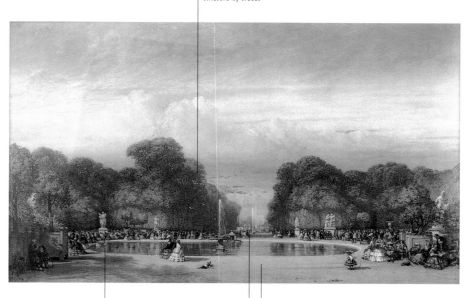

The royal garden of the Tuileries assumed a "public" function as early as the late 17th century. The reorganization of the garden was entrusted to Le Nôtre and completed in 1672.

The central axis of the Tuileries continues beyond the garden and along the Champs-Élysées, culminating in the Arc de Triomphe.

The entrance was originally patrolled by the king's personal guard, and admittance was forbidden to domestics, soldiers, and "poorly dressed" people. Not until the 19th century did the Tuileries garden become the famous site for public recreation that was popularized by the Impressionist painters.

▲ William Wyld, *The Jardins des Tuileries with the Arc de Triomphe in the Distance*, 1858. Private collection.

The Public Park in Paris

The Bois de Boulogne, originally a royal game preserve with a radial system of avenues, was redesigned by Haussmann according to the principles of the landscape garden, with twisting paths running through the woods.

Between the late 19th and early 20th centuries, the emphasis shifted from aesthetic to functional concerns in garden design. This reflected a change in the activity of the typical garden's visitor—no longer a cultivated observer but rather the beneficiary of a space organized to satisfy his need for recreation and rest.

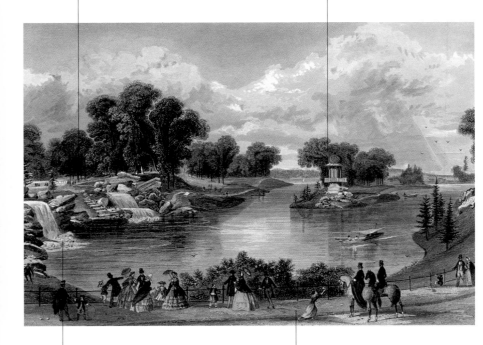

A system of streams fed by water from the Seine runs through the park, creating two lakes with landing wharves in some of their inlets.

The Bois de Boulogne was the first example of a landscape garden designed for the general public, and it met with enthusiastic approval.

▲ The Lake at the Bois de Boulogne, 19th century. Paris, Bibliothèque des Arts Décoratifs.

The urban parks of England became models for the rest of Europe, and after the mid-19th century they surpassed those of France in size and number.

The Public Park in London

In 1800 there was a severe shortage of green space in urban England. Aside from a few promenades in the royal parks and commons, which were always being threatened with new construction, England would not see any great public parks until the Victorian era. John Claudius Loudon, after personally assessing the situation on the Continent, was among the first to declare the need for public parks. England's delay in this area was due above all to the fact that during this period the country was in the throes of profound upheaval brought on by the Industrial Revolution. Not until the mid-19th century did the British begin to realize the extent of the devastation wrought by the uncontrolled growth of cities, following the mass influx of people from the countryside in search of work. Public parks in London, and in England in general, began to spread after Parliament promulgated a number of measures aimed at ameliorating social conditions that were becoming explosive. The urban gardens in England were thus designed to accommodate mass use, offering an alternative to the deteriorated environment of the insalubrious city neighborhoods in which most workers lived. At the same time, the parks were considered areas for creating new social connections, enabling the proletariat to absorb models and codes of behavior from the middle classes. Though born of malaise, the English park became a symbol of the recuperation of the lower classes. It was a place where one could relax after an exhausting workday and reclaim the sociability and play that had been lost with the closing of the commons.

Characteristics
The design of the public parks is based on the models of the landscape garden, the pleasure garden, and the botanical garden

Symbology
The park takes on strong social connotations, representing a kind of recuperation of the most dispossessed classes

Related Entries
Fashionable Promenades

▼ English school, *Grosvenor Square in London*, 1754. Private collection.

The term "mall" comes from "pall-mall," a game played along a long rectangular alley lined on both sides with tall trees that provide shade during the competitions.

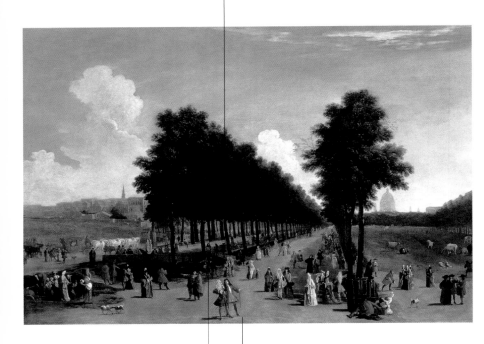

When the game of pall-mall went out of fashion, the long, shady courts became promenades. The term "mall" ended up meaning a tree-lined lane intended for public walks, before assuming its even broader present-day meaning.

St. James Park was originally a fashionable meeting-place for the English aristocracy. In fact, one could get in only by paying an entrance tax, which entitled one to the gate key.

▲ Marco Ricci, *View of the Mall and Saint James Park in London*, ca. 1710. York, Castle Howard.

The Crystal Palace dominates the vast park from its elevated position. The building's structure served as a reference point for the layout of the garden, whose different components—lanes, fountains, terraces—were conceived in relation to the Crystal Palace.

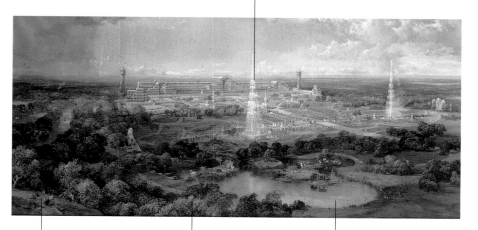

Joseph Paxton, the famous creator of the Crystal Palace of London, established a finance company in Sydenham for the purpose of reconstructing the great London greenhouse, creating a vast for-profit park for people's amusement and education. Sydenham Park represents the prototype of the sprawling theme parks of the 20th century.

In its central area, the garden follows the principles of the Italian garden. In the more outlying, contiguous parts, it reflects the principles of the English landscape garden.

A kind of prehistoric park, with life-size cement dinosaurs, adorned the shores of one of the larger lakes.

▲ Joseph Paxton, *The Crystal Palace and Its Gardens at Sydenham*, ca. 1855. London, Royal Institute of British Architects.

Viktoriapark was built on a hilltop that was originally intended for a cathedral celebrating the Prussian victory over Napoleon.

Viktoriapark in Berlin

Characteristics
Designed in keeping with the eclectic theories of the time

Symbology
Celebration of the Prussian victory over Napoleon

▼ *View of the Kreuzberg, Viktoriapark, ca. 1890. Berlin, private collection.*

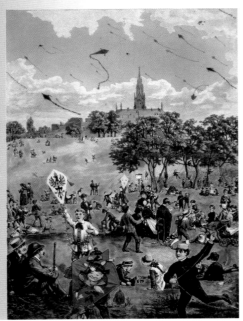

After the Congress of Vienna in 1815, the city of Berlin decided to plant an iron cross at the spot where a cathedral was supposed to have been erected. The state thus acquired an area in the southern zone of Berlin where the land had been utterly devastated by the construction of fortifications in 1813. The site afforded, however, a brilliant panorama of the city. The cross at the top of the monument was a copy of the one that, in keeping with the democratic tendencies of the period, had been awarded to both officers and common soldiers. It was later decided that the monument should be surrounded with a protective enclosure, and finally, around 1824, the city began to plan a park. Following a variety of vicissitudes, the park was finally completed by order of Kaiser Wilhelm I, who had the monument moved and aligned with the visual axis of the main entry road into the city. Upon its completion in the late 19th century, in an eclectic style, it was given the name of Viktoriapark, a reference to the hereditary princess Viktoria, but also as a reminder of the original reason for its creation—the victory over the French. An artificial waterfall began at the monument and plunged some twenty-four meters (about 80 ft.) downward. The cascade was built with great blocks of granite and limestone, to create the impression that the monument had been built on a cliff.

The Kreuzberg was sur-
rounded by a gate to
protect it from vandals.

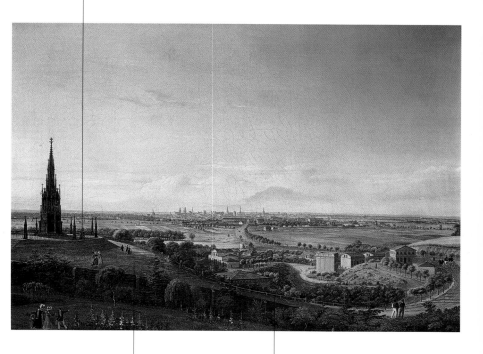

The monument stands on
a sandy hill that was aug-
mented with masses of
stone.

Still in its original state in this early-19th-
century image, the park was a place for
strolling and hiking. From the top of the hill,
one enjoyed a splendid view of the city and
the surrounding territory, which had not yet
been spoiled by the relentless urbanization of
the peripheral neighborhoods.

▲ Johann Heinrich Hintze, *The
Kreuzbergdenkmal with Berlin in the
Background*, 1829. Berlin, Verwaltung
der Staatlichen Schlösser und Gärten.

The first great public park in the United States, Central Park, in the heart of Manhattan, was designed by Frederick Law Olmsted from 1856 onward.

New York's Central Park

Characteristics
The park's streets and lanes are planned so that they segregate different kinds of transport

Symbology
The park is considered a useful tool for improving social and hygienic conditions

▼ Currier and Ives, *Grand Drive, Central Park*, 1869. New York, Museum of the City of New York.

Central Park was designed to create an environment that was recreational but at the same time rational, encouraging modes of behavior that would bolster common civic life. It also included another novelty: the streets intended for carriage traffic, which cut through the park and linked the neighborhoods at opposite ends of the park, were designed, wherever possible, to lie at a level below grade, so they would not interrupt the visual continuity of the natural setting. Frederick Law Olmsted's vision of public urban green spaces took a variety of aesthetic and hygienic but also economic factors into account. In fact, the building of the park caused a boom in real-estate values in the surrounding areas. Olmsted often returned to the notion that a country's well-being can be determined by the relationship established between order, security, and the economic life of the cities. He was also keenly aware of the need to reclaim the natural element, not only in order to improve public hygiene, but also because a well-maintained environment allowed the principles of equality and social justice to flourish. For this reason, a park in the middle of a city should not be exclusive, removed from its densely built-up context, but must rather be integrated in the urban system itself and must above all be accessible to all citizens. Olmsted's intention—and that of all later American landscape architects—was to "naturalize" the city. This path, just begun, would eventually lead to the development of the "garden city" concept.

THE GRAND DRIVE CENTRAL PARK N.Y.

Central Park is an inversion of the philosophy of the "garden cemetery." The latter was a suburban public park set apart from the city, while Central Park becomes a kind of Eden situated inside the constraining materialism of the urban fabric.

Between the late 19th and the early 20th centuries, garden design shifted its attention from aesthetic concerns to functional ones.

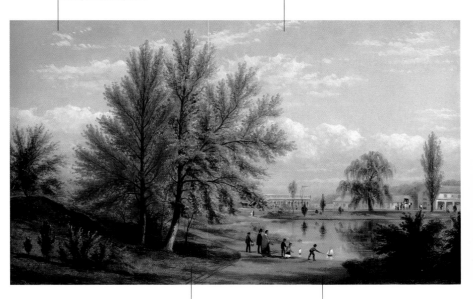

Central Park offered new and original solutions to functional problems. Wherever possible, the carriage roads were built at a lower level than the vegetation.

New York's Central Park was the first American example of a public park of huge proportions. According to its designer, who also designed the renowned Mount Auburn Cemetery in Cambridge, Massachusetts, the park was supposed to be a place for "rational amusement" that would encourage citizens to participate in civic life.

▲ William Rickarby Miller, *View of the Lake in Central Park, New York*, 1871. New York, New-York Historical Society.

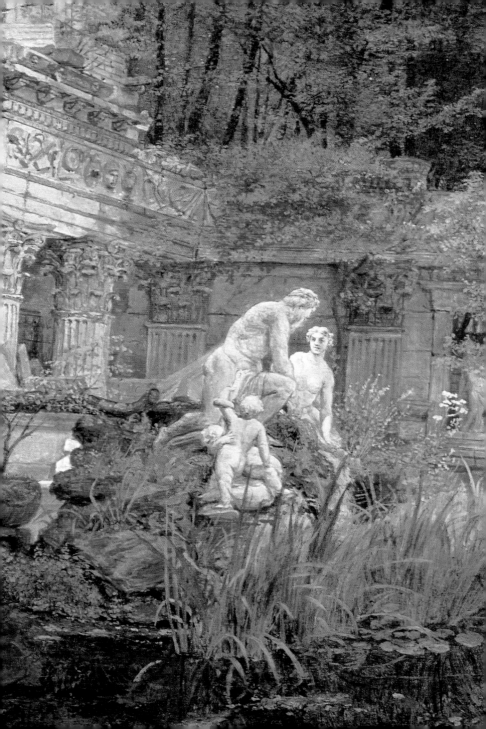

ELEMENTS OF THE GARDEN

Walls

Hortus

Topiary

Treillage

Living Architecture

Secret Gardens

Grottoes

Mountains

Statues

Garden Paths

The Garden of Wonders

Labyrinths

Sitting in the Garden

Flowers

Water

Technology in the Garden

The Garden Stage

Parterres

Fabriques and Follies

Greenhouses

The Orient in the Garden

Trees

Exotic Plants

Urns and Vases

Ruins

The Artificial Garden

◀ Ferdinand Georg Waldmüller,
*Roman Ruins in the Schönbrunn
Park* (detail), 1832. Vienna,
Österreichische Galerie Belvedere.

Building an enclosure wall implies the desire to create a sharp break from what lies outside this barrier, usually because it is viewed as a threat.

Walls

Symbology
Earthly paradise, *hortus conclusus,* purity

Related Entries
Ancient Egypt;
Islamic Gardens;
Monastic Gardens;
Secular Gardens;
The Garden of Mary

▼ Master of the Cité des Dames and workshop, *Lovers in a Garden,* miniature from *Cent ballades d'amant et de dame,* by Christine de Pisan (Paris, ca. 1410). London, British Library.

Throughout the Middle Ages, the wall enclosing the garden symbolized the division between cultivated land and a wilderness bristling with dangers. In addition, the walled garden recalled another enclosure, that of the Earthly Paradise from which Adam and Eve were banished. And since the Virgin Mary, intermediary between man and God, was often represented by the image of an enclosed garden, the wall itself came to signify purity and freedom from sin. In the Renaissance and Baroque eras, barriers divided the garden itself into a variety of sectors. These were veritable "green rooms," sometimes carved out of thickets and groves of trees, surrounded by carefully pruned hedgerows or marked off by trelliswork. Sometimes these enclosures had a particular function or theme, as if they were outward extensions of the rooms or halls of the palace. The outer wall ceased to be a barrier to nature—marking it as a separate entity—with the birth of the landscape garden. The absence of enclosures in landscape parks has been interpreted as a rejection of constraints and restrictions. Between man and nature, the garden and the surrounding countryside, there must no longer be any barrier. The garden must open onto the landscape and incorporate it in its visual prospect. The practical application of this principle is embodied in the development of the "ha-ha," a steep, dry ditch with a retaining wall, which kept the livestock out while allowing the garden to overflow its confines visually and spread out into the surrounding space.

The garden depicted here is a hortus conclusus, *as the words written at the top make explicit.*

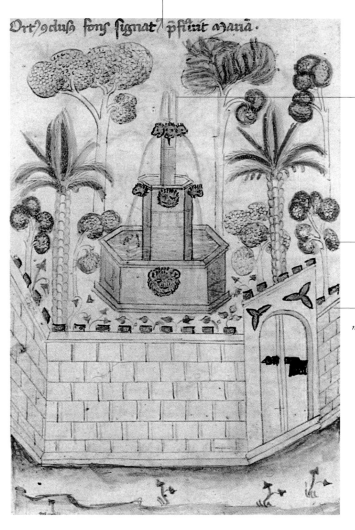

The spindle fountain represents the "sealed fountain," symbolizing the Virgin Mary.

This image emphasizes the protective function of the garden, a place where evil cannot enter and where everything grows in abundance and in a state of original purity.

The high, crenellated wall makes the garden an impenetrable fortress.

▲ *Speculum humanae salvationis,*
1370–80. Paris, Bibliothèque Nationale.

Walls

Le Roman de la Rose contributed to the diffusion of courtly ideals, including the aristocratic concept of love that developed toward the end of the Middle Ages.

The image of the garden of delights was a prototype for the medieval garden as a reflection of Eden, an enclosed garden that abounds in colorful flowers and plants of every species, where water burbles in the fountain and birds sing in the trees.

On the wall that surrounds the garden, which represents protection and the desire for isolation from the outside world and daily cares, are images of the Vices that must be banished from the courtly garden.

The Vices and human frailties, which cannot cross the threshold of the garden, are represented along the wall: Covetousness, Avarice, and Envy (on the left side), Hypocrisy, Perfidy, Hatred, Incivility, and Old Age. In the interior, on the other hand, the lovers will be surrounded by the courtly Virtues.

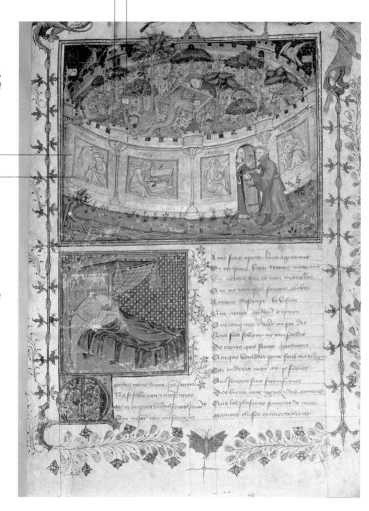

▲ Flemish school, *Lovers at the Entrance to the Garden of Delights,* 1400. London, British Library.

The Latin term hortus *implies an enclosure, a private space that would gradually expand to include the territory around the house.*

Hortus

Symbology
Image of the garden of Eden or the Church

Related Entries
Secular Gardens; The Garden of Mary

The Romans used the term *hortus* to designate the land intended for the cultivation of vegetables and everyday produce, a kind of "second pantry." In the plural, however, the same term, *horti*, refers to gardens in general, including those used mostly for recreation. The symbolic image of the *hortus* dates from the Middle Ages and is directly associated with the *hortus conclusus* of the monasteries, a symbol of Earthly Paradise. Born of the profound religious and symbolic needs of medieval man, the *hortus* ends up becoming a place in which one may find answers to the great existential questions and establish a relationship between oneself, nature, and God. Through labor, a direct consequence of original sin, man could re-create the original forms of Edenic life. The symbolism of the *hortus* remains for the most part linked with the medieval world as an image of Paradise and an allegory of the Church. At Versailles, for example, Louis XIV, who looked kindly on everything that had anything to do with gardens, decided to have his own *hortus conclusus* be an evocation of Paradise, a kind of Eden celebrating nature's bounty. This symbolic value would fade with time, and the *hortus* would become little more than the kitchen garden cultivated near the home and planted with vegetables and fruit trees. As a place for growing rare plants, the kitchen garden also evolved in an alternate, more "learned" direction that eventually led to the birth of the botanical garden.

▼ Master of the Geneva Boccaccio, *Raking, Planting, and Spading*, 15th century. Chantilly, Musée Condé.

Hortus

The symbolic meaning of the hortus would fade with time, as it assumed a more functional role as a kitchen garden, a place for growing vegetables and fruit trees.

The garden in this painting still appears as an enclosed space in which plants are segregated by species.

The artist adds touches of light to his rendering, giving a faithful image of the garden on a gray spring morning.

▲ Camille Pissarro, *Vegetable Garden in Eragny, Overcast Sky, Morning,* 1901. Philadelphia, Museum of Art.

During World War II, London, like the countryside, was committed to reducing food imports, and even the exclusive St. James's Square, designed by architect John Nash, became part of the effort.

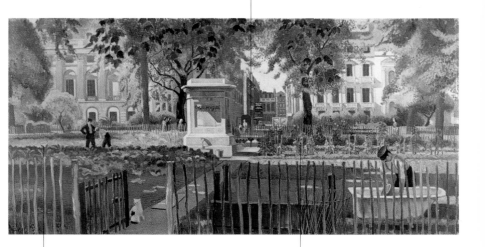

The painting depicts an urban vegetable garden in the center of London, in the chic West End district, during World War II. It is being tended by auxiliary firemen.

"Dig for Victory" was the slogan of the propaganda campaign undertaken by the British government that encouraged the population to produce their own food. Minimizing the need for imports meant that ships could be used exclusively for military transports.

▲ Adrian Paul Allinson, *Dig for Victory in Saint James's Square*, ca. 1942. City of Westminster, Archives Center.

The ars topiaria, *or the artistic pruning of bushes, was already being practiced by the ancient Romans. In Latin treatises on pleasure gardens, the term* topiarius *means "gardener."*

Topiary

Plants such as the box elder, yew, and certain types of laurel lend themselves quite well to being cut into shapes. The use of topiary became widespread over the course of the Renaissance and the Baroque eras. This diffusion was due in part to the republication of Latin texts on the subject, but mainly to the *Hypnerotomachia Poliphili*, the famous book of Francesco Colonna that discussed numerous, often elaborate, examples of the *ars topiaria*. In reviving the Latin term, Renaissance humanists adapted it to their own cultural principles, which led them to see the geometrical transformation of plant forms as a "mathematical domestication of nature." The fashion soon spread all over Europe, and countless catalogues appeared depicting the various forms that could be created by systematic cutting of hedges and bushes. The topiary works of Versailles, which were made into truly extravagant shapes, were the subject of an album of collected drawings. The topiary arts began to fall out of vogue with the popularization of landscape gardening, which saw this constriction of form as a way of depriving nature of its freedom of expression and as a manifestation of bad taste. Topiary began to reappear in the gardens of the Victorian age, particularly in England, where the revival of geometrical forms and the reconsideration of past styles, together with a passion for botanical extravagance, found natural expression in this art. Yet, despite the new life given to topiary over the course of the 19th century, it would never again reach the level of sumptuous composition that it achieved in the Baroque era.

▼ Bramantino, *April* (detail), 1504–9. Milan, Castello Sforzesco, Museo d'Arti Applicate.

It is hard to miss the creations of the ars topiaria derived from the study of classical architecture, of which the architect was a passionate exponent.

Aside from their fundamental academicism, de Vries's images constitute very important documentation of the Dutch garden of the 16th century.

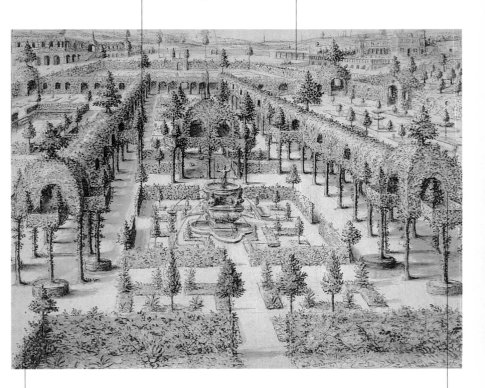

Hans Vredeman de Vries became famous in the field of garden architecture thanks to a work called Hortorum formae, *published in the late 16th century. In a series of plates, the architect presents the architectural orders of Vitruvius and applies them to gardens. The beautifully engraved prints display examples of Doric, Ionic, and Corinthian gardens.*

The rigorously architectural garden here represented is framed by an arcade of greenery, at the center of which stands a fine sculpted fountain, framed in turn by a geometrical plant bed. The central module seems to be repeated endlessly, making the garden a sequence of separate spaces.

▲ Hans Vredeman de Vries, *Drawing of an Ornamental Garden*, 1576. Cambridge, Fitzwilliam Museum.

Topiary creations in elaborate shapes adorn the parterres of the Grande Allée of Versailles, which extends all the way to the Basin of Apollo.

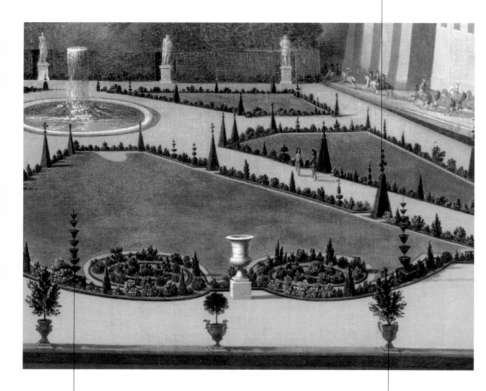

The many designs of the topiary works at Versailles appear in an album cataloguing all the garden decorations of the Sun King.

The potted plants, generally more delicate than the rest, were sheltered in greenhouses during the colder months.

▲ Etienne Allegrain, *The Promenade of Louis XIV in the Gardens of Versailles* (detail), late 17th century. Versailles, Musée des Châteaux de Versailles et de Trianon.

The Victorian garden revived the geometric forms and styles of the past, evincing a great passion for extravagant and exotic plants and shapes, reflected as well in the revival of the ars topiaria.

Harshly condemned as a tyrannization of nature, topiary largely disappeared from the landscape garden, only to reappear in the English Victorian garden.

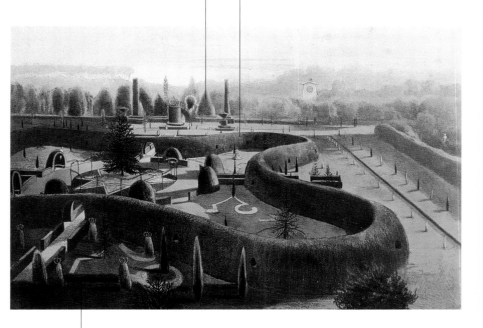

In the garden of Elvaston Castle, estate of the Marquess of Harrington, topiary achieves some extremely eccentric forms.

▲ *View of the "Mon Plaisir," in the Garden of Elvaston Castle,* from *The Gardens of England,* by E. Adveno Brooke (London, 1857).

Topiary

The female figure is pruning the high walls of the labyrinth, created according to topiary techniques.

The labyrinth is a symbol of disorientation and searching, and one of its peculiarities is that one does not know how far away the exit is, or how to find one's way back to the entrance.

This garden consists of an infinite series of labyrinthine rooms in which identical women are busy at different tasks.

The surreal perspective of the labyrinth gives the scene a sense of infinite suspension. This labyrinth appears to be an Irrgarten, that is, a web of passageways that creates a profound sense of disorientation in anyone passing through them.

▲ Pam Crook, *The Bird Garden*, 1985. Private collection.

Treillage connotes a latticed structure or trellis, usually made of wood, which was used as far back as Roman times for the cultivation of climbing plants.

Treillage

The term *treillage* derives from the medieval French *treille*, or vine bower. The extreme sophistication of the Romans' lattice-work allowed them to give gardens an architectural structure at once varied and well defined. Although the technique of "woven trellises" was revived in the Middle Ages, the medieval models were rather simple compared to their exuberant Roman predecessors. Internal barriers within gardens were often made with this method and took on different forms each time. They might be simple screens of woven rush, fences or espaliers of lath running vertically and horizontally, or lozenge-patterned lattices. The latter two were most common, and both usually supported climbing roses. Later on, wooden railings came into use as well. Toward the end of the 15th century, wicker lattices were gradually abandoned in favor of more solid structures. During the Renaissance, barrel-vaulted rooms were made out of wooden trellises and their climbing plants, creating an illusion of actual buildings made of vegetation. The technique of treillage was considered the most suitable for creating architectural spaces out of greenery because it was quick and relatively easy.

▼ *View of a Garden with Latticework Structures* (detail), fresco from Pompeii. Naples, Museo Archeologico.

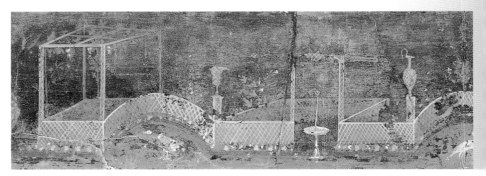

*Barriers of woven rush were among the most
common in the Middle Ages, especially in the
gardens of less prosperous people.*

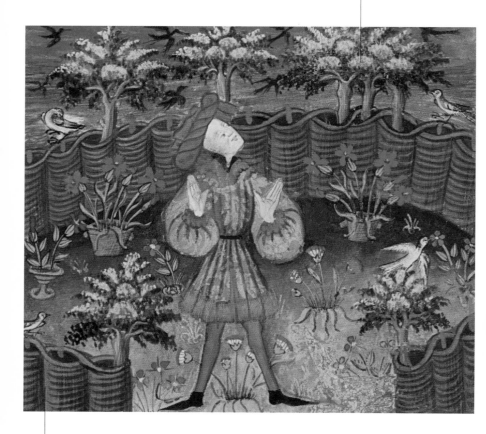

*Enclosures of this sort can also demar-
cate the area used to grow vegetables
or medicinal plants, while the more
refined pleasure gardens use more
complex structures.*

▲ French school, *The Dream of Georges
de Chasteaulens*, 15th century. Chantilly,
Musée Condé.

The garden is enclosed by a low wooden railing with lozenge-shaped latticework.

Even the carnations are supported by a light trellis.

The tree in the pot is pruned according to a typically medieval procedure. The branches are trained and made to grow along the radii of a wooden or metal hoop. The plant's foliage accordingly grows to resemble a stack of disks.

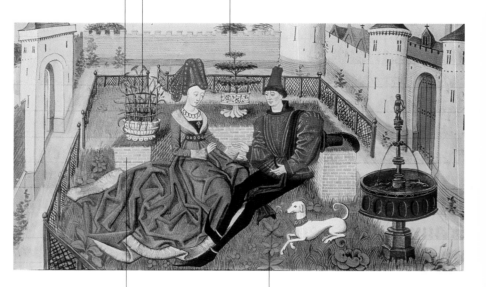

Seated on the ground, the two lovers lean against a masonry bench with grass on top.

This elegant courtly scene is taking place in a garden reminiscent of the prototypical garden of love.

▲ Renaud de Montauban, *Oriande and Maugis*, 1468. Paris, Bibliothèque de l'Arsenal.

"Living architecture" refers to garden structures made out of vegetation that look like actual buildings.

Living Architecture

Within a garden, one can create spaces and volumes that resemble actual buildings, a kind of "living architecture." This is an evolved form of topiary and treillage, used to guide and contain the growth of plants. In general, the structures created are round or square pavilions and arbors covered with grapevines or fragrant climbing plants such as jasmine or roses, under which one can stroll or enjoy the cool shade in the hot summer months. The architectural structures on which the "domesticated" plants can climb are often conceived to evoke a particular idea of the relationship between man and nature. Oftentimes the human dimension is hidden artificially, creating the illusion that the final result is some mathematical whim of nature. In early-18th-century Europe, such garden structures took on increasingly peculiar forms. They were sometimes rather bold and bizarre and geared to highlight the garden's dramatic aspects. The *"cabinets"*— rooms of greenery cut into the shrubs—were sometimes replaced by veritable architectural structures made of plants, creating unusual mazes of space and paths within the greenery. These were constructed through the skillful juxtaposition of green walls so that linear or tortuous paths led to other green spaces. The domestication of these walls of plant life, constantly cared for and pruned, took years. For this reason, they were sometimes replaced by trellises with climbing plants or even walls of painted wood on which one would place ephemeral decorations of leaves and flowers.

▼ Leonardo da Vinci, Sala delle Asse, 1498. Milan, Castello Sforzesco.

The arbor is a structure conceived and created by means of growing plants, which are "domesticated" until they look like an architectural structure of greenery.

The plant architecture in Mantegna's painting actually looks like the apse of a church and has flowers and fruits, symbols of Mary's virtue, growing on it.

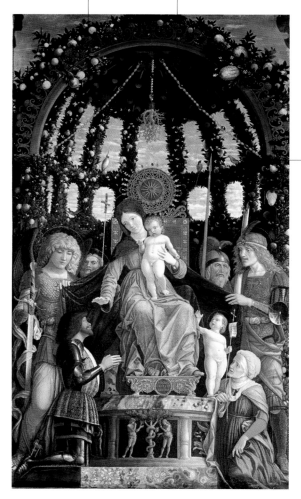

The domed recess is at once an element of closure—thus hortus conclusus—and an opening to the sky. The arbor's windows allude to Mary's role as intercessor between earth and heaven.

▲ Andrea Mantegna, *Madonna of Victory*, 1496. Paris, Louvre.

The garden is framed by two architectural structures that appear to function as theatrical wings, while the daily drama of amorous encounters and banquets is enacted on the garden stage.

The vegetal architectural forms echo those of the palace in the background: a low, horizontal main body dotted with openings, and a central, vertical structure topped by a dome.

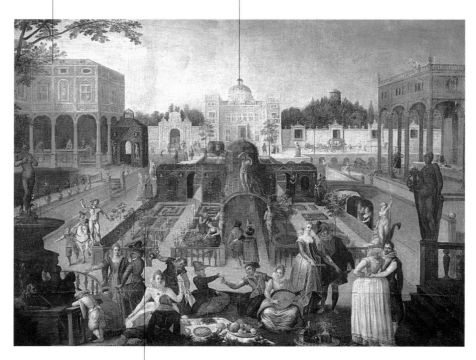

The Renaissance garden is an integral part of the villa, its outward extension. As such it conforms to specific architectural rules whose forms recall the geometry of the palace.

▲ Sebastian Vrancx, *Feast in the Garden Park of the Duke of Mantua*, ca. 1630. Rouen, Musée des Beaux-Arts.

The image depicts a temple made of vegetation. It is dedicated to Ceres, the goddess and protectress of agriculture and plant life in general.

Drawing inspiration from the 18th-century idea that classical architecture was derived from nature itself, Lequeu here imagines an actual work of architecture built out of vegetation.

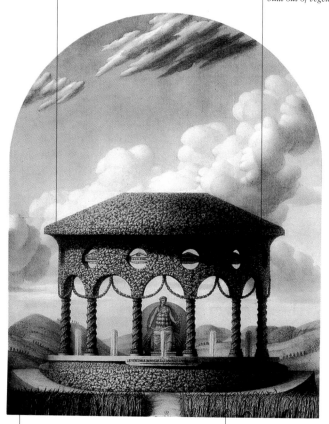

Around the time of the French Revolution, the architect Jean-Jacques Lequeu created a great many fanciful images, rich in allusions to classical and medieval architecture.

Between the late 18th and early 19th centuries, the theatrical aspect of Baroque plant architecture would gradually disappear, as the understanding of man's relationship to nature began to shift, giving greater emphasis to the vitalistic aspects of this communion.

▲ Jean-Jacques Lequeu, *Temple of Greenery Dedicated to Ceres*, second half of 18th century. Private collection.

The idea of the secret garden finds its basis in the medieval hortus conclusus, *which already has all the trappings of secrecy.*

Secret Gardens

In the Renaissance garden, because of the perceived need for privacy, green space was organized in a variety of ways, depending on what it was supposed to represent. In a prince's garden, for example, one might find a spot excluded from the complex symbolic design to which the garden itself conformed. Alongside the conception of the Renaissance garden as an image of the prince's power was the quest for a secluded, "secret" place in which one might devote oneself to private life and family affairs. The secret garden also had erotic aspects, however, which derived from the courtly love tradition; it can thus be considered a secularization of the *hortus conclusus*. The "gardens of love" were secret gardens where one could celebrate erotic and amorous rites behind the protection of high walls. In the Renaissance, the secret garden remained a secluded, protected space where the nobleman could devote himself to recreation and his private life. This practice was developed and consolidated in the Baroque garden, where the image of the private garden took on great importance against the background of grandiose royal gardens such as Versailles. Here there was no longer any outer barrier; privacy was achieved merely by physically distancing oneself from the pomp of the court. Louis XIV had the Trianon built for precisely this purpose. The concept of the private garden thus persisted through the ages, even if the typology and architecture associated with it changed. No longer enclosed by walls, the secret garden was an open, secluded space far from the main stage of events. It thus ended up becoming a private, more intimate garden, such as we find it again later on, in the "green rooms" of certain 20th-century English gardens.

▼ William Waterhouse,
Psyche Opening the Door into Cupid's Garden, 1904.
Preston (England), Harris Museum and Art Gallery.

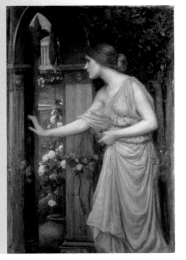

This miniature depicts a secret area of the garden inspired by such medieval themes as the fountain of youth and the garden of pleasure, derived from Le Roman de la Rose.

The high walls create a feeling of privacy, isolating the space and the pleasures of its secret rites from the surrounding city and its monuments.

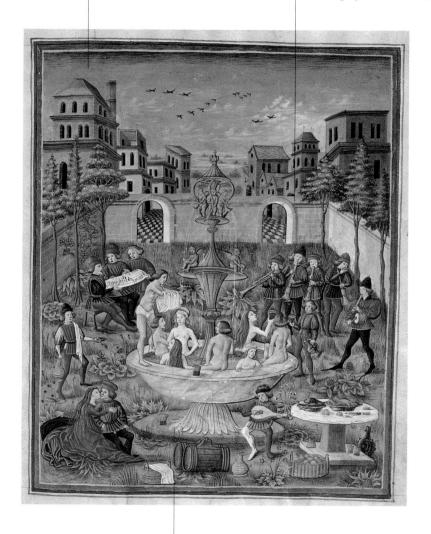

▲ *The Fountain of Youth, in* De Sphaera (ca. 1450). Modena, Biblioteca Estense.

According to some interpretations, the role of the secret garden is directly connected to the erotic aspects of love, as manifested in the secularization of the hortus conclusus *by the courtly love tradition.*

A place of mystery and magical events, the grotto evokes melancholy agitation and mystical tension. It is a nocturnal recess in which the soul can get lost.

Grottoes

Based on surviving examples in ancient Roman villas, Leon Battista Alberti recommended the creation in gardens of grottoes, either natural or artificial, and even suggested the materials one should use in making them. The interest in grottoes became particularly widespread in the 16th and 17th centuries, leading architects to experiment with ways to imitate nature through the use of rough stones, corals, conches, and fluvial rocks. Other solutions, derived from archaeological models, revived the elegant mosaic decorations of ancient Roman nymphaea. The image of the grotto aroused compelling emotion, evoking a secret, magical world of wonder. Entering a grotto was like going into the womb of Mother Earth, into a secret place where the concept of time as marked by the rising and setting sun lost its meaning and all that remained was the time of the soul. The grotto or cave could also be the site of great initiations, a place of ritual and mysterious rites and ceremonies. It is a place where one could re-create a world of fantasy, as in the grotto that Alexander Pope had built at Twickenham, a true chamber of wonders in which the garden views outside were reflected on the walls in a complex play of mirrors.

► *Project for a Grotto in the Garden of Villa Litta at Lainate*, 18th century. Private collection.

The great grotto in the Boboli Gardens unfolds in a
succession of rooms, suggesting an entry into the
womb of Mother Earth. The last room, oval in form,
evokes fertility and birth.

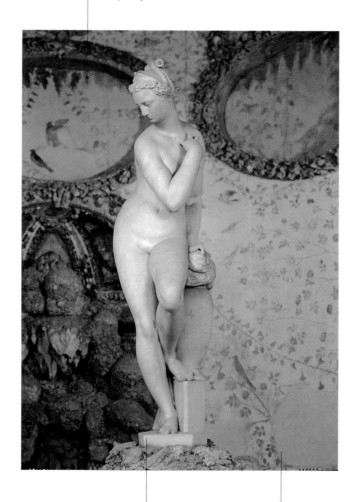

▲ Giambologna, *Venus*, ca. 1570.
Florence, Boboli Gardens.

Giambologna's Venus repre-
sents generative nature,
understood as reason and
universal love, the element
linking heaven and earth.

The message conveyed in the
Boboli complex is that the com-
plete man, the perfect fusion of
sense and reason, can approach
an understanding of the divine
only if he is guided by the power
of love, which unites everything.

Conch shells, colorful rocks, and precious materials decorate the vault of the artificial grotto of Idstein in Germany, a place of marvels.

While the upper part is executed in rocaille, the grotto's walls are composed of a variety of rough, colored rocks to make the site look as natural as possible.

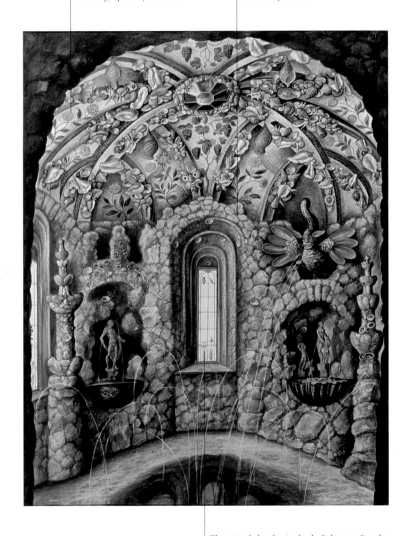

▲ Johann Jakob Walther, *The Grotto of Idstein Castle*, 1660. Paris, Bibliothèque Nationale.

The stained glass lets in the daylight, revealing the artificiality of the grotto. It nevertheless succeeds in being a mysterious, intriguing place in which the owner has assembled treasures and wonders from distant lands.

The horses of the sun are at the far side of the grotto, being tended by tritons.

The entrance to the vast grotto reproduces the entrance to the palace of Thetis, where one finds Apollo and his nymphs, sculpted by François Girardon.

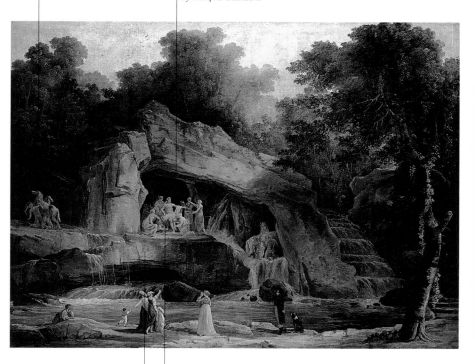

A former painter for Louis XVI, Hubert Robert was assigned the task of renovating the Baths of Apollo at Versailles in 1777. His efforts met with approval, and he was officially named "designer of the king's gardens."

The sculpture group of Apollo was originally in the grotto of Thetis near the royal palace, but this was torn down in 1684 to make room for a new wing of the palace.

▲ Hubert Robert, *The Grove of the Baths of Apollo*, 1803. Paris, Musée Carnavalet.

The mountain can be considered one of the many manifestations of Earth, the great mother from which everything is born, as well as an emblem of proximity to God.

Mountains

Mountains tower over mankind and come close to heaven. One of the many traditional images of the mountain is that of Mount Parnassus, mythic home of Apollo and the Muses. Raising such a mountain in a garden not only signifies that the owner is conversant in classical literature but also invokes the power of Apollo and the Muses to lift the garden's denizens up to the gods' world of music and culture. Moreover, the presence of Pegasus, the winged horse, might allude to the myth that Mount Helicon, enchanted by the Muses' singing, rose to such heights of delight that it threatened to reach the heavens. At Poseidon's behest, Pegasus struck the mountain down with his hoof. Helicon resumed its proper dimensions, and at the spot where the winged horse had struck, there rose up a spring called the Hippocrene, or the "Horse's Spring." In the 17th century, Sir Francis Bacon, in his essay *Of Gardens* (1625), recommended that one build a simple, conically shaped mountain at the center of the garden and provide it with three pathways broad enough to accommodate four people. Such a mountain should be about ten meters high. It could also serve the eminently functional role of giving a greater sense of movement to the structure of an otherwise generally flat garden and at the same time afford a complete overview of the garden from its highest point.

▼ Salomon de Caus, *Artificial Mountain*, from *Les Raisons des forces mauventes* (1615). London, British Library.

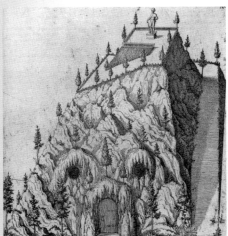

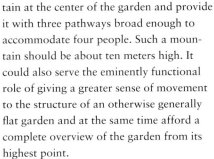

At once a statue, a mountain, and a grotto—there is a cave inside with decorations and ornamental waterworks—the Appenine dominates the Pratolino garden from above.

The Appenine *is simultaneously an anthropomorphic figure—a personification of the mountain—and an anamorphic structure: depending on the distance from which it is viewed, the limestone pieces of which it is composed either come together to form the figure or disappear into the vegetation, becoming indistinguishable from the mass on which the figure rests.*

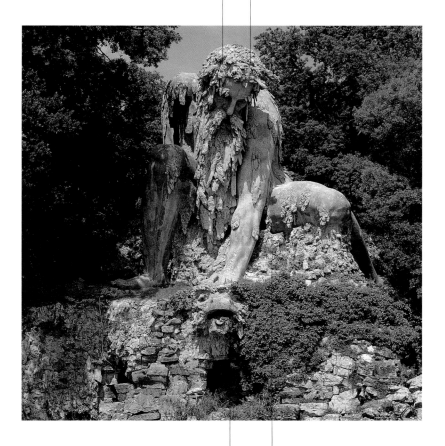

▲ Giambologna, *Appenine*, ca. 1580. Florence, Park of the Villa di Pratolino.

Made up of human forms and rock formations, the giant crushing the dragon's head is reminiscent of some of the composite images found in Giuseppe Arcimboldi's paintings.

The Appenine, or sacred mountain, represents the second level of the alchemical "work," the sublimation: that is, the moment in which the human will recognizes the "monsters" created by human passions and, by transforming them into its own power, begins the purification of matter.

The placement of statues in gardens dates back to ancient times. With the rise of humanistic studies during the Renaissance, the educated public was gripped with a passion for antiquities.

Statues

The gardens of Renaissance noble residences were adorned with archaeological treasures. Some of them became open-air museums, such as the Vatican's Belvedere Courtyard, designed by Bramante for Pope Julius II. There the pontiff exhibited his collection of antiquities, the most famous of which was *Laocoön*. Already by the end of the 15th century, ancient statues, as well as sculptures made by contemporary artists, had become integral parts of gardens, taking on important symbolic meanings. This same period witnessed the emergence of the iconographer, an intellectual of broad cultural expertise who composed visual programs of allegorical and symbolic imagery, usually drawn from ancient mythology and generally aimed at glorifying the patron. This tradition was carried on in the Florence of the Medicis and the Rome of the great popes, and reached its apotheosis in the gardens of Versailles, where the many mythological effigies nearly all allude to the sun. The landscape garden itself did not shun the "language of stone," but used it to express different concepts. Usually the statues in these gardens at once brought together and juxtaposed ancient virtue and modern virtue, emblematic figures of antiquity and prominent figures of contemporary culture—poets, intellectuals, scientists, philosophers, and statesmen. Later, the complex, pagan allegorical symbologies were abandoned, and statues often represented allegorical figures such as Peace or Victory. The 20th century revived at least one of these past models, establishing numerous open-air collections in which the art aims to rediscover a long dormant relationship between man and nature.

▼ *Laocoön,* 2nd century B.C.–A.D. 1st century. Vatican City, Vatican Museums.

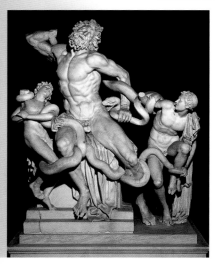

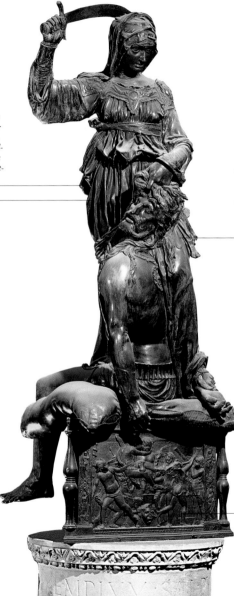

Donatello's Judith *and* David *statues were intended to be part of the iconographic program for the Medici garden in Via Larga. The* Judith *stood high atop a pillar and also served, visually, as a fountain, without actually spouting water.*

The image of Judith slaying Holofernes could serve as a warning to avoid excess. One would not want to meet the same end as the Assyrian general, a victim of his own intemperance.

This sculpture group was positioned atop a tall marble column bearing two inscriptions, one exalting the virtues of the biblical heroine and the other praising the fortitude and freedom of the Florentine republic.

The three faces of the bronze base depict different stages in the production of wine: the harvest, the pressing, and the bacchanal. They are executed in the ancient style and thus were consistent with some of the archaeological objects that adorned the garden.

▶ Donatello, *Judith and Holofernes*, 1455. Florence, Palazzo della Signoria.

The sculptural and decorative program of the gardens of Versailles revolves around the image of the sun and its various personifications.

Apollo appears at the center of the Grand Canal, rising from the sea on his chariot. Here he is shown after his return from his diurnal journey, being washed and laved with unguents by the nymphs.

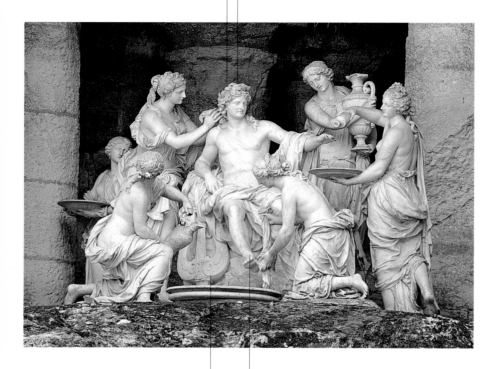

The allegorical message for the viewer of the time was clear: like the sun god, the Sun King, imperturbable servant of his people, must be paid homage.

The ancient Apollo Belvedere of the Vatican served as the model for this statue of the sun god.

▲ François Girardon, *Apollo and the Nymphs*, 1666–75. Versailles, Basin of Apollo.

These statues functioned as ironic counterparts to the grandiose mythological allegories present in every corner of the garden.

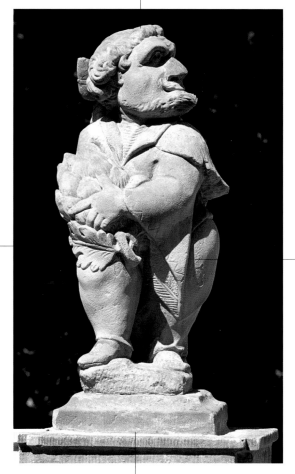

The brewer is holding some hops, used in the production of beer.

The balustrade of the terrace in front of the palace features a series of statues caricaturing the court staff: buffoons, housemaids, drummers, servants, and gardeners.

▲ Philipp Jakob Sommer and Johann Friedrich Sommer, *The Brewer,* ca. 1715. Weikersheim (Germany), palace garden.

The complex sculpture cycle celebrating the Hohenlohe dynasty at Weikersheim garden is still completely intact and features allegories of the four winds, the four elements, and Mount Olympus.

The Empress is the most important character in Saint-Phalle's cycle. She is queen of the sky and mother, the magical bearer of civilization. The artist conceives of her as a big, enigmatic sphinx possessing arcane wisdom.

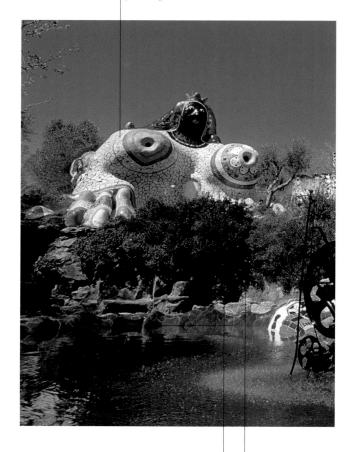

▲ Niki de Saint-Phalle, *The Empress*, ca. 1979. Garavicchio (Italy), Tarot Garden.

The idea for the Tarot Garden came to its creator, Niki de Saint-Phalle, in a dream, in which she found herself walking through an enchanted garden peopled by magical, fantastically colored creatures covered with precious stones.

In the late 1960s, the artist realized her dream of creating the Garden of the Tarot, fashioning huge, fanciful sculptures covered in polychrome materials that seem to rise up out of the earth. The figures follow one another without any predetermined logic; visitors are free to choose their own route through the park, just as they would choose their own cards when consulting the Tarot.

The fundamental structure around which the garden is organized, the path can take on a variety of connotations, from purely functional to highly symbolic.

Garden Paths

The medieval monastic garden was divided into four parts by paths intersecting to form a cross. This layout contained numerous symbolic meanings: the four rivers of Paradise, the four cardinal virtues, and the four evangelists. The allegorical symbolism of medieval garden paths gave way in the Renaissance to the ordering principles of geometry. In this period, walkways did not afford a view of the palace or the nearby town but served only to link the green spaces to one another. Some of these spaces were concealed or situated at different elevations, and the paths linking them were rather narrow and hidden from sight. Even the central path seldom led to the villa, acting instead as a geometrical element around which the garden radiated symmetrically. This ordering tendency relied on the rules of equilibrium and symmetry that all the Renaissance garden's component parts, from the central avenue to the lateral sections, were supposed to reflect. In the Baroque garden, however, the central axis stood out from the rest, gaining importance until it projected into infinity, beyond the garden itself, often with a celebratory intent. Visual perspectives were amplified by the radial design of the paths, which fanned out into the surroundings from a central point. Contrasting with the magnificence of French Classicism was the simplicity of the Dutch garden, where the paths functioned only to link the different segments and were sometimes hidden from the view of the palace, allowing those walking in the garden a sense of seclusion. A decisive rejection of the rigid French model was finally ushered in by the landscape garden, which favored asymmetrical design, so that nature could grow freely.

Related Entries
Monastic Gardens; Secular Gardens; Renaissance Gardens; Baroque Gardens; Landscape Gardens

▼ Raffaellino da Reggio, *Villa Lante at Caprarola*, 1568. Bagnaia, Villa Lante.

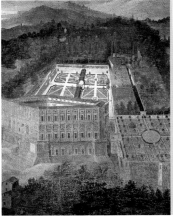

In the Baroque garden, the solemnity of broad open areas intended for strolling and carriages was counterbalanced by the more intimate, secluded atmosphere of the smaller spaces.

In the new conception of the Baroque garden, the main avenue gained in importance, running from the palace to the open country.

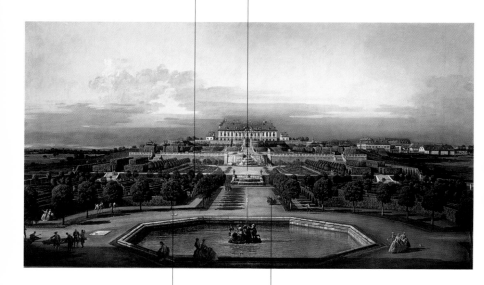

The rows of trees, made almost identical to one another by perfect pruning, run parallel to the green hedge walls, which are also pruned to perfection. This creates a regular surface that helps to define the garden according to an ordered, geometrical plan.

The main avenue, or allée, is lined with trees or hedges. It usually has a central focal point, most often a fountain.

▲ Bernardo Bellotto, *View of the Schlosshof*, 1758–61. Vienna, Kunsthistorisches Museum.

In the Baroque garden, the areas allocated to trees were defined by barriers of vegetation or latticework structures.

The three lanes fan out à patte d'oie, that is, in a trident formation, branching out from a central point. The middle one follows a perpendicular path, while the side lanes run obliquely.

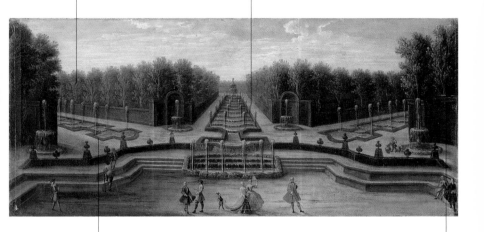

The axial disposition of the lanes was typical of the 17th century and was also sometimes used outside the garden, for city streets or, as here at Versailles, for water canals.

The retaining walls precisely defined the boundaries of the treed areas, so as to avoid any overlap between the two environments. The Baroque garden was articulated in accordance with this great tension between positive and negative space, creating a delicate balance that required assiduous maintenance.

▲ French school, *The Grove of the Théâtre d'Eau in the Garden of Versailles in the Early 18th Century*, ca. 1725. Versailles, Musée des Châteaux de Versailles et de Trianon.

Garden Paths

The term sharawaggi is used to designate a garden inspired by the Chinese model, which implies a rejection of geometrical symmetry and rigid schemata and an embrace of designs in which nature is left unhindered.

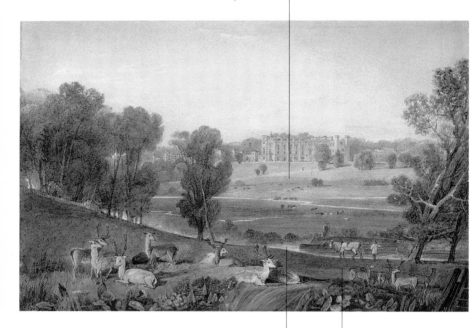

In the landscape garden, the paths followed winding routes and were used mostly for strolling. They tended to take roundabout ways, often affording new views and inviting the visitor to continue walking.

The landscape garden, which favored asymmetrical design, represented a clear opposition to rigid French garden design.

▲ William Havell, *Cassiobury Park*, *Hertfordshire*, ca. 1850. Private collection.

The cultural panorama of the 16th century was marked by a penchant for the "fantastic," which included unusual and sometimes monstrous natural objects and curios from faraway lands.

The Garden of Wonders

The garden was sometimes turned into a kind of giant curiosity cabinet, an open-air *Wunderkammer*, in which all sorts of marvels were exhibited against a backdrop of fountains, grottoes, labyrinths, and waterworks. One early example is in Mantua, where the grotto, secret garden, and famous *studiolo* of Isabella d'Este together formed a unique whole that became the site of humanist cultural gatherings. A few decades later, Ferdinand of Tirol built a *Wunderkammer* that took up the entire Lower Castle at Schloss Ambras near Innsbruck, while the garden, located inside the royal preserve, served as a showcase for animal and plant species. But the most successful such creation, where the relationship between the natural curiosity cabinet and constructed nature was most evident, was the Medici park at Pratolino. Conceived by Francesco I de' Medici in the late 16th century, the complex consisted of a large villa housing numerous marvels and a garden park dedicated to both glories of the past and astonishing curiosities of the present. Pratolino was a veritable open-air cabinet of *mirabilia*, featuring grottoes, fountains, and every sort of artifice. Its

▼ *The Theater of Automatons.* Salzburg, Hellbrunn Park.

grottoes contained precious corals and gemstones, while its meadows boasted countless species of flowers. The intricate walkways allowed one to get to know the garden in stages, as a series of carefully planned scenes induced astonishment in the visitor: little theaters of automatons, hydraulic organs, mechanisms simulating bird calls, and ornamental waterworks. Pratolino's "magnificent contraptions" were soon imitated all over Europe, but of the many gardens of wonders based on the model of Pratolino, only one remains: the garden of Hellbrunn (Salzburg), from the early 17th century.

The Garden of Wonders

A system of grottoes ran underneath the palace. These sites, which elicited great wonder in the people of the day, were filled with automatons, whose movements were accompanied by special effects of light and sound.

One theory holds that the images of Pratolino do not conform to any single signifying system, but rather appear to be a kind of "figurative alphabet of the prince's imagination," an open-air museum in which the prince could collect naturalia and artificialia. Thus the park took on the function of a museum workshop intended for scholarly and scientific experimentation and served at the same time as a place for stimulating the senses and abandoning oneself to aesthetic perceptions.

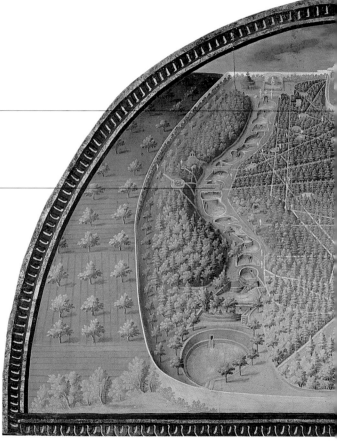

▲ Giusto Utens, *The Villa and Park at Pratolino*, ca. 1599. Florence, Museo Storico Topografico "Firenze Com'era."

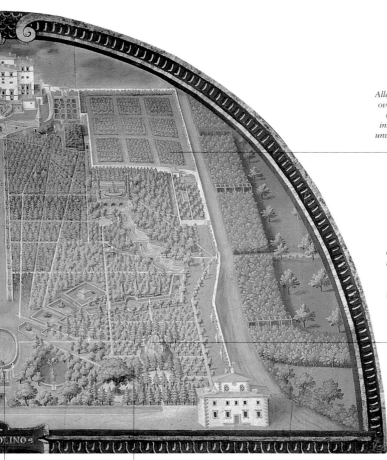

Allegories scattered all over the park seem to be part of a kind of initiation intended to unveil the mysteries of the natural world.

Mount Parnassus, with Apollo and the Muses, was equipped inside with a hydraulic organ, to create the impression that the gods were playing their own instruments. Chairs were placed around the mountain so that people could enjoy the spectacle.

A broad lane of grass adorned with fountains and waterworks began at the villa and ended at the Fontana della Lavandaia, the "Washerwoman's Fountain."

The arbore praticabile, or "inhabitable tree," is depicted as an enormous oak whose crown could be reached via two sets of stairs. At the top, in a space some sixteen yards wide, was a fountain.

The Garden of Wonders

This garden featured the Rocher *(or "Rock"), a kind of rocky lookout that extended some 250 meters (750 ft.) around part of a rectangular canal.*

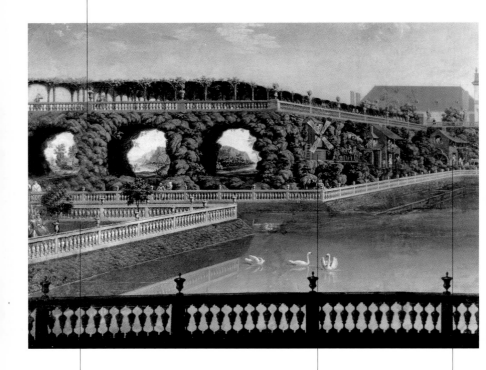

The exiled king of Poland, Stanislaw Leszczyński, Louis XV's father-in-law, began restructuring the garden of Lunéville in 1737.

This part of the rock contained life-size representations of a rural village along with its inhabitants, animals included, going about their daily business. Their movements were powered by sophisticated hydraulic devices.

There were some eighty-six automatons populating the Rocher de Lunéville, made in imitation of the automatons of Renaissance grottoes. They not only moved but also emitted sounds, such as the noises made by tools, the cries of animals, and musical melodies.

▲ André Joly, *The Château of Lunéville and the Rocher around the Basin of Automatons* (detail), ca. 1775. Nancy, Musée Historique Lorrain.

The labyrinth offers a difficult, tortuous path, but one whose outcome is certain. The Irrgarten emphasizes the irrationality of the path, and the disorientation that this creates.

Labyrinths

In the late 16th and early 17th centuries, gardens all over Europe featured labyrinths, particularly *Irrgarten*. This complex cultural phenomenon stemmed principally from the pleasure patrons derived from learned cultural allusions, and their desire to brave the supposed dangers of losing one's way or to hold trysts in places that obviously lent themselves to this end. The labyrinths were generally made out of tall hedgerows. Around the late 17th century, the custom of planting trees and bushes to form dense masses of vegetation became widespread, and little pathways were cut into these thickets. The 16th century had witnessed the emergence of a kind of labyrinth intended above all to evoke the troubles and ambiguities of love. The formal structure of these labyrinths, known as "labyrinths of love," followed a pattern of concentric circles of hedges, at the center of which stood a pavilion. In the middle of the pavilion stood a May tree, evoking pagan feasts and rites associated with the cyclical rebirth of nature and serving as emblems of fertility, with strong erotic connotations. At the same time, however, the tree at the center of the labyrinth also stood for the Tree of Life in the garden of Eden.

▼ School of Tintoretto, *The Labyrinth of Love*, ca. 1555. London, Hampton Court Palace.

Seen in this light, the couples strolling inside it and heading toward the center recall the situation of the first couple in the garden of Eden. The negative side of this coin is the allusion to original sin and the expulsion from Paradise. Interest in labyrinths then began to fade, and by the end of the 18th century, they were cleared away to make way for the new landscape compositions.

Labyrinths

The labyrinth of love alludes to erotic intrigues and the forbidden union of David and Bathsheba.

The structure of love labyrinths consists of concentric circles of hedges, at the center of which stands a pavilion or a May tree.

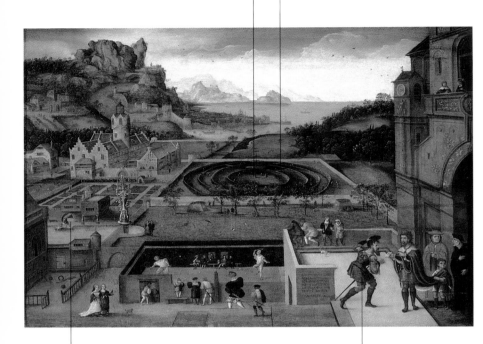

Having seen Bathsheba bathing from the balcony of his palace, David falls madly in love with her.

David tells Uriah, Bathsheba's husband, that he will soon be sent on a military expedition, from which he will never return.

▲ Flemish school, *Stories of David and Bathsheba*, 16th century. London, Marylebone Cricket Club.

The labyrinth of Versailles was begun in 1674. It
is an Irrgarten, where the paths, which are like
narrow streets, cut into the densely compacted
vegetation.

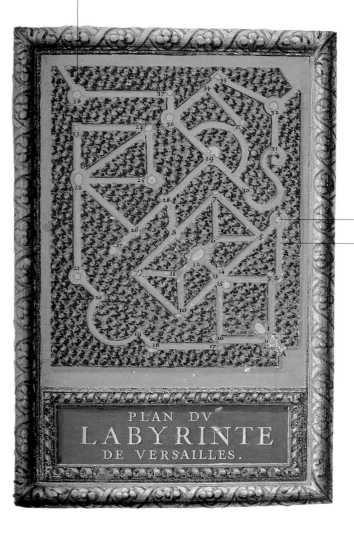

The labyrinth was dotted
with fountains and sculp-
tures depicting scenes
from Aesop's fables. It
was destroyed in late
1775 to make way for
the queen's grove.

In the Baroque period,
the symbolic and meta-
physical meanings of a
labyrinth—such as the
search for oneself, or the
world of sin, or the world
of the dead—began to
lose their currency, giving
way to more lighthearted,
frivolous, formal games.

PLAN DV
LABYRINTE
DE VERSAILLES.

▲ Jacques Bailly, The Labyrinth of
Versailles, 17th century. Paris, Musée
du Petit Palais.

Labyrinths

With its circular labyrinth consisting of six concentric hedge corridors, the island may be an allusion to Cythera or Crete. At its center stands the classic May tree pruned into superimposed disks of foliage. The labyrinth probably alludes to amorous complications.

The painting is part of a series depicting the months or seasons and probably represents the month of May.

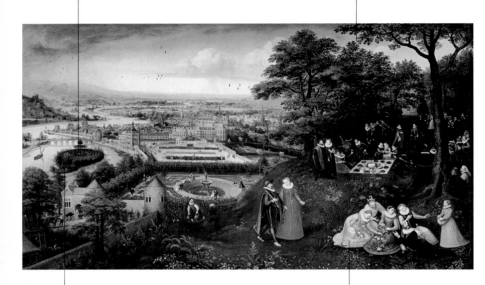

The first garden labyrinths appeared in the 14th century. The labyrinth in the garden of the castle of Hesdin (France) was called the Maison Dedalus, an allusion to the Cretan myth. The existence of this "House of Dedalus" is known from written sources, but we do not know what it looked like, though it was probably close in form to the labyrinths of love.

The figures in the foreground devote themselves to rural pleasures, enjoying a picnic in a grove. In the background, a city, probably Brussels, rises up amid a fantastical landscape.

▲ Lucas van Valckenborch, *Spring Landscape*, 1587. Vienna, Kunsthistorisches Museum.

A bench in a garden fulfills a purely practical function, but its workmanship expresses the owner's culture and sensibility.

Sitting in the Garden

Aside from manifesting the patron's tastes—which cannot be separated from the sociocultural context—the bench can also be seen as a handcrafted object placed in a specific environment and as such capable of changing its surroundings. Since antiquity, an object's design has been a reflection of the contemporary stylistic language on which it is entirely dependent. In medieval miniatures, we often see benches covered with grass. A variety of materials were used for the benches' support structure: in Germany, for example, simple wooden boards were used, while the rest of Europe generally preferred stone or brick. The structure was then filled with soil and finally covered with sod, thus integrating itself into its surroundings. In Renaissance and Baroque gardens, resting places were relatively rare and generally featured stone or wooden seats. Over the course of the 19th century, during the wave of eclecticism, the garden bench finally came to correspond to different demands: it had to be original and visually imposing or else display a "rustic" style appropriate to the landscape garden. During the Industrial Revolution, eclecticism reached new extremes as the mass production of goods and the availability of new materials made it easier both to revive old styles and to create new forms reflecting contemporary tastes. The object thus could either impose its own presence in the garden or blend in with the surroundings.

▼ Francesco del Cossa,
The Month of April
(detail), ca. 1467. Ferrara,
Palazzo Schifanoia.

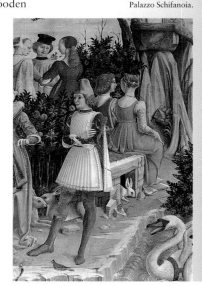

The large brick bench serves as a stage for a group of musicians.

The garden is isolated from the world by a high wall, which serves to separate the inside—that which is known and safe—from the outside, which is unknown and wild.

The seats were created below the stage level so that dancing couples could rest.

In the Middle Ages, many different materials, such as wooden planks, stones, and bricks, were used to make benches. The structure was filled with soil, then covered with sod, allowing it to blend in with the greenery.

▲ Master of the Jouvenel Codex,
Dance in the Garden, ca. 1460.
Paris, Bibliothèque Nationale.

The public park of Helsinki has the typical features of a landscape garden, where nature is not kept in check.

The bench seems perfectly integrated with the environment and does not appear out of place.

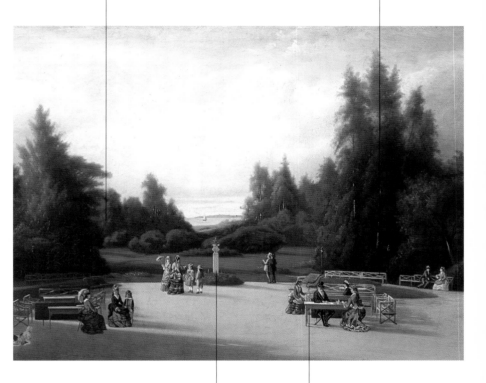

A microcosm isolated from the general context of the garden, the potted plant may be a specimen that requires special care, it may simply be decorative, or it may express specific symbolic meanings.

The Industrial Revolution allowed designers to come up with new forms of garden furniture reflecting contemporary tastes.

▲ Johann Knutson, *Public Garden in Helsinki*, 1872. Helsinki, Museum of Finnish Art, Ateneum.

Sitting in the Garden

Like the benches, the circular foun-
tain is made of stone and stands as a
discrete object in the middle of the
garden.

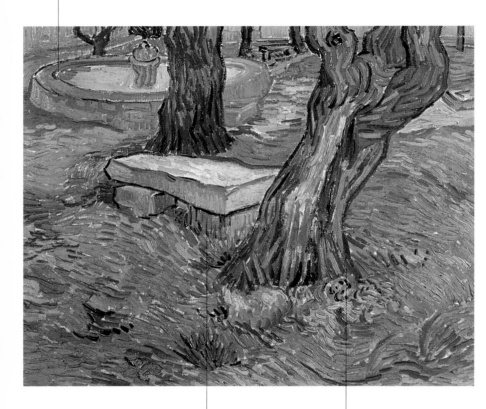

The stone bench blends
in with the surroundings
without imposing itself
as a separate, symbolic
presence.

Van Gogh depicts the garden
from a very low point of view.
The dense hatch of brushstrokes
and the contortions of the tree
trunks in the foreground bring
out an expressive tension that
conveys a sense of boundless
solitude.

▲ Vincent van Gogh, *Stone Bench*,
1889. São Paolo (Brazil), Art Museum.

▶ George Segal, *Three People on Four
Benches*, 1979.

Segal creates plaster models of ordinary people engaged in everyday activities.

The figures are close to one another but look as though they are isolated, lost in thought. The park bench no longer represents coming together and communication, but on the contrary becomes a symbol of the malaise and loneliness of modern life.

The benches seem to underscore the feeling of disorientation and solitude of the seated figures.

The flower has been the great protagonist of gardening since antiquity. The cult of Flora, an Italian goddess, ran deep in ancient Rome and soon spread throughout the known world.

Flowers

In the medieval garden, flowers were grown in the *herbarium*, an enclosed area reminiscent of the *hortus conclusus*. This small garden featured lilies, roses, and peonies, while roses and honeysuckles climbed the trellises together with ivy and grapevines. In the Renaissance, complemented with the compact shapes of evergreen plants—which were the garden's primary elements, its skeleton, as it were—flowers formed an integral part of the decorative makeup, arrayed in flower beds or special pots. Over the course of the 16th century, moreover, the number of available species greatly increased, thanks to the importation of flowers from newly contacted parts of the world. Even the French garden, with its boxwood parterres and its perfectly pruned hedgerows and evergreens, did not disdain flowers. Louis XIV himself possessed a vast collection at Trianon, where the immense flower beds in the garden featured a great variety of species. And to spare the king the sight of their wilting, they were also cultivated in pots, so they could be more easily replaced. Flowers were banished from the landscape garden, however, at least as long as gardeners drew inspiration from the paintings of Lorrain and Poussin: there, brown tones and variations of green predominate against backgrounds of blue sky or golden sunsets. The decorative exuberance of the Victorian age put the flower back in the garden, where the practice of cultivating extremely colorful beds, in continuous rotation, became widespread, sometimes leading to jarring contrasts of form and color.

▼ Vincent van Gogh, *Irises*, 1889. Los Angeles, J. Paul Getty Museum.

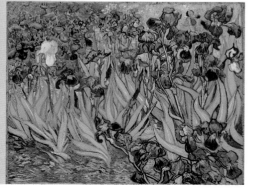

The Dutch garden, usually small in size, was regular and symmetrical. It was sometimes enclosed by barriers of trees or, in areas of reclaimed land, by a system of canals.

In Holland, the notion of the garden was inseparable from the country's Calvinist, Republican spirit. The theatrical, celebratory magnificence typical of Baroque gardens was absent.

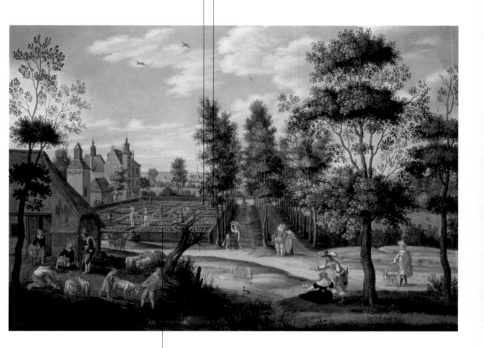

A typical feature of the Dutch garden was the abundance of flowers, grown in beds and pots. Tulips became particularly predominant starting in the mid-17th century.

▲ Izaac van Oosten, *Landscape with Garden*, 17th century. London, Rafael Valls Gallery.

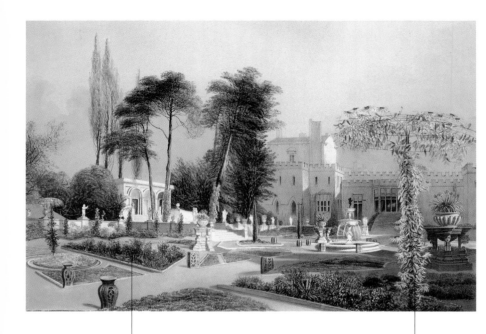

The flower forcefully reasserted itself in the Victorian garden, where it became common practice to cultivate extremely colorful flower beds, which were sometimes dissonant in form and color.

A wealth of flower varieties became available over the course of the 19th century, thanks to the fashion for exotic plants. Species from the New World and the Antipodes greatly enhanced the variety of species and the range of colors, sometimes resulting in gardens that had lost their sense of aesthetics.

▲ *Trellis of Flowers at Trentham Hall*, from E. Adveno Brooke, *The Garden of England* (London, 1857).

With the model of espaliered roses—typical of the hortus conclusus—now a distant memory, Repton organized his garden around an architectural structure of arches covered with climbing roses. The flower motif is repeated in the petal-shaped flower beds, which also feature roses.

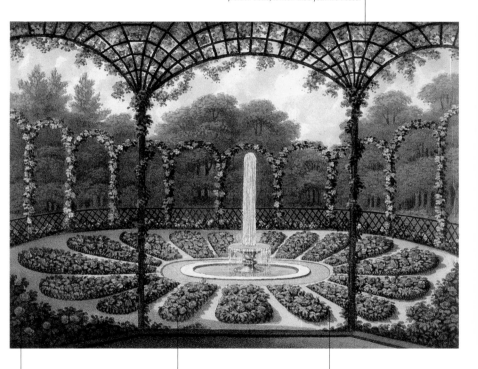

As this watercolor shows, Repton arranged the flowers in his garden with great sensitivity.

Eschewing landscape painting as his model, Repton brought the flowers banished from the "painted gardens" back into his own.

Around this time, a great many new species of flowers were imported to England, where they were registered and published in books and catalogues.

▲ Humphry Repton, *The Rosary at Ashridge*, from *Fragments on the Theory and Practice of Landscape Gardening* (London, 1816).

The garden was softened by the presence of vegetation left to develop naturally. Jekyll harmoniously combined colors and forms, creating the famous "herbaceous borders," made up of various grassy plants combined with noble as well as common plants such as irises, lupines, roses, and sweet peas.

A passionate plant enthusiast, Gertrude Jekyll (1843–1932) was the most famous creator of English gardens in her time. In the late 19th century, she began collaborating closely with Edwin Lutyens, an architect and landscaper, and together they designed nearly one hundred gardens.

The collaboration between Gertrude Jekyll and Edwin Lutyens produced gardens that could satisfy at once the demands of those aspiring to a formal garden and of those who wanted a more natural garden.

▲ Helen Paterson Allingham, *Gertrude Jekyll's Garden, Munstead Wood,* ca. 1900. Private collection.

Thanks to her great skill and her profound knowledge of plants, Jekyll was able to combine different varieties of flowers, achieving splendid chromatic effects and tonal variations. Her studies were published in 1908 under the title Colour in the Flower Garden, *which even today remains a source of inspiration for garden designers and flower enthusiasts.*

The original image that
Warhol used as the start-
ing point for Flowers was
a photo that won second
prize in a competition
called "Photograph Your
Garden," promoted by a
French women's magazine.

Warhol takes the com-
mon, universally recog-
nized image of a flower
out of its context as a
cliché of mass-market
imagery, giving it
autonomous life.

The four-flower motif,
isolated and repeated ad
infinitum, reflects the arche-
typal image of the garden,
evoking a love of flowers
and the natural impulse to
create one's own garden.

▲ Andy Warhol, *Flowers*, 1964.
Private collection.

The symbolic element par excellence, water is a fundamental presence in a garden. Indeed, one can say that water is the "soul of the garden."

Water

Related Entries
Islamic Gardens; Monastic Gardens; Versailles; Democratic Holland; Stourhead; Gardens of Meditation

▼ *The Fountain of the Organ*, 16th century. Tivoli, Villa d'Este.

The archetypal image of primordial flux, present at the creation of the world, the source of life but also an agent of dissolution in the form of floods, water is a vital component of the garden. In every garden in every epoch, its presence has contained a message to decipher and determined a particular state of mind, as well as nourishing the plants. Even Socrates is said to have thought that the placid gurgle of a fountain, together with the cool evening air, predisposes the mind to speculative activity. The sudden roar of a waterfall can elicit surprise, apprehension, and even fear of the unknown. The magical variations of sound, accompanied by allegories narrated by fountains, invite the observer to solve the enigmas, to decode the messages that the garden as a whole expresses in the system of its water. Water's supreme malleability, combined with our passion for artifice and spectacle, permits a tremendous variety of form in the creation of vessels for holding it. It inspires us to increase the force of the water and leads us to invent automatons and musical instruments driven by hydraulic power. Water shoots up into the sky with an impetus that defies the laws of gravity, or suddenly grows calm in broad pools that reflect the surrounding space and expand its dimensions. If what stands out most in Baroque fountains was the artificial, spectacular aspect of water, by the late 18th century, in conjunction with a general crisis in representative symbolism, the fountain lost its allegorical function and went back to expressing the naturalness of the stream, lake, or spring.

The geometrical, linear conception of the original garden is gone. Without the original, unitary vision to guide them, the different sections no longer directly connect with one another, but break up into so many self-enclosed spaces.

The garden's decaying state can be seen in the vegetation, which is disorderly and tending to grow wildly over the sculptural displays, creating a gloomy, alienating atmosphere.

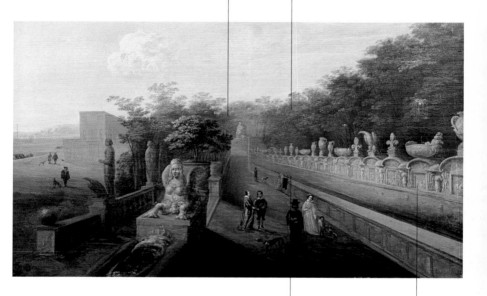

Artifice and spectacle dominated the aesthetics of Baroque fountains. The Alley of the Hundred Fountains features a long sequence of water spigots that links up visually with the Fountain of the Ovato in the Rometta complex.

The reliefs inside the squares represented mythological episodes from Ovid's Metamorphoses.

▲ Johann Wilhelm Baur, *The Gardens of the Villa d'Este at Tivoli*, 1641. Budapest, Museum of Fine Arts.

Water did not play as prominent a role in the Dutch garden as it did in the Italian garden. It generally took the form of pools or canals, especially in the polder areas, and effectively served as a mirror of the environment.

On an island in the middle of an artificial pool, there is an oval labyrinth with concentric hedgerows, at the center of which stands a Maypole. Couples and individuals are strolling inside the maze.

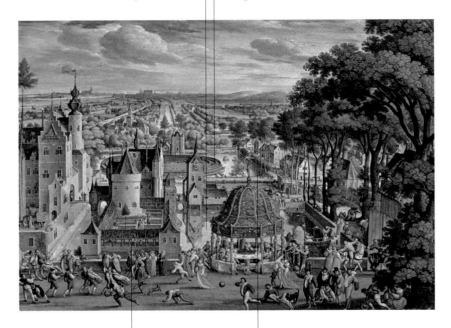

The roses blooming on the pavilion and along the bowers remind us that spring is a time for love and amusement.

The Dutch garden was regular, symmetrical, and divided up into quadrangular, usually square, spaces divided from one another by tall hedges.

▲ Hans Bol, *Park with Castle*, 1589. Berlin, Gemäldegalerie.

In England, the rejection of the formal French garden had political significance as well, becoming a symbol of the liberal British system of government.

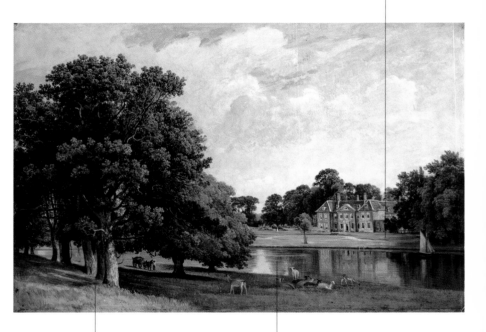

Viewed as a fascinating blend of freedom and disorder, nature is left to grow as it may.

In an English garden, water, stripped of its grandiose allegorical symbols, rediscovered its natural dimension in the lakes and streams flowing freely in the garden.

▲ Frederick Richard Lee, *Deer Grazing by the Lake at Chilston Park*, 19th century. London, Agnew and Sons.

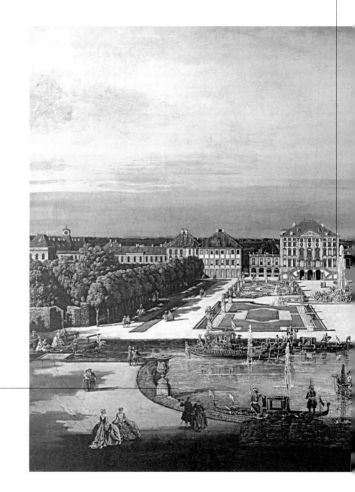

The ornamental pool is a reservoir of water contained in a symmetrical space giving onto the garden. In this case, its artificial banks are used to launch sumptuously decorated boats and gondolas.

▲ Bernardo Bellotto, *The Castle of Nymphenburg*, ca. 1761. Washington, National Gallery of Art.

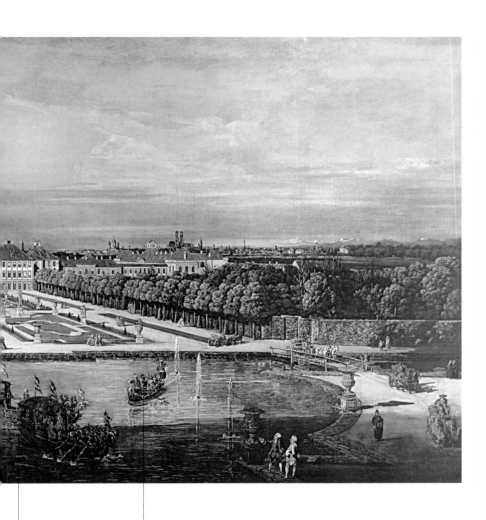

The castle gardens give onto a basin that leads to the central Grand Canal, on the same axis as the palace.

Apparently Italian gondoliers were hired by the prince to organize pleasure excursions for the nobility that frequented his palace.

A jet of water is supposed to shoot out of the stem, covering the cherry in a layer of water, which then shines in the sunlight.

From the stem's upper part a second, finer jet of water shoots up, which then falls directly into the spoon and thence into the pond. Sometimes the spray of water, when struck by sunlight, will create a rainbow.

Conceived as a fountain-sculpture, the "spoonbridge" spans a small pond, giving the garden a light-hearted, playful dimension and integrating itself into the surrounding landscape.

Oldenburg typically re-creates simple everyday objects on a large scale, turning them into genuine works of art.

▲ Claes Oldenburg and Coosje van Bruggen, *Model for Spoonbridge and Cherry*, 1986. Minneapolis, Walker Art Center.

*The Baroque garden harnessed the new scientific and techno-
logical knowledge that was being developed and perfected at
the same time.*

Technology in the Garden

Baroque gardeners were called upon to create the garden of
infinity, structured around a unitary geometric design in which
all the different parts were interrelated. They also had to take
into account the spectator's point of view, the range of his
vision, and his movements. They thus had to confront the very
sorts of problems that faced engineers of fortifications and
strongholds. Similarly, the preparation of the ground—leveling
the surface by constructing terraces, bulwarks, and inclines—
used construction methods borrowed from military engineering.
Although the mathematical tools available to gardeners had
been available for centuries, their application was being per-
fected over the course of the 17th century. The long, rectilinear
axes in Baroque gardens made it necessary to effect a series of
optical modifications, because, beyond a certain distance, the
eye's visual range is no longer rectilinear, because of the curva-
ture created by refraction. For this reason, the ground level had
to be adjusted. These sorts of purely geometrical operations
required a mastery of the rules of perspective, a science that
over the 17th century was integrated into such new fields of
knowledge as the three branches of optics—geometrical optics,
dioptrics, and catroptics—which at this very time were making
considerable progress. The operating systems
for fountains, moreover, required the use and
transfer of considerable quantities of water.
One example of colossal mechanisms needed
to carry out such operations is the famous
pump built at Bougival, on the Seine, called the
Machine of Marly. The Marly aqueduct trans-
ported the river's water from the pumping sta-
tion all the way to Versailles, where it fed no
less than fourteen hundred fountains.

▼ Pierre-Denis Martin, *The
Machine of the Marly
Aqueduct*, 1724. Versailles,
Musée des Châteaux de
Versailles et de Trianon.

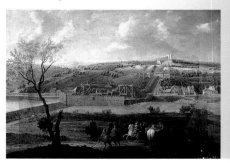

Over the course of the 18th century, the garden became a kind of green stage set for an endless sequence of gallant encounters and magnificent celebrations.

The Garden Stage

The garden served as backdrop for social gatherings and worldly events. The theatrical events unfolded in a dramatic space that was framed by landforms, arcades, staircases, and terraces that gave onto garden panoramas. Dramatic artifice and plays of perspective created the illusion of infinite space, especially where the territorial expanse itself was nearly infinite, as at Versailles. The garden theater par excellence, Versailles used its continuously changing sequence of perspectives to surprise the visitor. The objective was to transfer, into the garden, the effects a painter achieves on canvas or a decorator on the stage. The garden designer, painter, and dramatist Louis de Carmontelle, planning the Monceau garden, said: "Let's change the garden's stages the way we change the décor at the Opera; let's make it so that one can see there, in reality, the same thing that the most skilled painters offer in the form of decoration, all times and all places." The garden thus became a place for dream and illusion, and a practical realization of these concepts. An odd commingling even occurred between gardens that suggested the theatrical milieu and stage decors inspired by actual gardens. Just as the garden's decorations included staircases, amphitheaters, and ballrooms, so theatrical stages began to add elements derived from gardens, such as statues, obelisks, and fountains, to the point that it is sometimes difficult to tell whether an artwork is depicting a theatrical stage or a real garden. Absorbed in the mechanisms of theatrical illusion, the spectators gave themselves over to this form of pleasure, the ultimate purpose for which both theater and garden were created.

▼ Marcantonio dal Re, *The Garden of Villa Arconati-Visconti at Castlelazzo di Bollate*, 1743. Milan, Civiche Raccolte delle Stampe A. Bertarelli.

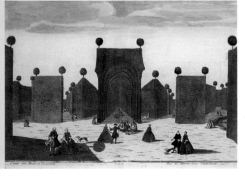

Laid out like telescopes along the three lanes, the water chains and fountains could assume a variety of forms.

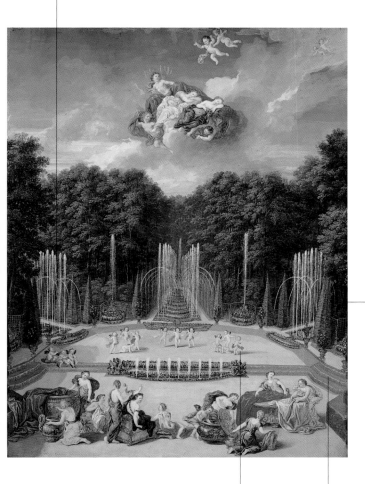

Backdrops of water alternate with backdrops of greenery and pyramidal topiary works are lined up along the dense sectors of woods, which are framed by treillage structures.

▲ Jean Cotelle, *View of the Upper Part of the Grove of the Water Theatre of Versailles*, 1693. Versailles, Musée des Châteaux de Versailles et de Trianon.

The water theater, adorned with statues of the gods as children, was destroyed between 1770 and 1780.

The area reserved for spectators has three grass-covered steps for seating. It was separated from the stage by a canal with fountains.

A fleet of five feluccas and sixteen fes-
tively bedecked boats led the guests of
the king and queen to the more delight-
ful venues of the festivities.

The park of Aranjuez, like many other
royal parks, was conceived as a kind
of stage on which one could hold
magnificent celebrations.

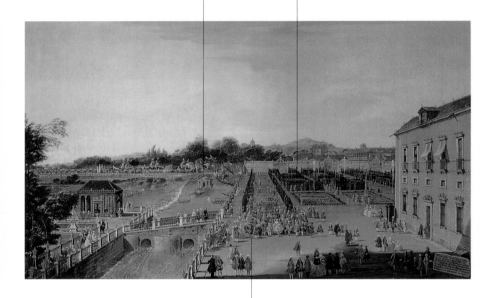

All the elements of the garden,
from the parterres to the barriers
of greenery, have been decorated
to set the stage for the festivities
and welcome the king, queen, and
their court into the garden, where
the celebration will take place.

▲ Francesco Battaglioli, *King Ferdinand
VI and Queen Barbara of Braganza
with Their Guests in the Gardens of
the Royal Palace of Aranjuez*, 1756.
Madrid, Prado.

Each avenue ends with a small building in the Palladian or Neoclassical style.

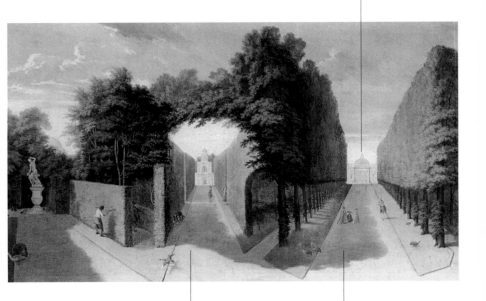

In the patte d'oie, or trident, pattern, the three avenues fan out from a single point; the central one is straight, the other two oblique.

The trident pattern of walkways echoes the models of the Olympic Theatre of Vicenza and the Théâtre d'Eau at Versailles.

▲ Pieter Andreas Rysbrack, *View of the Rectilinear Axes of Chiswick,* 1729–30. Chatsworth, The Trustees of Chatsworth Settlement.

The Garden Stage

In the first half of the 18th century, the fashion of creating stage sets of vegetation, specially conceived for feasts and celebrations, began to spread all over Europe.

The permanent backdrop of perfectly pruned trees is complemented by other plants brought out from hothouses.

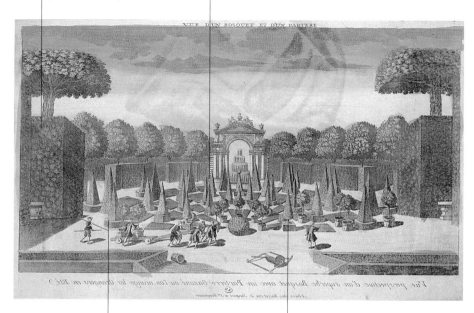

In the garden's imposing decor, one can scarcely distinguish between the manmade objects and the actual trees, which have been reduced to identical geometrical figures.

In the rigid grid of the garden, the vegetation is trained and molded to man's will, an approach that would be refuted by the principles of the English garden.

▲ French school, *Summer Arrangement of Orange Trees*, ca. 1750. Paris, Bibliothèque des Arts Décoratifs.

The imposing arbor structure, which is supported by caryatids, invites us into the scene being prepared.

The theatrical arrangement of the scene unfolds in a series of parallel frames centered around the garden's main axis.

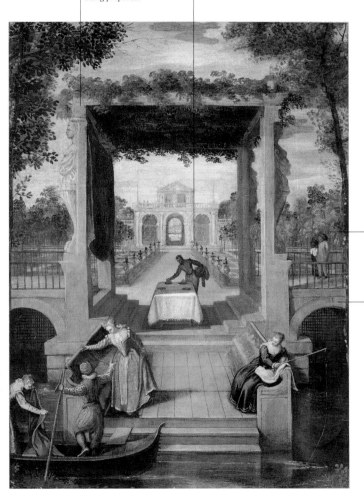

The curtain of wild trees all around the garden underscores the distinction between the garden's geometrical forms and the uncultivated, natural environment.

The garden seems to stand on an actual stage, where a broad lane adorned with vases cuts through a series of geometrically designed parterres.

▲ Benedetto Caliari, *Garden with Figures*, second half of 16th century. Bergamo, Accademia Carrara.

Rendered with wispy, staccato brush-strokes, this garden evokes the dreamlike atmosphere typical of the country feasts and balls so cherished by the aristocracy.

A screen of treillage and a sculpted, gushing fountain serve as backdrop to the amorous scenes in the foreground.

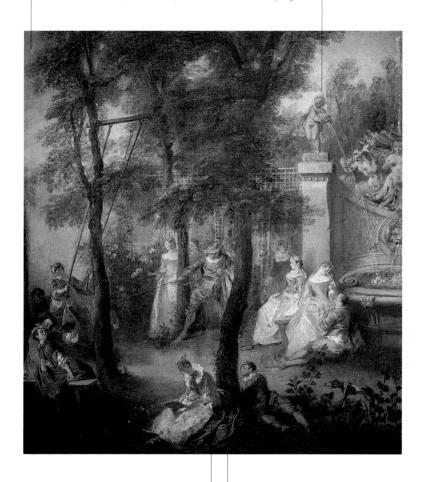

▲ Nicolas Lancret, *The Swing*, ca. 1735. Madrid, Museo Thyssen-Bornemisza.

The gallant encounters typical of Baroque culture naturally take place in gardens, where lovers may find the most secluded corners and the intimate, secret atmosphere of the groves.

The three trees in the fore-ground increase one's percep-tion of depth in the scene and also serve as the main focal points of the composition, call-ing our attention to the girl on the swing, the man pulling the rope, and the loving couple by the fountain.

The decadence of this Baroque garden is visible in the disorderly growth of the wood, which is no longer carefully manicured. Overgrown trees invade the open spaces and block one's view of the perspectival axes, as if reasserting their forgotten sovereignty.

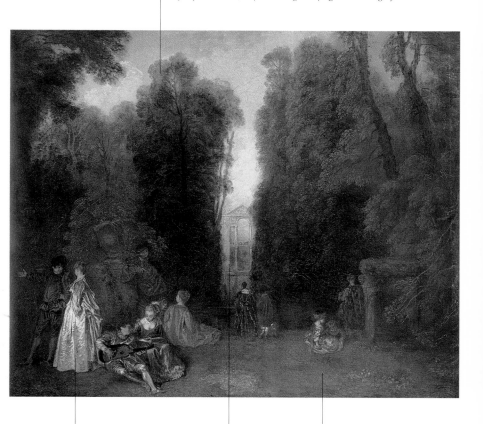

A refined interpreter of the lifestyle spreading throughout France as well as the Rococo style, Watteau depicts a new society in which gallantry, parties, and music were rapidly becoming the dominant modes. One senses, however, a feeling of melancholy pervading these compositions, as if the artist were conscious of the relentless passage of time and the fleeting nature of life's pleasures.

Cutting a narrow passage through the wood beyond a pool of water, the perspective ends with the facade of a Palladian-style building, dimly visible in the distance.

A typical example of a garden suggesting a theatrical stage or, conversely, a stage set inspired by real gardens, this painting may represent the garden and home of Pierre Crozat near Montmorency, or a composition inspired by an opera set.

▲ Jean-Antoine Watteau, *La Perspective (View through the Trees in the Park of Pierre Crozat),* ca. 1718. Boston, Museum of Fine Arts.

Parterres are broad, geometrically shaped plant beds designed for ornament and usually situated in the immediate vicinity of the palace or château.

Parterres

The parterre is normally a low-lying decorative bed characterized by a variety of designs made out of boxwood, grass, colored gravel, or flowers, and it can assume many different forms. The best known is the *parterre de broderie*, or "embroidered" parterre, which recalls the complicated embroidery designs of the reigns of Henry IV and Louis XIII. It uses a great variety of curving decorative motifs. In the *parterres à pièces coupées*, literally, parterres with "cut pieces," the key decorative motif is the flower, distributed in flower beds cut into geometrical shapes that are arranged symmetrically and bordered by narrow walkways that allow gardeners to tend the flowers. The *parterre à l'angloise*, or "English-style" parterre—so called because it is rather widespread in England—is a geometrical lawn of mown grass often framed by sculptures, flowers, or topiary decorations. The geometrical, or Italian-style, parterre features a regular design that is based on the compartments (or quadrangular subdivisions) typical of Italian gardens. The term *parterre* emerges in late-16th-century France and denotes a specific new garden design. It later came to refer only to the Baroque period, but the word eventually entered common usage as connoting any composition of flower beds, whether those of the Baroque era or those typical of other epochs before or after the 17th century.

▼ Flemish school, *The Garden of the Palace of Nancy*, 1635. Prague, Národní Galerie.

*The uniform lanes converge toward a central space domi-
nated by a parterre. The high walls of vegetation are care-
fully pruned to form a veritable green barrier, beyond which
are perfect rows of identical trees.*

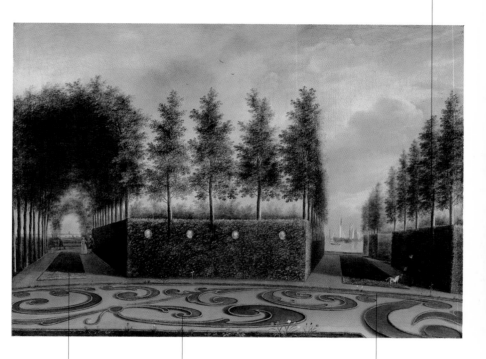

The lane on the left
leads to a cultivated
plot of land, while the
one on the right opens
onto a view of mar-
itime traffic, the two
primary sources of
Dutch prosperity.

The parterre de broderie
recalls the complex
embroidery designs of
the time of Henry IV
and Louis XIII, assum-
ing the forms of vegetal
shoots, arabesques, and
sinuous volutes.

Flowers, some of
which have already
blossomed, appear
to have been
recently planted
inside the volutes
of the parterres.

▲ Johannes Janson, *Formal Garden*, 1766.
Los Angeles, J. Paul Getty Museum.

Parterres

The French term
par terre *means*
"on the ground."

*The geometrical, or Italian-style,
parterre follows a uniform
design inspired by the "com-
partments" of the Italian model.*

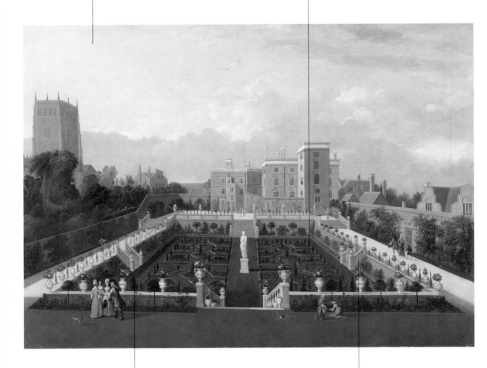

*The French parterre
evolved directly from the
Italian model of geometri-
cally linear and compart-
mentalized plant beds,
where the hedgerows were
sometimes a meter high.*

*This garden's parterre lies
at a below-grade level
bordered by a low wall
decorated with pots of
flowers. Apparently this
was a rather common
design for English gardens
in the Renaissance.*

▲ English school, *Pierrepont House
at Nottingham,* ca. 1710. New
Haven, Yale Center for British Art,
Paul Mellon Collection.

The German Baroque garden took elements of the Italian Renaissance garden and reworked them in an original fashion.

The symmetrical layout is perfectly integrated with the architecture and sculpture.

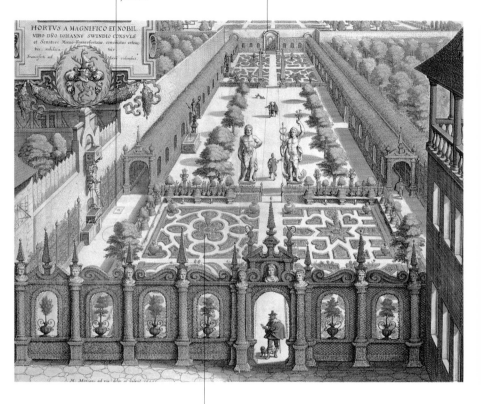

HORTVS A MAGNIFICO ET NOBIL
VIRO DÑO IOHANNE SWINDIO CONSVLE
et Senatore Moeno-Francofurtano, concinnatus extrus
bus aedificia tus
Francofurti ad Monte videndus.

M. Meriano ad vivi delin et sculpsit 1641

In the parterre à pièces coupées, or parterre of "cut pieces," the flower is the principal decorative motif. The parterre is divided into geometrical shapes that are symmetrically arranged and bordered by narrow walkways allowing gardeners to tend the flowers.

▲ Matthäus Merian the Elder, *The Garden of Burgermeister Schwind*, ca. 1641. Private collection.

Bellotto's view of Vienna includes
the Belvedere Garden, created
between 1700 and 1725 and
inspired by French models.

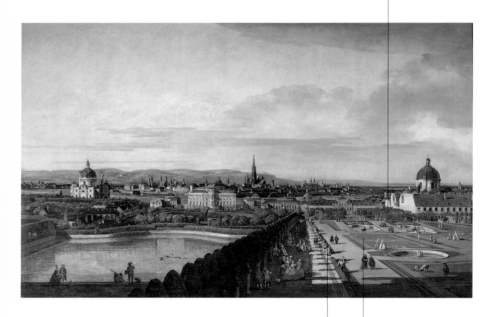

In Bellotto's painting, we
see some of the statues that
adorned the garden. They
were inspired by the myth
of Apollo and the four ele-
ments, but many have been
lost or destroyed.

The parterre à l'angloise, or
"English-style" parterre, so
called because it was popular
in England, is composed of a
geometrical lawn of mown
grass often framed by sculp-
tures, flowers, or topiary.

▲ Bernardo Bellotto, *View of Vienna
from the Belvedere*, 1758. Vienna,
Kunsthistorisches Museum.

Before the famous Hall of Mirrors was built in 1679, the central mass of the palace gave onto a broad terrace.

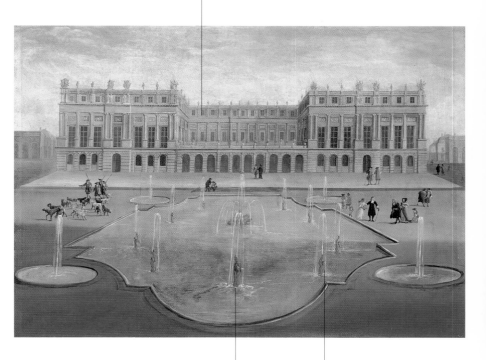

Fountains often gush from the surface of parterres d'eau.

A parterre d'eau, *or "water parterre," consists of one or more pools arranged in such a way that they assume the appearance of a compartmentalized or geometrical parterre.*

▲ French school, *View of the Château of Versailles from the Parterre d'Eau around 1675*, 17th century. Versailles, Musée des Châteaux de Versailles et de Trianon.

Fabriques and follies are miniature buildings or architectural structures constructed to embellish panoramas and express a specific iconographical intention.

Fabriques and Follies

Related Entries
Monastic Gardens;
Stourhead; The Political
Garden: Stowe;
Ermenonville; The Orient
in the Garden; Ruins

Once "liberated" by English landscapers, gardens slowly began to acquire buildings. Among them were Orientalizing pavilions and other architectural structures that were supposed to lend character to the garden's views, sometimes as purely decorative elements, but often as bearers of a specific iconographical program and expressions of the garden's innermost aspects. Each object in the garden took on meaning. An obelisk evoked ancient Egypt; a temple, ancient Greece. The buildings thus wrapped themselves in explicit cultural significations and were perceived as emblematic symbols of times gone by and distant lands. The garden became a kind of open-air encyclopedia, and as one strolled along its paths, one could see different parts of the world. But in addition the garden might conceal a particular ideological message, under the guise of a simple faux ruin. The Temple of Philosophy at Ermenonville, for example, can be interpreted as an encomium to human progress—an unfinished building that only future generations will be able to complete. Fabriques are half model, half real architecture, and sometimes end up the megalomanias of their patrons. The passion for these "architectural baubles" eventually turned into a

▼ English school, *View of Duncombe Park in North Yorkshire*, 18th century. Private collection.

true mania, leading artists to treat the phenomenon ironically. A painting by Hubert Robert at the Kunstmuseum of Basel, for example, depicts a garden with a dog's bed in the form of a grotto with an obelisk on top—an obvious poke at the grotesque pitch that the passion for such follies had reached.

The many stage sets created in the Parc Monceau included a grove of sepulchres, Turkish and Tatar tents, a windmill, a ruined castle, a lake for recreational navigation, and an Egyptian pyramid. These tableaux were designed, when viewed from a distance, to create the illusion that the garden possessed much vaster dimensions than it actually did.

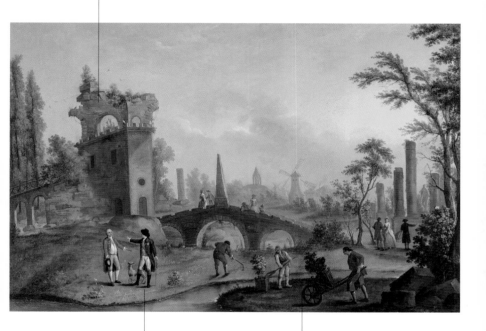

The garden of Monceau was designed by Louis Carrogis, known as Carmontelle, a painter, art critic, garden designer, and playwright. It was constructed from 1773 to 1778 for the Duke of Chartres, a great admirer of English culture.

Carmontelle developed an art of garden landscaping based on fantasy and illusion. One could see an endless variety of scenes during a single promenade. According to the artist, one garden should include within its confines "all times and all places."

▲ Louis de Carmontelle, *Carmontelle Presenting the Keys to the Park of Monceau to the Duke of Chartres,* ca. 1790. Paris, Musée Carnavalet.

Chinese-inspired build-
ings stand alongside
Neoclassical structures,
alternating with broken
columns that evoke a
taste for ruins and
expressing Carmontelle's
desire to bring together
"all times and all places"
in a kind of open-air
museum.

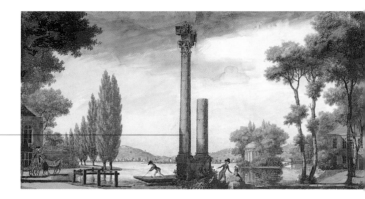

Genteel couples stroll among
the many monuments and fol-
lies that fill the park. From up
close, they are reminiscent of
Carmontelle's drawings for the
Parc Monceau.

▲ Louis de Carmontelle, *Figures
Walking in a Parkland*, 1783–1800.
Watercolor and gouache on translucent
Whatman paper. Los Angeles,
J. Paul Getty Museum.

Among the scenes depicted on rolls of transparent
paper, we see English-style gardens, real and imagi-
nary, reflecting the era's taste for the follies and
monuments that punctuated so many gardens.

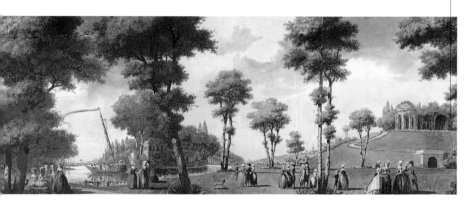

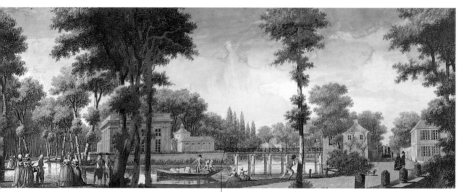

In 1783, Carmontelle started painting
scenes on strips of onionskin paper
some fifty centimeters wide and
dozens of meters long. These came
together to form a kind of magic
lantern, a tableau mouvant that,
when rolled slowly around a trans-
parent tube, created the illusion of
images in motion.

Fabriques and Follies

The spread of the landscape-garden aesthetic in France coincided with the fashion for re-creating scenes of country life within complexes such as the ferme ornée (decorative farm) and the hameau (hamlet), seen as a return to rustic life.

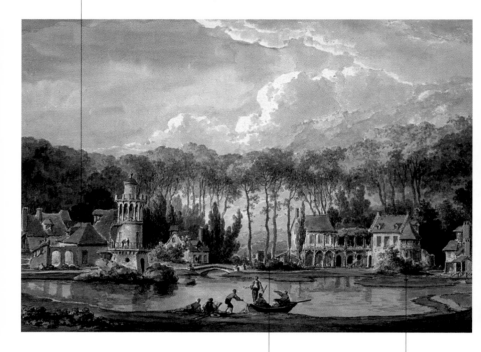

The return to nature and the simple life was advocated by the Philosophes, Rousseau foremost among them. This trend led to the creation of hermitages and secluded sites that lent themselves to contemplation.

In 1782, Hubert Robert and Richard Mique created the celebrated petit hameau of Versailles for Queen Marie Antoinette. It looks like a genuine rural village, with the requisite farm buildings, from farmhouse to stables, looking out onto the lake.

▲ Claude-Louis Châtelet, *The "Hameau" in the Petit Trianon Garden,* 18th century. Modena, Biblioteca Estense.

A laboratory, a conservatory for scientific specimens, and a pleasurable place to visit, the greenhouse embodied and established a new relationship between man and nature.

Greenhouses

Originally the prerogative of princely estates and the government, greenhouses began to appear in the 19th century in areas designated for collective use as well, such as urban parks, botanical gardens, and, in general, all those public places intended for the study and conservation of plants. Riding the crest of the Industrial Revolution and contemporary technological progress, greenhouse design rapidly rose to extraordinary levels. First there were the great constructions of Joseph Paxton, who, favoring a combination of traditional materials and iron and glass, succeeded in creating a structure that could adapt to temperature variations. This led the way to inventions of ever-increasing—and sometimes extreme—originality, until certain greenhouses were counted among the most extraordinary architectural creations of the 19th century. Around mid-century, the greenhouse became a favorite attraction in botanical gardens and horticultural fairs, and especially in the great universal expositions. In 1846, a magnificent "winter garden" was erected on the Champs-Élysées, in which one could admire rare plants, buy flowers, and also have lunch or read the newspaper in designated areas. It was such a success that the following year an even larger building was constructed containing ballrooms, billiard halls, and even an art gallery and an aviary. By this point the phenomenon was unstoppable. Soon the greenhouse became available to private individuals, who expanded on its function as a winter garden to create orangeries or variable-temperature hothouses, among other things, and made it an integral part and extension of the home.

Related Entries
Exotic Plants

▼ Etienne Allegrain, *View of the Orangerie and Parterres of the Château of Versailles* (detail), 1686–96. Versailles, Musée des Châteaux de Versailles et de Trianon.

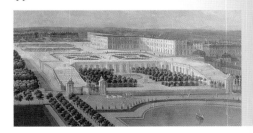

Greenhouses

Hesperides *was the first book to treat the husbandry of citrus trees. The volume's international success led to the spread of orangeries and hothouses throughout Europe.*

The orangery, or green-house for orange trees, is a large cold-house designed to protect exotic plants such as citrus, mimosas, camellias, and myrtles during the winter months; it is usually a masonry construction with light exposure on one side, to the south or west, where light passes through large windows with movable frames.

The arrangement of plants inside the green-house follows a strict order: the largest items are placed closest to the blind wall, while the smallest and most deli-cate plants are placed nearest the windows.

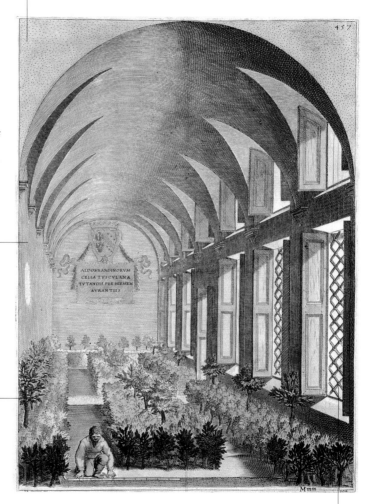

▲ Camillo Cungi, *Citrus Trees in a Greenhouse,* from Giovanni Battista Ferrari, *Hesperides* (Rome, 1646). Private collection.

The northern side of a greenhouse is usually a blind wall, often resting against a natural mass or another building to ensure good thermal insulation.

The greenhouse is heated by large coal-burning stoves, and its size allows it to house plants up to five meters (15 ft.) tall.

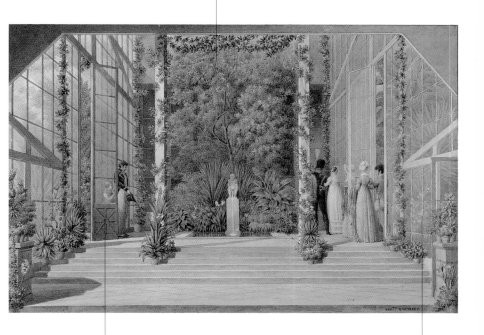

The great hothouse of Malmaison, some fifty meters (150 ft.) long, was a glass structure divided into a series of rooms in which one could admire the many plants collected by Empress Josephine. The rooms also served as galleries for collections of Greek vases.

The great 19th-century greenhouses were by-products of the burgeoning scientific interest in previously unknown plants arriving in Europe from different parts of the world, following the journeys of the great explorers.

▲ Auguste Garneray, *Interior of the Hothouse at Malmaison*, early 19th century. Rueil-Malmaison, Musée National des Châteaux de Malmaison et Bois-Préau.

Greenhouses

The imposing structure of iron and glass that Paxton designed for the Great Exhibition of 1851 in Hyde Park made it possible to save the park's ancient trees by including them in the building.

Paxton used iron for the unexposed support elements, and wood for the external frames and joins, making the structure more adaptable to major swings in temperature.

Greenhouses bring man close to an exotic world of fanciful imagery. French painter Henri Rousseau, for example, conceived his lush jungles after visiting the Jardin des Plantes in Paris.

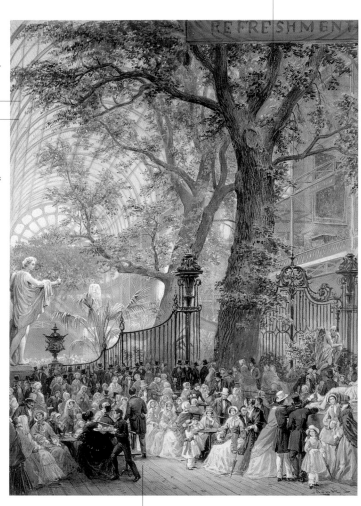

▲ Louis Haghe, *Interior View of the Crystal Palace at the London Exposition of 1851*, ca. 1851. London, Victoria and Albert Museum.

The massive greenhouse became a place for social gatherings, strolling, recreation, and rest.

The winter garden serves a different scientific purpose than the greenhouse. It allows one to have a natural, exotic environment available in any season, which is especially welcome in countries with a harsh winter climate.

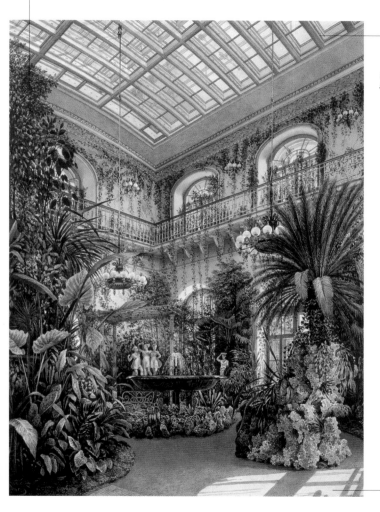

The glass ceiling implies the use of new construction techniques made possible by the Industrial Revolution.

The garden contains a bizarre assortment of elements that create an atmosphere of exoticism and whimsy.

▲ Konstantin Andreyevich Ukhtomsky,
Winter Garden in the Winter Palace of St. Petersburg, 1862. St. Petersburg, Hermitage.

A major influence on the development of the landscape garden was the Chinese garden, whose popularity underlay many of the new philosophical and political ideas.

The Orient in the Garden

Related Entries
Landscape Gardens;
Fabriques and Follies

The West's discourse with China, which since medieval times had been considered a kind of wonderland, was given a boost when the Portuguese arrived there in the early 16th century. By the end of that century, the political and social institutions of the Chinese government, considered tolerant and disinclined to wage war, had also won the admiration and appreciation of Western observers. In the 1800s, thanks to the work of missionaries, the great Chinese classics were translated into European languages and met with great success. Western philosophers recognized the moral salience of Confucianism, which is founded on reason and tolerance. One passionate supporter of Confucian principles in England was Sir William Temple, who in 1685—when Versailles was at the height of its splendor—wrote an essay giving a detailed description of the Chinese garden. The latter is seemingly more disorderly than the European geometrical model, with a studied asymmetry in the pattern of walkways and placement of trees. Temple coined a name for this composition, *sharawaggi* (or *sharawadji*), which was to enjoy great popularity. The term was associated with gardens that followed Chinese models and thus had sinuous paths dotted by clearings or round spaces featuring ornamental objects, usually pavilions or statues, to mark the different stages of the promenade. The

▼ William Daniell, *The Fishing Temple at Virginia Water*, 1827. Brighton, Museum and Art Gallery.

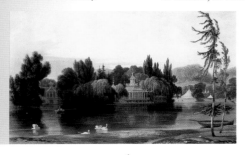

adoption of "Oriental" elements differed in France and England: while in the former the garden acts as a sort of stage set on which actors follow one another in sequence, in the latter the scene unfolds—as in a painting by Lorrain or Poussin—according to a finite, self-sufficient composition, in which man's presence adds little to the suggestive view of the whole.

The first images of Chinese gardens to reach England in the early 18th century were thirty-six views of imperial palaces and gardens by the Jesuit priest Matteo Ripa, who sojourned in London while traveling through Europe in 1724.

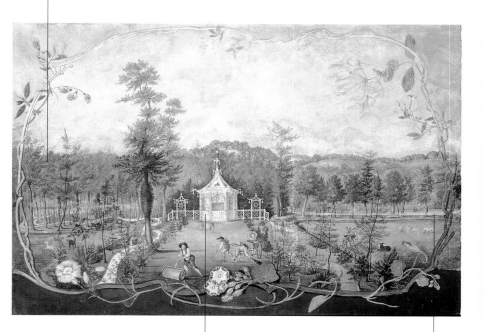

In his essay Upon the Gardens of Epicurus; or Of Gardening, in the Year 1685, *William Temple treated the subject of the Chinese garden. While coming out in its favor, he paradoxically advised the English against adopting the model at home.*

The term sharawaggi *refers to gardens that, taking their cue from Chinese models, feature paths that wind through a mixed landscape of clearings and circular spaces, eschewing the rigid symmetry of formal European models.*

▲ Thomas Robins the Elder, *Chinese Pavilion in an English Garden*, ca. 1750. Private collection.

The Orient in the Garden

The background is bursting with lush exotic plants, underscoring the clearly "Oriental" cast of the garden. Instead of an Eastern-style fabrique we have a sedan chair, whose form recalls a pagoda.

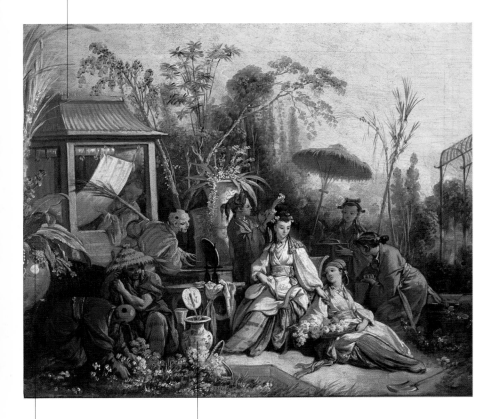

In France, the fashion for exoticism translated into a genuine passion for China, where gardens were asymmetrical and "disorder" allowed nature to grow freely.

The decorative whimsy, the elegant drawing, the use of rich, luminous colors, and a keen sense of detail underscore how the taste for chinoiseries extended to household objects and paintings as well as gardens.

▲ François Boucher, *Chinese Garden*, 1742. Besançon, Musée des Beaux-Arts.

The arrangement of trees within the garden has altered over the course of the centuries with changes in taste and the aesthetic allusions they are supposed to convey.

Trees

Related Entries
Baroque Gardens;
Landscape Gardens;
Fabriques and Follies

Ever since antiquity, the recommended method of planting trees has been *en quinconce* ("in quincunx"), that is, with a central tree surrounded by four others in the corners of an imaginary square. This basic module, repeated ad infinitum, made for a rational method of cultivation. The model was taken to extremes in the Baroque garden, where trees were planted in lines, pruned to look almost identical, and placed in geometrically precise relation to hedgerows, which were in turn carved into mathematically precise shapes. The landscape garden radically transformed the idea of man's relationship to nature, and hence to trees. Nature was no longer to be dominated by the human hand but was on the same level as man, to be treated with respect. By the turn of the 18th century, even the landscape garden began to seem too orderly to some, with its mown lawns and its pleasantly meandering paths. Gardeners were encouraged to make closer study of unspoiled nature. According to the new ideas, the garden should be stripped of all those useless, meaningless structures—the pagodas and little Greek temples—and any human intervention should be discreet and nearly invisible. Once the architectural signs, with their related sculptures and inscriptions, were removed, what remained were the truly natural materials with which to create one's garden: rocks, water, and trees. Landscape painting still exerted its influence, but gardeners were supposed to interpret it in a more natural manner, expressing their ideas with the available materials, especially trees, which were to be arranged as naturally as possible.

▼ Johann Ziegler, *The Vienna Augarten*, 1783. Vienna, Wien Museum.

Though fairly natural in appearance, the arrangement of the trees is actually quite orderly, as is the disposition of the surrounding meadow.

According to more naturalistic conceptions of the garden, the stone bridge in the middle of the lake mars the overall view of the landscape.

The path is well tended and too straight, clean, and orderly to be considered natural.

▲ Humphry Repton, *Water at Wentworth, Yorkshire*, proposal for transformation, from *Observations on the Theory and Practice of Landscape Gardening* (London, 1803).

Apparently Richard Payne Knight drew inspiration for the garden at Downton Castle from this painting by Lorrain, which he owned at the time.

The exponents of a more naturalistic conception of the English garden included Richard Payne Knight and Uvedale Price, two prominent figures in British culture at the time.

A picturesque view was supposed to look to unspoiled nature, which is wild and far less orderly than the natural world of the landscape gardeners.

▲ Claude Lorrain, *View of La Crescenza*, ca. 1648. New York, Metropolitan Museum.

In his garden at Foxley, Sir Uvedale Price kept his interventions in the natural setting to a minimum.

Richard Payne Knight, whose poem "The Landscape" set off a vigorous debate on the meaning of "picturesque," felt that trees were indispensable in a picturesque setting, framing one's views and creating a soothing vault overhead.

The garden's path is little more than a disconnected trail.

The only manmade element in the garden is a rustic wooden fence.

▲ Thomas Gainsborough, *Beech Trees at Foxley, Herefordshire, with Yazor Church in the Distance*, 1760. Manchester, Whitworth Art Gallery.

In the early 16th century, following the great voyages of discovery, many species of exotic plants started arriving in Europe from the Balkans, Turkey, Africa, and the Americas.

Exotic Plants

Thanks to botanical gardens and herbaria, which managed to cultivate plants that could not otherwise have survived the European climate, a new international market for rare flowers began to form in the late 16th century, especially in Italy, the Netherlands, Germany, France, and England. In the 17th century, the flowers in greatest demand were anemones and tulips, but also the many varieties of hyacinth, narcissus, and iris. These flower collections were usually kept in a separate part of the house and arranged in specialized gardens. In addition to flowers, there were also collections of fruit trees, with a comparable abundance of species. The passion for collecting and breeding exotic plants reached its height over the course of the 19th century, especially in England. The number of available species—already considerable in the late 18th century—grew tremendously after 1830, in large part due to the invention of the "Wardian case," a kind of portable terrarium, named after its creator, Nathaniel Bagshaw Ward. This case made it possible to collect and import quantities of botanical species to Europe from all over the world. Then in 1845, just a few years after Ward invented his plant case, the tax on glass was abolished, making it much less costly for the English to build greenhouses. The passion for exotics soon spread to their gardens, which sometimes degenerated into gaudy, incoherent displays of imported plants, flowers, and shrubs.

Related Entries
Flowers; Greenhouses

▼ Theodorus Netscher, *Pineapple Grown in Sir Matthew Decker's Garden at Richmond*, 1720. Cambridge, Fitzwilliam Museum.

Exotic Plants

The garden behind the king, with its typically
Baroque geometric parterre and central per-
spectival axis, has been identified as that of the
Duchess of Cleveland near Windsor.

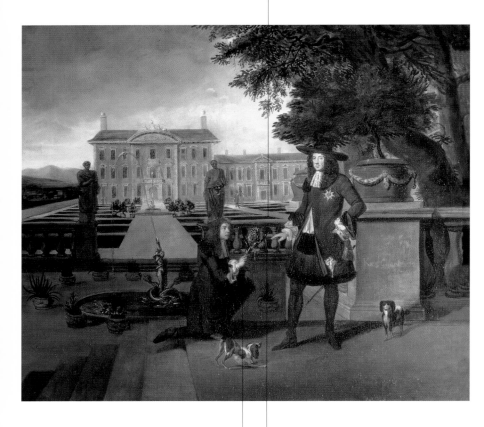

The royal gardener, John Rose, presents
Charles II with the first pineapple ever grown
in England. Rose had been directly involved in
the fruit's cultivation and here plays an impor-
tant role in the celebration of the event.

From the 17th century on, the
passion for collecting exotic
plants included the cultivation
of rare fruits.

▲ Hendrick Danckerts, *John Rose, the
King's Gardener, Presents Charles II with
the First Pineapple Grown in England*,
17th century. Richmond, Ham House.

The interest in and passion for exotic plants led many gardeners and collectors to embark on long journeys in search of new plant species to adapt to their own country's climate.

From North America, Tradescant brought to England the bald cypress (of the Taxodiaceae *family), the* Sarracenia purpurea *(pitcher plant), and the liriodendron, or tulip tree.*

▲ Thomas de Critz (attr.), *John Tradescant the Younger as Gardener,* mid-17th century. Oxford, Ashmolean Museum.

John Tradescant the Younger (1608–1662), voyager, horticulturist, collector, and gardener, traveled often, especially to Virginia, to find plants and curios to put in his garden and his museumlike home, which was full of rare items from all over the world.

A scion of the Russian haute bourgeoisie and a passionate naturalist, Prokofy Demidov created his own botanical garden, which contained many rare plants.

He is portrayed in a dressing gown, proudly pointing to a pair of potted flowers and leaning on a watering can, to underscore his passion for rare plants.

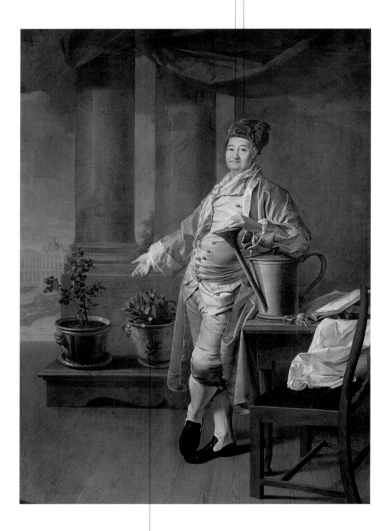

▲ Dmitri Levitsky, *Portrait of Prokofy Akinfievich Demidov*, 1773. Moscow, Tretyakov Gallery.

Destined for the conference room of an educational institution that Demidov, a renowned philanthropist, had generously financed, the portrait defies the rules of protocol and presents the patron in a whimsical manner, highlighting the collector's love for exotic flowers.

The number of exotic plant species in England increased considerably after the invention of the Wardian case, a kind of portable greenhouse that made it possible to import many new varieties by keeping them alive during long sea voyages.

The profusion of botanical species ended up creating a vast array of forms and colors in English gardens, to the point that the aesthetic sense sometimes got lost.

▲ Edward John Poynter, *In a Garden*, 1891. Wilmington, Delaware Art Museum.

The young woman is reading in the garden, shading herself with a fan that itself recalls the shape of an exotic flower.

Urns and vases are objects rich in symbolism, designed to hold special varieties of flowers and plants.

Urns and Vases

Related Entries
The Portrait in the Garden;
Gardens of the Dead

A pot, particularly a flowerpot, creates a microcosm isolated from everything else in the garden. The use of pots was sometimes strictly a pragmatic measure, so that the plant could be moved easily and taken inside during cold weather. But a potted flower could also have specific symbolic connotations. In the Adonia, or "gardens of Adonis," an ancient Athenian rite, anemone plants were grown in small terracotta pots or improvised baskets to celebrate the start of spring and to commemorate both the union of Aphrodite and Adonis and their sudden separation. In medieval iconography, the potted flower often alluded to the Virgin Mary but was also sometimes merely a decorative item, to add a classical flavor to the garden. The landscape gardeners in the late 18th and early 19th centuries learned to appreciate urns and vases because they evoked certain feelings in the viewer. The many publications devoted to gardening at that time abound with examples of urns and pots for adorning gardens. They could be left empty, without any plants at all, and placed in the garden simply to emphasize certain decorative or archaeological aspects of the place. In some cases, an urn might be more than purely decorative, evoking death and mourning by reference to its function as a funerary vessel.

▼ Charles Collins, *Three Spaniels in a Formal Garden,* ca. 1730. Private collection.

The scene unfolds against the background of a classic English park. A manor house is visible in the distance.

The urn is adorned with a garland of flowers, a classical allusion to fleeting beauty and the brevity of life. Its presence probably suggests a death in the family.

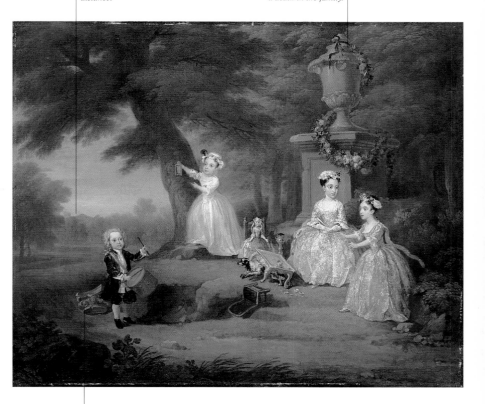

The broken capital lying on the ground behind the little boy and the mirror in the girl's hand are symbols of vanity and the perishability of earthly things.

▲ William Hogarth, *A Children's Tea Party*, 1730. Cardiff, National Museums and Galleries of Wales.

The painting depicts the garden of "The Orchard," which is at the southern end of the Isle of Wight overlooking the English Channel. The owners acquired the property and commissioned the garden in the early 19th century.

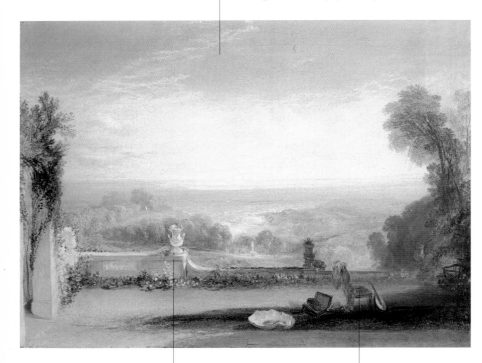

The terrace is bordered by a low wall adorned with pots serving a decorative purpose. This painting was based on a sketch by Lady Julia Gordon, one of Turner's pupils.

The palette, shawl, and lute may be symbols of civilized life, standing in contrast to the natural disorder of the sea cliffs jutting out into the Channel.

▲ Joseph Mallord William Turner, *View from the Terrace of a Villa at Niton, Isle of Wight, from Sketches by a Lady,* 1826. Boston, Museum of Fine Arts.

The Romantic "aesthetics of the ruin" saw the vestige of antiquity not only as an archaeological object but as a means of provoking emotion.

Ruins

In a Renaissance context, the ruin was seen as an invitation to reconstruct a distant, glorious past. The humanists sought to re-create the forms of an extraordinary past with the tools that their culture made available to them. The ruin was one such tool, and it was often brought to bear in the scientific and archaeological arguments aimed at reviving, not without a certain nostalgia, a past golden age in its proper historical context. Later on, the image of the time-worn ruin, in both its classical and medieval forms, would evoke reflections—usually melancholy—on times past, transforming the garden into a place of silent contemplation and meditation. In the ancient vestige, one perceives a memento mori, a reflection of life's transience and the irreversible decay that leads to dissolution and death. Vegetation sprouts around and atop the ruined edifice, sometimes nearly overwhelming it, as if trying to reclaim for nature a space once inhabited by man. This was a subject dear to the aesthetics of the Romantics, who purged their parks of elements of play and whimsy to make room for the cult of melancholy. The aesthetics of decay would soon spread to the landscape garden through the use of ruins—often fake ones constructed precisely for this purpose—that seem to be succumbing to the indomitable force of nature, evoking conflicted feelings in the observer.

▼ English school, *Figure among the Ruins of an Ancient Temple*, 19th century. Private collection.

The "Gothic" element became associated
with notions of a morally superior and
vanished past. These "ruins" were erected
at the end of the 18th century.

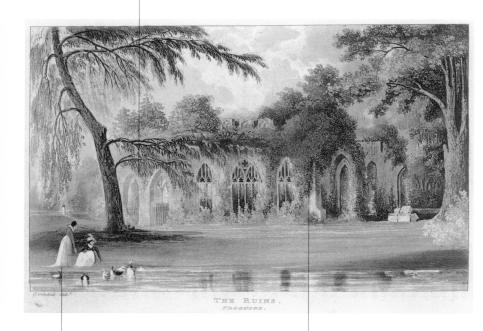

THE RUINS,
FROGMORE.

The strong emotional charge evoked
by the building dominating the scene
is attenuated by the two women in
the foreground, who are looking at
the ducks on the lake.

Natural vegetation has grown up
spontaneously all along the building,
as if taking back its original space
and evoking the image of the irre-
versible decay that leads to death.

▲ John Gendall, *Ruins at Frogmore*,
1828. Private collection.

The oblique view lends force to the image of the great arch, which is supported by columns that seem to vanish in the vegetation and the swampy water below.

The view of the ruins, which look as though immersed in a timeless space, creates a feeling of estrangement that enables the viewer to appreciate the overwhelming power of nature.

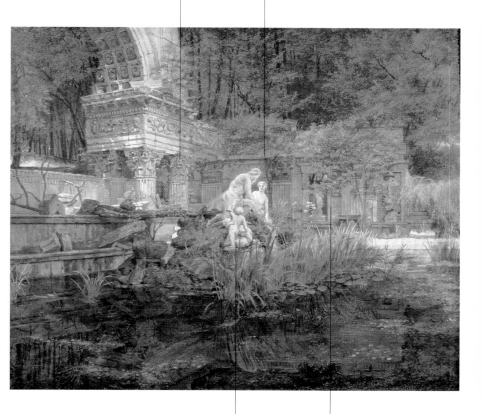

The sculpture group at the center of the composition looks cold and isolated, while the vegetation around it invades and reappropriates the space.

The ruins act as a kind of barrier, establishing a clear separation between the woods and the plant vegetation in the foreground.

▲ Ferdinand Georg Waldmüller, *Roman Ruins in the Park of Schönbrunn Castle*, 1832. Vienna, Österreichische Galerie Belvedere.

Artificial means can be used to re-create the image of the garden inside the home, underscoring the semantic reach of this small slice of cultivated nature.

The Artificial Garden

Eastern sovereigns have long been fond of artificially reproducing garden flora and fauna. One history recounts that in 917, Caliph al-Muqtadir had in his palace a Tree Room in which mechanical birds sang from the branches of trees made of gold and silver. But it was in the early 20th century, when discoveries and new technologies developed during the second Industrial Revolution lent machines a mythic stature, that this sort of artifice would most significantly affect the design of gardens. The artificial garden found one of its most extreme expressions in a project proposed by the Italian Futurists, whose aim was to align reality with the new principles of modernity. The natural world, which the Futurists considered obsolete, "passé-ist," and in conflict with the needs of modern society, was not exempt from this utopian vision. In the early 1910s, Giacomo Balla was already painting the new flora of the Futurist garden as a universe of geometrical forms with flashy, intentionally artificial colors. Similar considerations inform the *Manifesto of Futurist Flora* (1924), which condemns the "laurels" of ancient Rome and the "decorative roses of Watteau" in favor of an artificial universe and the creation of a "sculptural Futurist flora." Even the smells would be no longer those found in nature but rather those created by industry, such as those of gasoline and carbolic acid. The new gardens would be made of the most disparate materials, from silk and velvet to wire and celluloid, so that artists could finally express themselves with whatever means they had available.

▼ Graham Fagen,
Where the Heart Is, 2002.
Bronze sculpture.
Edinburgh, Doggerfisher
Gallery/London, Matt's
Gallery.

The hanging behind the guests creates the illusion that they are seated in a flower garden rather than in a courtyard. This device is one of the first examples of an artificial garden.

In the background, one can see a true garden with a bower whose lower section consists of a trellis with flowers, presumably roses, growing on it.

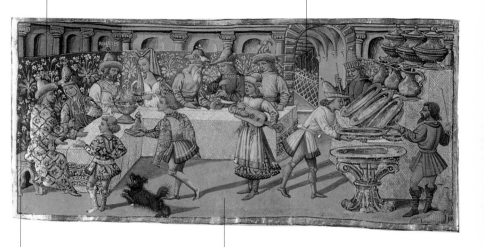

The house's inner courtyard is decked out with either a millefleur tapestry or a cloth painted to look like a garden, creating a sort of artificial, eternal spring, perhaps to lighten spirits during the winter months.

This miniature from the Virgil Codex places the banquet of Dido and Aeneas inside a typical aristocratic Renaissance dwelling.

▲ Apollonio di Giovanni, *Dido's Banquet for Aeneas*, ca. 1460, from *Virgil Codex*. Florence, Biblioteca Riccardiana.

The Artificial Garden

The Manifesto of Futurist Flora, *penned in 1924 by Fedele Azari, followed such precedents as the famous 1915 manifesto of Giacomo Balla and Fortunato Depero*, The Futurist Reconstruction of the Universe.

Expressing the will to "reconstruct the universe by cheering it up," *Balla and Depero write*, "a spring garden blown by the wind led to the concept of the Magical transformable motor-noise flower."

The "futureflower" is not a mechanization of nature, but seems conceived as an exemplar of an artificial nature serving as indoor or outdoor furnishings that are supposed to "cheer up" their surroundings (in the Futurist sense).

Balla devoted his efforts to his "futureflower" from 1918 to 1925, creating many different specimens. It is a wooden sculpture consisting of numerous flat forms assembled into a brightly colored, three-dimensional object.

▲ Giacomo Balla, *Green Blue and Azure Futurist Flower*, ca. 1920. Private collection.

Every corner of the room featured a bed adorned with splendid quilts of satin, a symbol of love.

This image shows one of the corners of the large central room, which was turned into a sort of grotto by covering the ceiling with numerous coal sacks and the floor with a thick layer of dead leaves. At the center of the installation was a tiny pond with reeds and water lilies.

At the Exposition Internationale du Surréalisme at the Galerie des Beaux-Arts in 1938, Marcel Duchamp created an installation in the gallery's large central room, into which several hallways led, creating a kind of surrealistic garden with pond.

On the one hand, the installation juxtaposes the mud of the pond with the symbolic purity of the bed; on the other, it alludes to the domestication of nature inside the home.

▲ Marcel Duchamp, *Installation in the Central Room of the Surrealist Exhibition*, 1938. Paris, Galerie des Beaux-Arts.

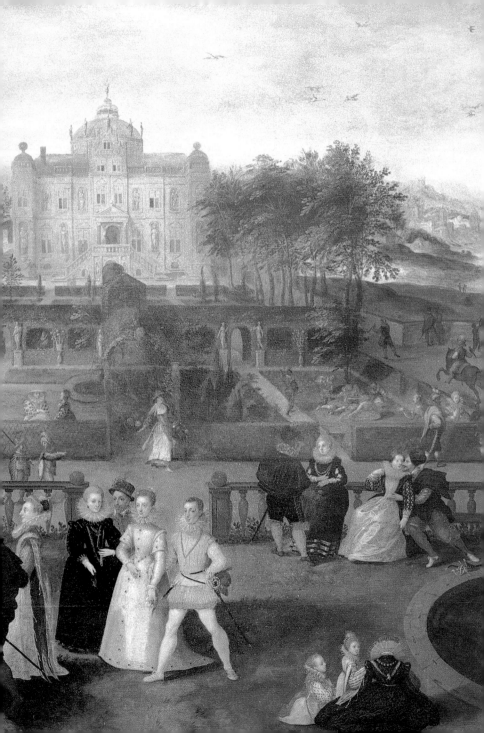

LIFE IN THE GARDEN

Everyday Life
Science in the Garden
Work in the Garden
Love in the Garden
Festivities in the Garden
Games, Sports, and Activities
Fashionable Promenades
The Portrait in the Garden
Hubert Robert's Gardens
Monet's Giverny

◄ *Party in a Palace Garden* (detail),
ca. 1610. Gaasbeck (Belgium), castle.

*A place of meditation and prayer, celebration and play, as well
as rest and memory, the garden reflects the rituals that mark the
different aspects of life.*

Everyday Life

The garden is used according to the economic, political, and
social factors in play at a specific historical period or, by exten-
sion, among a certain set of people. Initially, images of every-
day life in the garden show domestic conviviality taken
outdoors. Ever since antiquity, banquets in the garden—a privi-
lege of the upper classes, if not the king himself—have been
recorded by artists. In secular medieval and Renaissance
iconography, the garden is usually reserved for an elite, a group
of people feasting, strolling, playing, or hunting, or collectively
enacting a garden ritual. This custom attained its highest form
of expression in the vast theater that was Versailles, with its
court rituals, etiquette, and the whole idle world revolving
around the figure of the king. But in this same period, along-
side the representation of outdoor and public life, a more inti-
mate dimension began to emerge in the world of the garden,
one directly connected to the everyday life of common people.
They are depicted attending to daily chores in their own pri-
vate plots of greenery, where the simplest of ceremonies take
place. Henceforth the theme of everyday life would be treated
in a variety of original ways by different artists. An important
contribution to this tradition came from Holland, the Calvinist
country par excellence, which made clean living and moral rec-
titude its point of pride, and where, in
the absence of a royal court or aristoc-
racy, the triumphant middle class cen-
tered its life around the close affections
of one's family and the small events of
daily existence.

▼ *Ashurbanipal and His
Queen Enjoying a
Banquet*, relief from
Nineveh (Iraq), ca. 645 B.C.
London, British Museum.

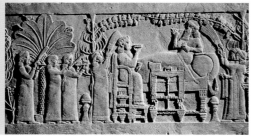

The garden fountain, fed by water flowing down from an artificial mountain, recalls the myth of Hippocrene, the spring that burst forth from Mount Helicon on the spot where Pegasus had struck his hoof on its surface.

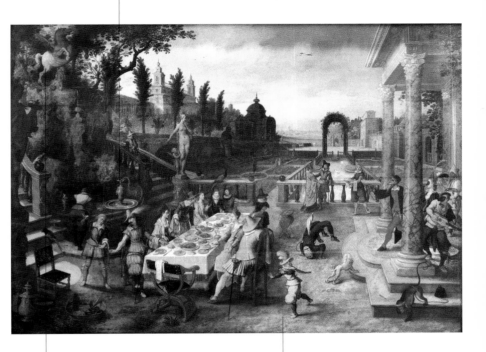

The mountain here depicted probably refers to Parnassus, the mythical abode of Apollo and Muses, while the figure of Pegasus the winged horse, above, evokes the contest between the Muses and the birth of the Hippocrene spring. The mountain's presence was supposed to elevate the garden's inhabitants into the world of music and the culture of the gods.

Dining in the garden is a custom whose roots go all the way back to antiquity. This group of nobles is portrayed at the final stages of the meal, as they are being entertained by musicians and acrobats.

The garden is alive with scenes of everyday life, reflecting a society enjoying its living space by adapting it to the social customs of the times.

▲ Sebastian Vrancx, *Luncheon in the Garden*, ca. 1600. Budapest, Gallery of Ancient Art.

In a scene seemingly suspended in time, De Hooch depicts a moment in everyday Dutch life, with its pervasive peace and quiet.

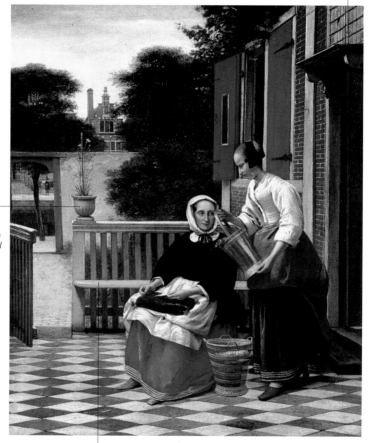

The love and appreciation of flowers that one inevitably finds in Dutch gardens is here suggested by the carefully tended pot of carnations. The trees in the background give a suggestion of a larger garden beyond.

Organized around a twofold system of enclosures, this garden suggests the hortus conclusus: *it is simple, orderly, and essential, in keeping with the rigors of the Calvinist spirit. It is a long way from the sumptuous stage sets of the Baroque.*

▲ Pieter de Hooch, *A Lady and Her Maidservant,* ca. 1660. St. Petersburg, Hermitage.

The two cherubs at the top of the pavilion are holding, respectively, a paintbrush and pen, symbols of painting and poetry, while the statue in the middle represents Fortune, balancing on a globe.

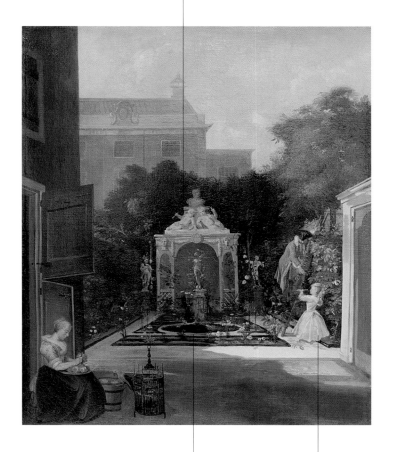

The garden includes some elements typical of the Baroque garden, such as the flower bed, statues, and pavilion, but they are on a small scale and do not evoke the overblown magnificence of its grander models. While indicating its owner's elevated social standing, everything in this garden is on a human scale.

The artist depicts a peaceful summer day inside a walled urban garden typical of upper-class houses in Amsterdam. A father is offering some fresh-picked flowers to his little daughter, while in the foreground a maidservant is cleaning cabbages.

▲ Cornelis Troost, *Amsterdam Garden*, ca. 1743. Amsterdam, Rijksmuseum.

Decorated in the Rococo style, this garden is centered around a profusion of sounds and colors. The decorations are light and frivolous, the spaces quiet and intimate.

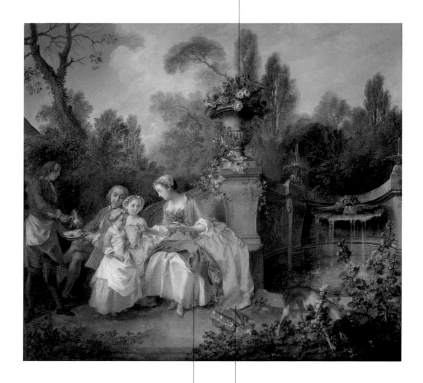

Over the course of the 18th century, the family became more independent from the social world and set aside moments in which to devote themselves to their own private lives.

Lancret depicts a typical bourgeois family about to enact the coffee ceremony in their garden. The more intimate dimensions of the Rococo garden seem to correspond to a new need for reserve, possibly stemming from a newly articulated family feeling that would eventually lead to the more private model of the modern family.

▲ Nicolas Lancret, *A Lady in a Garden Taking Coffee with Some Children*, ca. 1742. London, National Gallery.

The country garden is partly shaded by a trellis with dense grapevines climbing over it, creating a cool shelter from the summer heat.

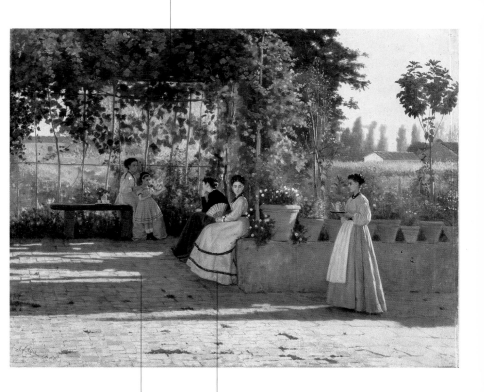

Under a pergola imbued with warm sunlight, a group of women are sitting in a placid atmosphere muted by the stillness of the afternoon sun.

In this area of light and shadow, an enchanting plot of intimate feelings is woven in the interplay between simple gestures and silent glances.

▲ Silvestro Lega, *The Pergola*, 1868.
Milan, Pinacoteca di Brera.

Medicinal plants were cultivated in the monastic gardens of the Middle Ages, but they were not given any scientific classification.

Science in the Garden

The cultivation of medicinal plants was a key component of the "doctrine of signatures," in which certain plants were thought to have curative powers for certain bodily organs on the basis of specific marks, colors, or similarities of form. Botanical gardens, autonomous places for growing and classifying indigenous as well as exotic plants for educational and research purposes, emerged in the 16th century with the rise of new fields of scientific study and a renewed interest in classifying the products of nature. Such research derived from the study of "simples," those vegetable and animal substances from which Galenic medicine drew its curative principles. The study and classification of new species by European botanists coincided with the rediscovery of the great naturalists of antiquity, such as Dioscorides, Theophrastus, and Pliny. "Scientific gardens," which first arose alongside pleasure gardens, gave rise to new methods of teaching and study at some of the most important universities of Europe: Padua and Pisa from 1545 on, but also Leyden beginning in 1587, Heidelberg and Montpellier in 1593, Oxford in 1621, and Paris in 1626. The botanical garden was

▼ *Selection of Medicinal Plants in an Herbarium,* 15th century. London, British Library.

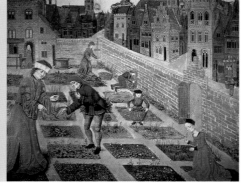

organized rationally, usually in four sectors oriented to the four cardinal points; there was sometimes a well at the center, a holdover from the medieval monastic garden, but also, obviously, of practical use in caring for the plants. The garden's geometrical form, moreover, helped in the systematic classification of plants and at the same time satisfied astrological requirements, considered fundamental at a time when the Hermetic tradition still played a prominent role in the natural sciences.

The construction of the botanical garden of Padua, the first in Europe, dates from 1545. It is circular in plan and divided into four plant beds.

▲ Plan of the botanical garden of Padua, from *Gymnasium Patavinum*, by Giacomo Tomasini (udine, 1654).

Compared to the medieval model, the Renaissance botanical garden became a "scientific garden," a place set aside for the cultivation and classification of plants for purposes of teaching and study.

The division into four parts recalls the medieval monastic garden, in which mostly medicinal plants were cultivated. These plants were classified not according to scientific principles but rather according to the "doctrine of signatures." For example, because liverworts (class Hepatopsida) resembled the human liver, they were thought to heal this organ and were classed with other hepatic aids.

Representations of the work in the garden began to appear consistently at the end of the medieval era, especially in the illustrations for the months in calendars and books of hours.

Work in the Garden

In medieval representations of the month of March, laborers are seen preparing the garden for spring: cutting grapevines and training them along trellises, and pruning and grafting plants. A rich source of iconographic documentation of garden work are the many illustrated editions of the *Liber ruralium commodorum*, a manual of agronomic and gardening techniques written by Pietro de' Crescenzi around 1300. This book enjoyed great success all over Europe and for a long time remained the sole reference book for the art of gardening. A particularly demanding garden, because of the complex and onerous maintenance required, was the Baroque garden. One had to keep the avenues and open spaces clear of vegetation by creating compact volumes of greenery around the boundaries of the wooded areas, which had to be assiduously contained. In paintings of Baroque gardens, it is not uncommon to see gardeners busy at work as the ladies and gentlemen stroll by, and indeed this must have been a normal occurrence. Other depictions of work in the garden have an underlying allegorical meaning, which sometimes relates to the "cultivation" of particular intellectual interests or moral inclinations. This tradition probably derives from classical writers, particularly Virgil, who saw the values that derived from agrarian life as the only ones enabling man to live a life of serenity and moral rectitude.

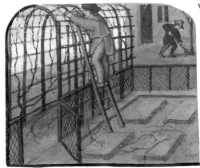

▶ *March: Repairing the Arbor*, from *Livre d'heures à l'usage de Rome*, ca. 1515. Rouen, Bibliothèque Municipal.

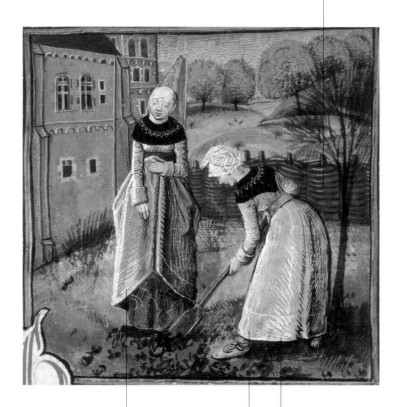

Around 1400, Christine de Pisan wrote The Book of the City of Ladies, *a sort of utopian vision in which Rectitude, Reason, and Justice assign the author the task of erecting an impregnable city for illustrious women.*

▲ Master of Margaret of York, *Clearing the Field of Letters,* miniature from *The Book of the City of Ladies,* by Christine de Pisan (ca. 1475). London, British Library.

Women are seldom shown at work in the garden, although we know that they sometimes did the heaviest work and were paid by the day.

The illustration depicts the moment when Lady Reason exhorts Christine de Pisan to leave for the Field of Letters, the rich, fertile land where the City of Ladies will be founded: "Take the shovel of your intelligence and dig deep." The enclosed garden becomes a symbol for Christine de Pisan's task, as she digs the Garden of Letters with her spade.

Work in the Garden

This painting illustrates the work done in Dutch gardens in winter and is precious documentation of the structure of a typical northern garden and the different sorts of maintenance it required.

The climbing plants are being trained along the pergola so that they will form a green vault overhead, supported by caryatids.

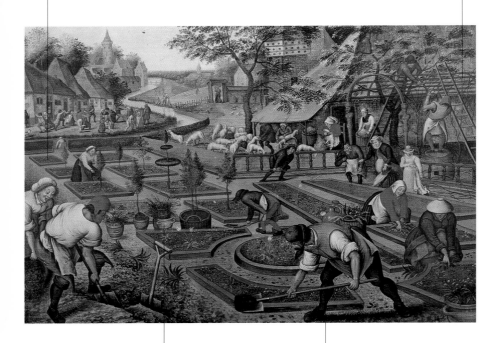

Less hardy plants that were taken indoors during the winter months are brought outside to decorate the garden. The garden is carefully fenced to keep out the livestock.

The men in the foreground are digging the flower beds, while a few women plant bulbs that will soon produce flowers.

▲ Pieter Bruegel the Elder, *Spring*, before 1570. Bucharest, National Museum of Art.

The woman's melancholy expression reflects her sad lot. Married at age fourteen, the Duchess of Chaulnes was rejected by her husband before the marriage could be consummated. From then on she habitually wore white, symbolizing the purity she maintained for her entire life.

The high wall of perfectly pruned vegetation is broken by what may be the entrance to a labyrinth or grove.

The duchess is portrayed in the guise of a country maiden, a fashion started by Marie Antoinette and common among French noblewomen.

Tidying up the ground along a path in the garden, Marie is probably posing during some social event at the Parisian court of the duc d'Orléans, where Carmontelle, the master of ceremonies, customarily entertained guests by painting their portraits.

▲ Louis de Carmontelle, *The Duchess of Chaulnes as a Gardener in an Allée*, 1771. Watercolor and gouache on paper. Los Angeles, J. Paul Getty Museum.

Work in the Garden

The space in a Baroque garden is extremely orderly. The growth of the hedges and trees is kept in check by constant trimming.

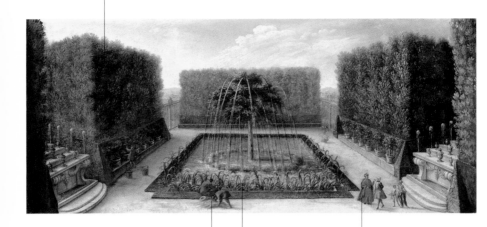

Two gardeners in the foreground work on the reeds of an artificial pond, while another tends to the potted citrus trees.

On a little island in the middle of an artificial pond in the Marais grove, Madame de Montespan, the favorite of Louis XIV, had an oak tree installed with artificial birds among its branches. From the birds sprang jets of water symbolizing the four elements, earth, air, fire, and water.

The group of nobles does not appear troubled to see gardeners at work in the garden because the arduous, ongoing maintenance of a Baroque garden was a strict necessity.

▲ French school, *The Marais Grove in the Garden of Versailles*. Versailles, Musée des Châteaux de Versailles et de Trianon.

The garden, which has shed its medieval symbolic meanings over the centuries, now has a more prosaic purpose: the cultivation of vegetables and fruit trees.

Plants are irrigated by hand using watering cans that scatter the water like gentle raindrops. The spare palette used in this painting emphasizes the pragmatic, efficient work of the gardeners.

The most fragile plants are sometimes protected by glass bell jars, which protect them from cold, wind, and the rays of the sun.

▲ Gustave Caillebotte, *The Gardeners*, 1875–90. Private collection.

Love is considered the highest form of happiness. To sing its praises, the medieval authors, still conditioned by biblical culture, cited Genesis and the Song of Solomon.

Love in the Garden

Related Entries
Secular Gardens; *Le Roman de la Rose*

A direct descendant of the biblical *hortus conclusus*, the garden of love is a place of happiness and seduction where perfect harmony reigns between man and nature. According to the medieval courtly tradition, Eden symbolizes the springtime of the world, the season when all is reborn and returns to a new life. Spring brings hope and is thus directly linked to the notion of Earthly Paradise. The celebration of the season, dating back at least as far as the Song of Solomon, became a common literary motif in the Middle Ages and found its loftiest expression in *Le Roman de la Rose*. In pictures of the garden of love, amorous couples stroll together or sit on the ground against backgrounds that appear to be faithful renderings of real gardens. The fundamental difference between the garden of Eden and the garden of love is that lovers can freely enjoy the garden's fruits without violating any prohibitions for which the punishment is death. In the garden of love, we no longer encounter the theme of obedience and disobedience. Rather, lovers may revel in the company of others and enjoy the pleasures of the table, which predispose them to amorous propositions. Musicians sometimes appear to entertain the lovers, who in turn might engage in the pleasures of playing a psaltery or viol. There is often a fountain in the garden, an allusion to the fountain of youth.

▼ Jean-Antoine Watteau, *The Pleasures of Love*, ca. 1719. Dresden, Gemäldegalerie.

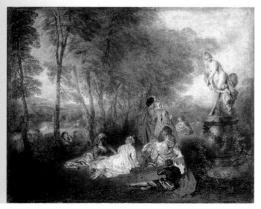

The scene takes place in a typical medieval garden, which is enclosed by a wooden palisade and enlivened by a fountain.

The illustration for the sixth commandment, "Thou shalt not commit adultery," is set in a garden of love, where couples devote themselves to amorous pleasures under the satisfied gaze of the tempting devil.

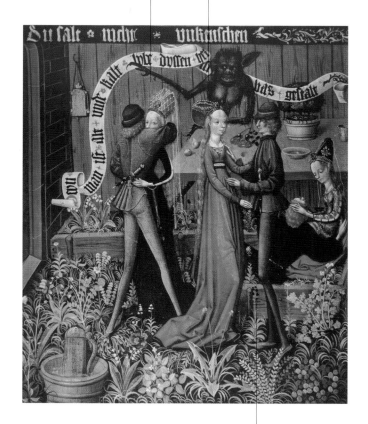

In northern countries, garden benches were often made of wood rather than brick. The frame was then filled with earth and seeded with grass and flowers on top.

▲ Danzig Master, *Thou Shalt Not Commit Adultery, Sixth Commandment*, 1490. Warsaw, Muzeum Narodowe.

Love in the Garden

In the garden of pleasure the lover finds youths engaged in amusements typical of the garden of love: playing music, dancing, talking, weaving garlands of flowers, or simply strolling.

The garden is divided into two parts by a typical wooden fence with lozenge-shaped latticework.

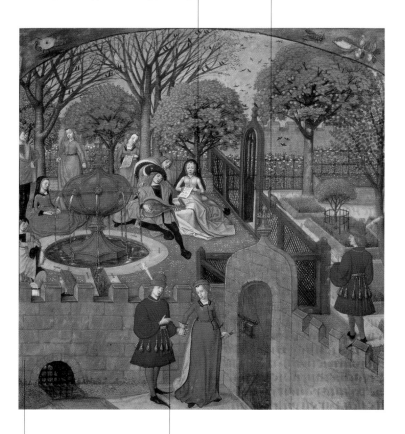

The garden that the protagonist of Le Roman de la Rose is entering displays all the typical features of a medieval garden: a high, impenetrable wall encircling a closed garden with plants and flowers of different species, and a fountain.

The narrator is welcomed into the garden by an idle lady. The imposing crenellated wall establishes a clear separation between the garden and the world outside.

▲ Bruges Master, *Image of the Garden of Pleasure*, miniature from *Le Roman de la Rose*, ca. 1495. London, British Library.

The theme of the fountain of youth is directly connected with that of courtly love and the garden of love. It is a kind of "courtly adaptation" of the religious motif of the fountain of life.

The fountain bestows renewed youth, and thus the possibility of love, upon elderly people. Its physical structure derives from images of the font of life in the garden of Eden, and its high walls recall the hortus conclusus.

In the foreground, the elderly are brought to the fountain, from which they emerge rejuvenated and full of vigor.

The newly rejuvenated cast off the clothing they wore before bathing in the fountain and don elegant costumes adorned with flowers and leaves to celebrate the return of spring and their newfound love. This costume recalls that worn by the god of love in Le Roman de la Rose, whose clothing is made out of flowers.

▲ The Fountain of Youth, tapestry, 1430–40. Colmar, Musée d'Unterlinden.

In Le Roman de la Rose, *the fountain of Narcissus's demise is turned into a fountain of love with unusual powers.*

The millefleur tapestry, with its many animals, evokes an image of Earthly Paradise. It re-creates the blooming Paradise belonging to the god of love found in courtly literature. There, spring reigns eternally.

Bringing the myth of Narcissus into the garden of love, the author alludes to the Metamorphoses *of Ovid, creating continuity between ancient literature and the garden of courtly love.*

After entering the garden of love, the protagonist of Le Roman de la Rose *approaches a fountain bearing an inscription recalling the death of Narcissus. At the bottom of the fountain is a magic crystal that has the power to make one fall in love. Looking through the crystal, the protagonist sees a rosebush covered with buds and falls in love with it.*

▲ French or Franco-Flemish tapestry workshop, *Narcissus*, ca. 1480–1520. Boston, Museum of Fine Arts.

The architectural structure in the background could be a temple of love: inside the edifice is a sculpture of the three Graces, handmaidens of Venus.

The burning torch alludes to the fire of love.

Venus presides over the scene from a fountain above, putting the human souls in a state of intoxicating passion.

Rubens painted this work after his marriage to Hélène Fourment, to express his personal happiness. The artist and his wife in fact appear in the painting among the figures in the garden of love.

The sensuality of the gestures and embracing bodies is amplified by the vivid colors of the subjects' clothing.

▲ Peter Paul Rubens, *The Garden of Love*, ca. 1633. Madrid, Prado.

Love in the Garden

Young couples flirt or listen to music against the background of a typical Dutch garden, which is divided symmetrically with geometric precision and has a fountain in the middle.

In Holland, the house was often off-center with respect to the garden and was sometimes hidden by vegetation, creating secluded, intimate environments.

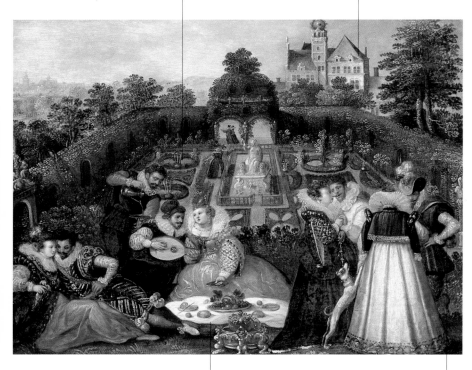

The table is still set and we see leftovers of what was probably a sumptuous feast.

A green arcade covered by dense vegetation runs around the entire garden, culminating in an original structure of greenery with two arches upheld by caryatids.

▲ Joos van Cleve, *Reception in a Garden*, first half of 16th century. Private collection.

Water pours from the fountain in which Cupid has dipped his arrows. The young couple drink from it and fall hopelessly in love.

This representation of the garden of love, an allegory of nature and the ways of love, revolves around the image of the fountain.

In the middle of a lush garden, an anxious young man and woman lunge toward a fountain, where a cherub offers them a golden cup to drink from.

▲ Jean-Honoré Fragonard, *The Fountain of Love*, ca. 1785. Los Angeles, J. Paul Getty Museum.

Love in the Garden

Even Van Gogh used the theme of the garden of love, a motif that was still relevant at the time. In fact, he spoke of this work as "the painting of a garden with young lovers."

The artist himself underscored that this garden represents a modern version of a garden of love, probably inspired by Watteau's fêtes galantes, which Van Gogh knew well.

The trees in the garden are planted in orderly fashion, creating a static composition interrupted by the snaking path, whose twisting form enlivens the whole.

▲ Vincent van Gogh, *The Voyer d'Argensons Park at Asnière.* Amsterdam, Van Gogh Museum.

The garden is the ideal environment for feasts, celebrations, tournaments, jousts, and superb banquets, as well as fireworks displays and theatrical and operatic productions.

Festivities in the Garden

The owners of the great gardens of Europe had many occasions for holding parties, oftentimes celebrating or solemnizing political events such as the birth or marriage of a sovereign, the arrival of a foreign dignitary, or the sealing of important political alliances. By using theatrical stage sets, it was possible to organize the garden space for many diverse purposes. In open-air banquets, for example, the garden served as the natural framework for the feast, assuming a primary role. During such receptions, the garden was transformed by artful decoration, with ephemeral architectural structures. These decorations might include sumptuous arrangements of flowers, fruits, and leaves posing as arbors and pavilions of vegetation. Greenery was even used to create the backdrops for theatrical productions, which were very popular among Italian courts from the 16th century onward. What mattered most at such garden parties, especially in the Baroque era, was the grandeur of the scenery, its magnificence and ostentation. Certain expedients were deployed to arouse the emotions and wonderment of the spectator. At nocturnal festivities, the most important element was lighting, upon which the dazzling effect of the whole spectacle depended. Through the artful use of lights and fireworks, the revelers' attention could be drawn by sudden glimpses of distant perspectives or nearby architectural constructions. Grand parties were *instrumentum regni*, requisite displays of the sovereign's wealth and power, tools of foreign policy, and an excellent means of establishing one's position.

▼ Brussels tapestry workshop, *Arras of Catherine de' Medici Banquet for the Polish Ambassadors*, 1582–85. Florence, Uffizi.

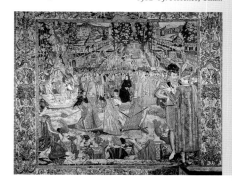

Festivities in the Garden

This painting is an enigma. Some have thought that it represents Philip the Good, Duke of Burgundy, and his court banqueting at the famous park of the castle of Hesdin, which was destroyed by Charles V's army in 1553.

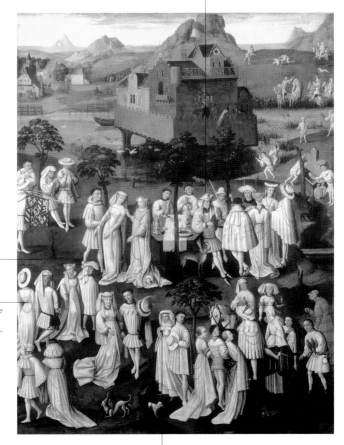

The park of Hesdin, the Duke of Burgundy's favorite, was an important model for the gardens of northern Europe. Inspired by Islamic gardens, it was famous for its fountains, automatons, and ornamental waterworks. A vast forest in which a great many species of birds lived and bred, the park was structured much like the later English landscape gardens.

Broken up into small groups, the elegantly dressed nobles engage in typical courtly activities: hunting, singing, dancing, strolling, and dining.

▲ French school, *Country Fête at the Court of Philip the Good in the Park at Hesdin*, ca. 1550. Versailles, Musée des Châteaux de Versailles et de Trianon.

From the red carnation, symbol of marital fidelity, held by the woman in the foreground, some infer that the painting depicts a wedding feast, possibly the nuptials of André de Toulegnon, squire of Philip the Good, and Jacqueline de Trémoille, a lady-in-waiting of the duchess, in 1431.

258

The park is enveloped in a mass of overgrown trees and shrubs, which by this time have almost completely lost their former geometrical shapes. This vegetation creates a unified whole and strong cohesion among the natural elements, the architectural structures, and the water spouting from the fountain, which seems to blend into the clouds in the sky.

Toward the end of the 18th century, some of the royal parks in Paris were opened to the public.

People crowd around the stages and tents of the acrobats, jugglers, and clowns, who were brought into the park for the festivities.

▲ Jean-Honoré Fragonard, *Festivities at Saint-Cloud*, 1775. Paris, Banque de France.

*This island estate on the Arno River in Florence, better known as the Parco delle Cascine because of its farms (*cascina *means "dairy farm"), was conceived as a predominantly wild agrarian space where the only building was the hunting lodge. It was erected by Giuseppe Manetti in 1786 at the behest of Grand Duke Leopold and intended for use by his family. The Cascine became a public park in the second half of the 19th century, in accordance with the wishes of Grand Duchess Elisa.*

▲ Giuseppe Maria Terreni, *Celebration in the Cascine in Honor of Ferdinand III: Games in the Meadow of the Great Oak,* late 18th century. Florence, Museo Storico Topografico, "Firenze Com'era."

A great celebration was held on July 3–5, 1791, to commemorate the accession of Ferdinand III of Lorraine to the throne.

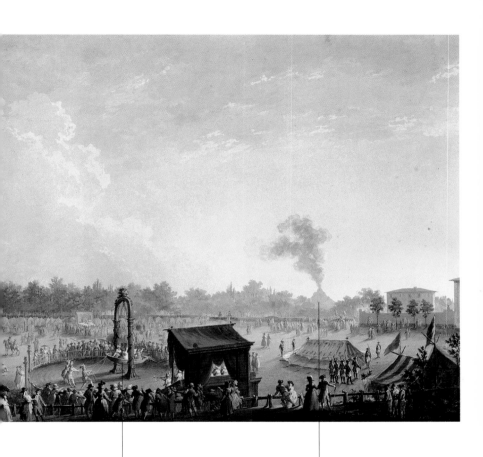

The park had areas designated for every sort of game and amusement. In the Park of the Lodge, a great boat-shaped swing was set up, as well as a stage for acrobats and performers. Many Oriental-style pavilions adorn the surroundings.

A machine in the shape of Vesuvius was also created. It spewed smoke during the day, as if it were about to erupt. At night, fireworks shot out of its crater, lighting up the sky until it was as bright as day.

▲ Alessandro Magnasco, *Reception
in a Garden in Albaro*, ca. 1720.
Genoa, Palazzo Bianco.

*This image of the garden
and the people in it por-
trays an aristocratic world
already in decline.*

A boater on a tiny lake evokes an image of Watteau's pilgrimage to the island of Cythera.

The potted flowers are supported by frames upon which they grow.

Noble ladies in crisp silk dresses take pleasure in conversing and strolling, while priests and bored gentlemen play cards or lie back in their chairs, as though fatigued.

Garden parties were also held in the more restrained ambience of aristocratic society, in which it was customary to organize open-air receptions at the various country houses.

Once designed exclusively for the pastimes of the aristocracy, the garden became a place for everyone's recreation and amusement from the late 18th century on.

Games, Sports, and Activities

Related Entries
The Public Park in Paris;
The Public Park in
London; Fashionable
Promenades

Aside from serving as a charming environment for parties and amorous encounters, the garden was also the appointed place for sports and athletic activities. Hunting, for example, was a favorite pastime of the nobility since ancient times. It was practiced mostly in artificial "wildernesses," groves created to accentuate the wild look of the place and serve as breeding grounds for game. Because of this passion for the hunt, it became common practice to build country houses in parks. Later a great many suburban and rural gardens sprouted up within these parks. Sport was exclusively an aristocratic pastime until the Industrial Revolution, when working people started to have both leisure time and a desire for physical activity. The development of sport and leisure activities paralleled the birth and growth of public parks in the great European cities, Paris first and foremost. One could enjoy many forms of recreation in parks, from concerts and balls to bicycle excursions, carefree hours spent escaping from the problems of everyday life. The splendid canvases of the Impressionist painters bear witness to these new pursuits. Many city planners in the 19th century also believed that recreation and amusement in the great outdoors would allow for greater social control and prevent the emergence of revolutionary discontent.

▶ Jacques de Celloles,
Archery Contest, ca. 1480.
Paris, Bibliothèque
Nationale.

*The boy pulls his hat over his
eyes to keep from seeing.*

*The garden is enclosed by a
bower of roses, beyond which
one glimpses a possible exit.*

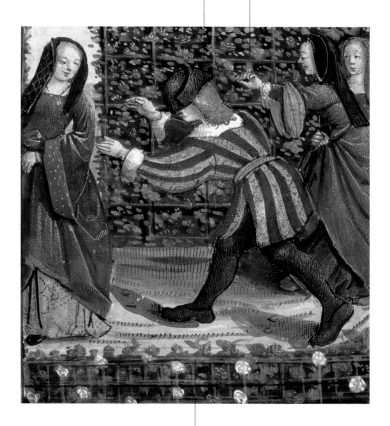

*One of the nobility's favorite games
was blindman's buff, which could
even assume symbolic meaning: as a
warning against the dangers of love,
for example.*

▲ *The Game of Blindman's Buff*, minia-
ture from a collection of French love
poems by Pierre Sala, early 16th century.
London, British Library.

265

The tall hedge surrounding the tennis court makes the space a kind of enclosed garden, with the ball court being a modern garden of love.

An image of bourgeois recreation in a park, the tennis game is depicted here with an expressive spontaneity typical of Impressionism.

▲ Sir John Lavery, *The Tennis Party*, 1885. Scotland, Aberdeen Art Gallery and Museums.

The couples playing tennis confront each other face-to-face, as if the game were an allegory for the game of love.

Invented in England in the 19th century, the game of tennis is thought to have derived from the ancient French jeu de paume.

Games, Sports, and Activities

A classic formal Dutch garden, with flower beds and statues and intricately shaped fountains, fans out in front of an imaginary palace.

Sports were generally practiced outdoors. Here, the players are using an allée normally intended for strolling.

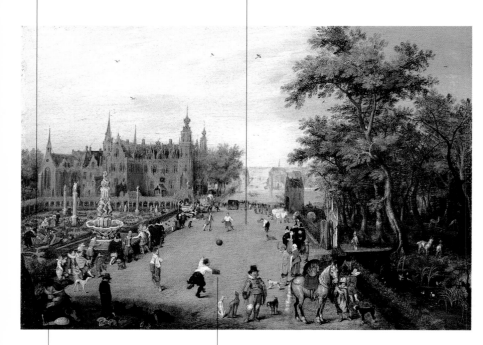

In what is perhaps an allusion to the garden of love, a couple sits near a tree, next to some clothing left on the ground by the ballplayers. Beside them is a lute, a common attribute of lovers.

The jeu de paume, or handball, was a direct forebear of the game of tennis. It involved propelling a wooden or leather ball back and forth across a long court with the help of a leather glove, which deadened the force of the blows.

▲ Adriaen van de Venne, *A Jeu de Paume before a Country Palace*, 1614. Los Angeles, J. Paul Getty Museum.

The statue of a cherub on a pedestal looks on with something like amusement. His gesture beckons us to silence, underscoring the secrecy of furtive love.

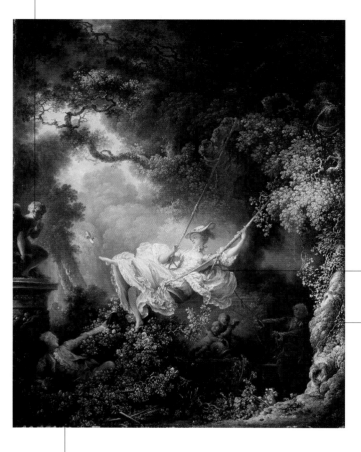

The woman spots her lover from above and coquettishly lets her slipper fly, so that her secret lover can pick it up.

In the Rococo garden, the spaces become more secluded, the decorative elements lighter and more frivolous.

The painting depicts, in a garden setting, a typical love triangle: the lover, hidden among the flowers, furtively watches his beloved on a swing as she is pushed from behind by her husband.

▲ Jean-Honoré Fragonard, *The Swing*, 1767. London, Wallace Collection.

Games, Sports, and Activities

During the reign of Napoleon III,
concerts were held twice a week in
the Tuileries, a garden popular among
fashionable Parisians.

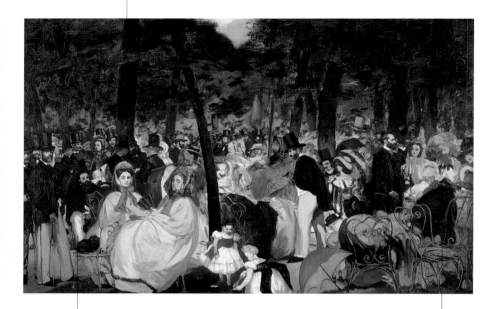

In the Tuileries, one could easily
encounter the most prominent
members of Parisian society.
Here we recognize likenesses of
the painter himself and a number
of his acquaintances and friends.

The artist provides an
original slice of modern
city life, as a band plays
on and a crowd gathers
to listen.

▲ Édouard Manet, *Music in the
Tuileries Gardens*, 1860. London,
National Gallery.

The introduction of green spaces into the cities over the course of the 19th century was closely connected to the urban restructuring made necessary by the great influx of people following the start of the Industrial Revolution.

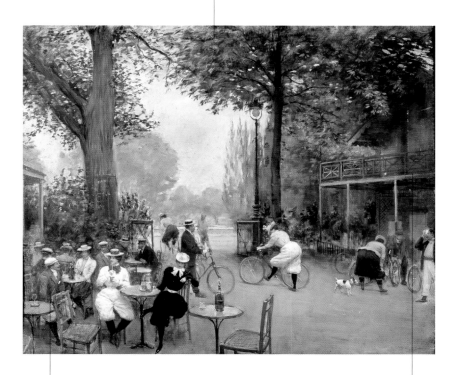

Napoleon III understood that by establishing a green oasis in the center of Paris, he was not only creating a place for recreation but giving form to certain political notions. The park was envisioned in part as a tool for controlling the masses, since it created a legitimate escape from the everyday tensions of urban life, and as such was supposed to dampen revolutionary tendencies.

A botanical garden and numerous pavilions and chalets were set up in the Bois de Boulogne. At the center of the vast park is the Pré Catelan, a vast open space housing various pavilions designed for entertainment and exhibitions.

▲ Jean Béraud, *The Bicycle Chalet in the Bois de Boulogne*, ca. 1900. Paris, Musée Carnavalet.

The fashion of strolling in the public park or riding in one's carriage down tree-lined avenues, the future boulevards, persisted, especially in France, up until the early 20th century.

Fashionable Promenades

The recreational ritual of the promenade first emerged in the context of 18th-century high society, where customs were subject to strict rules and conventions dictated by fashion. Thus strolling, too, became a way to display oneself and one's fashions, to see and be seen. In Paris, the habit of urban strolling, imported from Italy by Marie de' Medici in the early 1600s, was turned into a purely social *divertissement*, unfolding along the *grands boulevards* and in the parks, and allowing the different social classes to mingle. The newspapers of the age describe the sometimes bizarre behavior of certain representatives of high society, who would strut and pose along the great tree-lined avenues. Those seeking more placid amusement would go instead to the capital's older public gardens, newly refurbished, such as the Tuileries, the Luxembourg Gardens, or Palais-Royal. The fashion of the promenade even spread to London, especially to St. James Park, a smart place originally intended for informal encounters among members of the upper classes, where one had to pay a fee to enter. Toward the end of the 18th century, strolling in the park became a more open, less class-specific affair, an opportunity to parade the most eccentric and extravagant of the latest fashions.

The adoption of the French term *promenade* became general. English "pleasure gardens," where one had to pay to gain entry, provided a different way of using green spaces in the city. Here one could listen to music and dance, watch a theatrical production, or simply amble down the cool, tree-lined lanes. The English model was soon exported and spread successfully over all of Europe.

▼ Canaletto, *View of the Grand Walk in Vauxhall Gardens in London,* ca. 1751. Private collection.

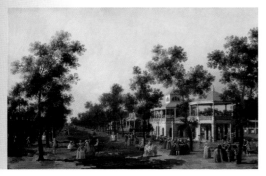

French high society and members of the nobility are portrayed ambling under the chestnut trees, whose boughs are trimmed to form arches.

The dense crowd walking through the intersection of two garden paths contrasts with the airy foliage of the trees. One path seems to dissolve in the distance, as the throng blocks our view of it.

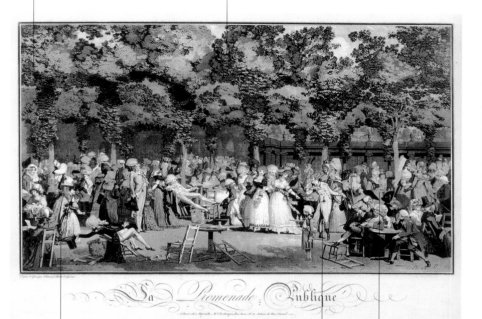

This image both satirizes the people who stroll to show off their garish clothing and mocks these fashionable parades.

Among the crowd are dandies languidly draped in chairs, amusedly observing the people going by or blowing kisses to coquettish ladies.

The crowd in the foreground passes before the observer's eyes like actors on a stage.

▲ Louis-Philibert Debucourt, *A Public Promenade*, 1792. Minneapolis Institute of Arts.

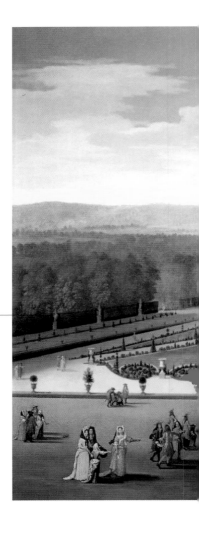

The garden is designed to create a delicate balance between the
woods, whose growth is contained by means of treillages and
high walls of vegetation, and the great perspectival axes, which
are kept clean and unencumbered. The relationship between the
two environments, which must remain separate, is not one of
dominance or submission (the wood is forced into geometrical
shapes), but a "dialectical contrast" whose final product is a
garden that thrives on the opposition between the masses of the
woods and the voids of the perspectival spaces.

▶ Etienne Allegrain, *Promenade of
Louis XIV in the Gardens of Versailles*,
ca. 1680. Musée des Châteaux de
Versailles et de Trianon.

Versailles is the product of two different, alternating scales of planning that define the garden's forms. On the one hand, there is the sumptuous stage reserved for strolling and court ceremonials; on the other, the more intimate dimension of the secluded groves, in which one may entertain and converse with friends.

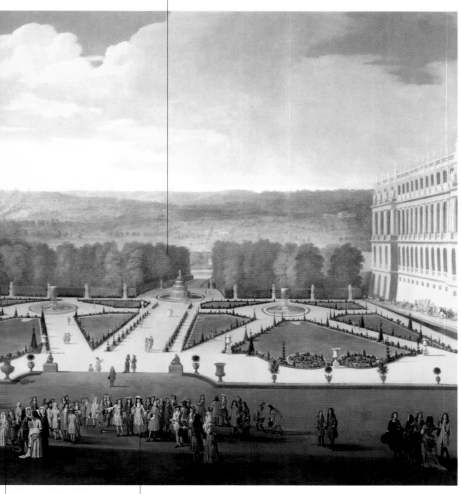

The court of Versailles was perhaps one of the most famous "windows" in which one could put oneself on display, wearing fashionable, flashy clothes in order to attract the king's attention.

Louis XIV himself chose the path of his daily walk, a veritable ceremony in which the king would attend to his many affairs, even private ones.

A girl coquettishly holds out her hand so the young man can help keep her from falling at a difficult point along the path.

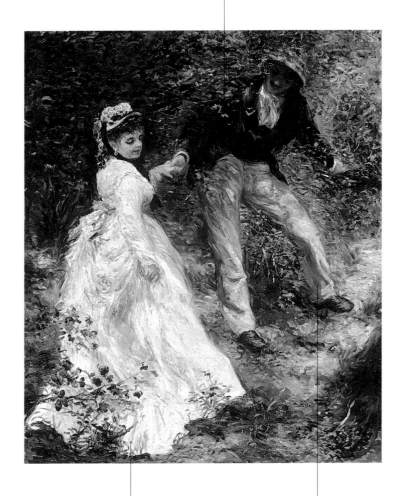

▲ Pierre-Auguste Renoir, *La Promenade*, 1879. Los Angeles, J. Paul Getty Museum.

Drawing inspiration from the sensual garden promenades portrayed in the paintings of Watteau and Fragonard, Renoir depicts a scene of the Parisian middle class, catching a fleeting moment in the life of two young people in a park.

Filtering through the dense vegetation, the sunlight shimmers all around in a magical play of reflections.

The Luxembourg garden, created at the behest of Marie de'
Medici, was later redesigned by Le Nôtre and underwent still fur-
ther transformations in the 19th century, when Haussman's urban
plans required that room be made for the boulevards.

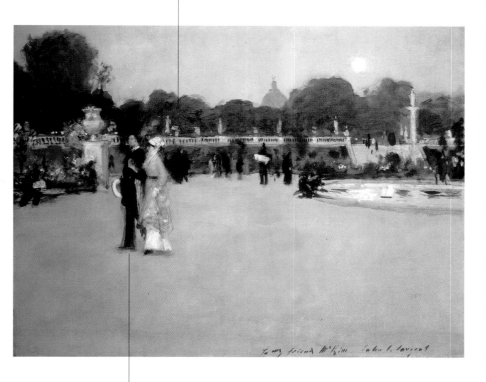

Sargent portrays a bourgeois
Parisian couple strolling at sunset,
in the peace and quiet of the gar-
den, far from the clamor and con-
fusion of the grands boulevards.

▲ John Singer Sargent, *The Luxembourg
Gardens at Twilight*, 1879. Minneapolis
Institute of Arts.

Though well represented in the Flemish tradition from the 17th century onward, the custom of painting portraits in gardens was most widespread in England.

The Portrait in the Garden

The garden in the background of a portrait—commonly seen in this genre since the 17th century—should not be interpreted as mere backdrop. Rather, it is an integral part of the message the portrait wishes to express. It can be read both in a documentary light, as depicting a certain garden typology existing at a given point in time, and in a symbolic light, as a reflection of the sitter's personality. Usually the elements in the garden reflect the virtues of the person portrayed, and the garden itself, taken as a whole, will highlight his or her social and cultural standing, lineage, or some fundamental moment in the individual's life, providing, at the same time, an image of the person's magnificent estate. Sometimes a plant may appear as a symbol of the person's passion for a certain species of exotic plant, or simply to underscore the subject's interest in botany. The garden in the background may also express the sitter's manner of relating to nature. According to some scholars, for example, the broad landscapes or distant mountains that figure in the background of certain Italian Renaissance portraits may allude to the fact that such sights were supposed to lift man above his daily preoccupations.

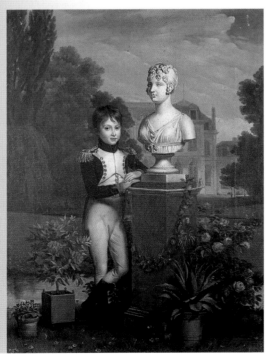

▼ Benjamin de Rolland, *Lucien Murat in the Garden of the Royal Palace in Naples*, 1811. Caserta, Palazzo Reale.

The villa has an Italian garden in front, with uniform plant beds and a fountain in the middle.

Within the garden, there is another "green environment" surrounded by a hedgerow, inside of which we can see a bed of tulips, costly flowers that were very much in demand in 17th-century Holland.

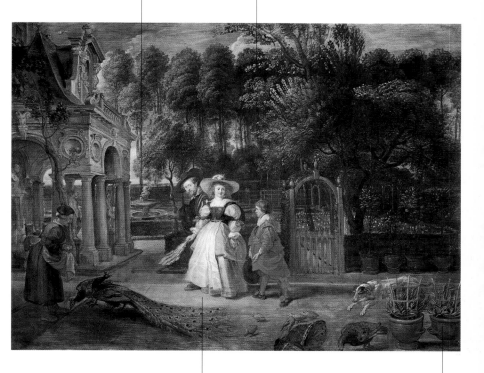

Rubens portrays himself in the company of his wife, Hélène Fourment, and their son, in the garden that reflects the high social standing he had attained.

The garden has its share of potted plants, including citrus trees, which were placed in greenhouses in the cold months, and flowers supported by frames. We also see exotic animals, such as turkeys, which were imported from America.

▲ Peter Paul Rubens, *The Artist with His Wife Hélène Fourment in the Garden*, ca. 1631. Munich, Alte Pinakothek.

The painting celebrates the nobleman's passage to a new, religious life.

The man stands with his back to his previous life, represented by the books, papers, and violin, and the family crest on the window pane. He is now turned toward the enclosed garden before him.

The image of the garden, a hortus conclusus, *represents the Church and stands in contrast with the wilderness of the pagan world, represented by the classical ruins in the distance.*

▲ English school, *Portrait of William Style of Langley*, 1636. London, Tate Gallery.

The globe with the heart in flames and the motto above it signify that the human heart, unable to find satisfaction in worldly matters alone, burns with love for the spiritual life and for God.

The garden is a precious place, laboriously reclaimed from the sea, where the Dutch people's beloved flowers, here represented by the rosebush, can grow in peace.

The entrance to the house is marked by a small bower, to which the nearly bare stems of a climbing plant cling for support.

The family is portrayed inside their urban garden, in which we see elements typical of the Dutch garden.

The clean pavement of the garden and the crisp simplicity of the family's garments reflect the ideals of a temperate, morally upright society that was also open and tolerant, and rewarded risky commercial ventures with the placid comforts of everyday existence.

▲ Pieter de Hooch, *A Dutch Family*, ca. 1662. Vienna, Akademie der Bildenden Künste.

The figure of the woman stands out against the dense foliage of trees, behind which we glimpse the countess's sprawling domains. They seem to reach all the way to the horizon, allowing us to appreciate the extent of her wealth.

▲ Thomas Gainsborough, *Portrait of Anne, Countess of Chesterfield*, 1777–78. Los Angeles, J. Paul Getty Museum.

Anne Thistlewaite, Countess of Chesterfield, is portrayed seated and leaning against the stone balustrade of a terrace, as we can see by the stairway leading down to the garden in the background.

An ancient vase, with untamed roses growing inside it, serves as an ornament in the garden.

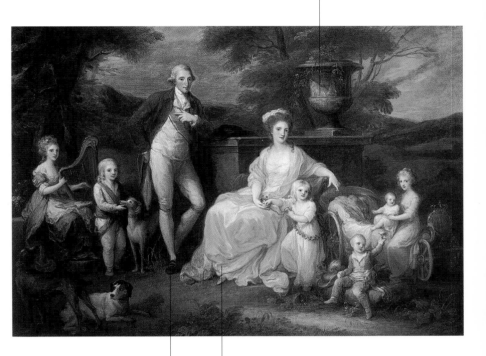

The composition derives from the classic model of the "conversation pieces," that is, group portraits in unofficial attire with a garden or landscape in the background. The genre originated in the early Rococo period in the Netherlands and France, from whence it spread all over Europe.

The artist portrays the royal family in the informal setting of their garden, focusing on their simple gestures and natural poses, far removed from the rigid etiquette of the court.

▲ Angelica Kauffmann, Model for the Portrait of the Royal Family of Naples, 1783. Vaduz, Sammlungen des Fürsten von Liechtenstein.

In the waning years of the 18th century, the garden was becoming a place of reminiscence and melancholy.

Exhibited at the Salon of 1799, this painting was called by critics "Sablet's painting of a woman adoring the bust of her daughter."

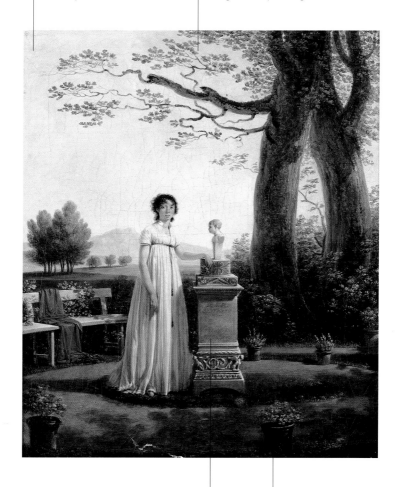

▲ Jacques Henri Sablet, *Portrait of Christine Boyer*, ca. 1798. Ajaccio, Musée Fech.

Christine Boyer, first wife of Lucien Bonaparte, stands beside the bust of her little girl, Victoire Gertrude, whom she lost in 1797. The cenotaph bears the words "I shall see her again."

A series of potted flowers arranged in a circle around the commemorative stele define the area as devoted to remembrance and reflection, as if it were a sacred, inviolable space.

The painting shows Lucien partly in shadow and the ancient trees darkening and nearly obscuring the surrounding landscape. This composition has led some to infer that when it was painted his wife Christine had already met her death (1801). The double portrait would thus have been made as a memento mori.

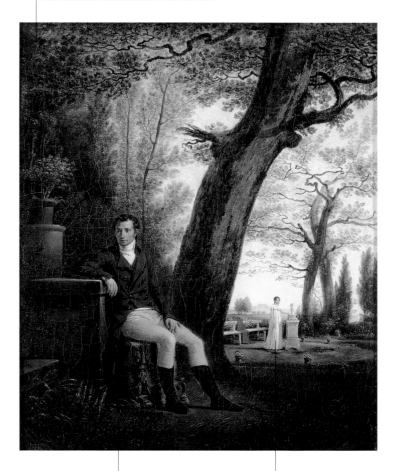

▲ Jacques Henri Sablet, *Portrait of Lucien Bonaparte*, ca. 1800. Ajaccio, Musée Fech.

Sitting in the shadow of a large tree, Lucien Bonaparte assumes a melancholy attitude.

The artist faithfully reproduced his portrait of Christine Boyer standing beside the bust of her deceased child and inserted it in the background of the garden, creating the fascinating effect of a painting within a painting and at the same time evoking a sense of memory.

The Portrait in the Garden

*As mythological references fell out of favor
in the age of Romanticism, moral and aes-
thetic concepts were given concrete form.
Buildings were erected to represent such
things as friendship, love, and melancholy.*

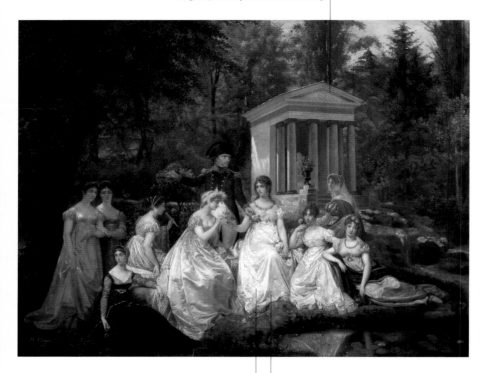

*After their divorce in 1809,
Napoleon gave Josephine the entire
estate of Malmaison, which was
inherited by her son, Eugene, after
her death. Eugene, however, sold
Malmaison to the Swedish banker
Jonas Hagerman in 1828.*

*Josephine is portrayed together
with her court and Napoleon
on the shores of the lake at
Malmaison. The empress is
holding some roses, the pride
of her garden, which contained
some 250 varieties of the flower.*

▲ Jean Louis Victor Viger, *The Rose of
Malmaison*, ca. 1866. Rueil-Malmaison,
Musée National des Châteaux de
Malmaison et Bois-Préau.

Hubert Robert, one of the most celebrated French landscape painters of the 18th century, also designed gardens at a time when the style of the painterly garden began to spread in France.

Hubert Robert's Gardens

From 1754 to 1765, Hubert Robert lived in Rome, where he studied archaeological ruins and Renaissance monuments and visited some of the finest Italian gardens. When he returned to his native France, he was named the personal painter of Louis XVI and, after creating the Baths of Apollo, the "designer of the king's gardens." He then collaborated on the design of the Petit Trianon gardens for Queen Marie Antoinette and worked on Thévenin's splendid Laiterie, whose architectural features harked back to Cicero's Amaltheum in Arpino. Robert also did work for private individuals, both noble collectors of paintings and garden lovers. Of particular note was the design for the park at Méréville (1786–90), which created so convincing a blend of real garden and painting that it is hard to distinguish between the actual representations of the garden, the designs accompanying its realization, and the imaginary views. Apparently Robert also worked on Ermenonville, though this is difficult to prove because the marquis of Girardin, the garden's proprietor, took credit for it himself. What is certain is that the tomb of Rousseau there was executed from a design by Robert. After Rousseau's ashes were transferred to the Pantheon, moreover, it was Robert who executed the paintings for the temporary tomb erected in the Tuileries. Always up on the latest trends in English gardening, he gave form to the philosophy of the painterly garden, passing with ease from the landscape painted on canvas to the "recomposed landscape" in nature.

Related Entries
Ermenonville; Grottoes;
Masonic Gardens

▼ Hubert Robert,
*The Rustic Bridge,
Château de Méréville,*
ca. 1785. Minneapolis
Institute of Arts.

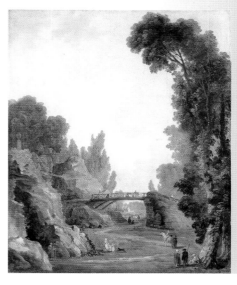

The Temple of Filial Piety, inspired by the Temple of the Sibyl at Tivoli, derives its name from the eponymous sculpture by Augustin Pajou, which was modeled on the favorite daughter of the marquis La Borde, Nathalie de Noailles.

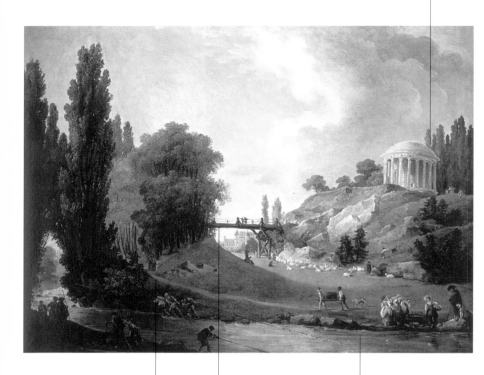

Between 1786 and 1790, Hubert Robert built the park at Méréville, replacing Bélanger as its architect. Acquired in 1784 by the marquis La Borde, it is one of the most important examples of a landscape garden in Europe.

The rustic bridge of Méréville, which appeared quite often in Robert's paintings, passes over a winding garden path rather than a river. It has also been speculated that the two rocks that the bridge joins were not natural but were placed there for "painterly" purposes.

Among his many paintings and drawings, the artist left behind numerous testimonials of the park at Méréville, though it is rather hard to distinguish between the actual designs and imagined views.

▲ Hubert Robert, *The Rustic Bridge and the Temple of Filial Piety at Méréville,* ca. 1785. Private collection.

Consisting of an aedicula in the Doric order, the cenotaph was surrounded by poplars, as at Ermenonville. Also taken from Robert's monument was the inscription, "Here rests the man of nature and truth."

While its forms are reminiscent of the cenotaph of Captain Cook, which Robert designed at Méréville (it is now on the grounds of the Château Jeurre), there is not enough documentary evidence to prove that the same artist also designed Rousseau's cenotaph.

Built at the behest of the National Assembly while they waited for the philosopher's mortal remains to be transferred permanently to the Pantheon, the temporary monument was placed at the center of the great basin in the Tuileries Gardens.

▲ Hubert Robert, *Rousseau's Cenotaph in the Tuileries Gardens*, 1794. Paris, Musée Carnavalet.

Claude Monet created a garden to suit his needs. It was conceived as a "painting already executed by nature, which lights up under a painter's gaze" (Marcel Proust).

Monet's Giverny

Seven years after moving to his property at Giverny in 1883, Claude Monet acquired the lot adjacent to the house and immediately set about transforming it into a flower garden. Later, in 1893, he managed to acquire yet another plot of land beyond the railway line, in the middle of which there was a small pond full of wild water lilies. Monet decided to expand the pond and to replace the wild orchids growing there with specially selected orchids that would produce white, yellow, purple, and pink flowers. He then had a small bridge constructed from Japanese models, with which the artist was very familiar, at one end of the pond. The bridge served as the focal point of the perspectival axis that ran from the house and passed through the entire garden. Every day Monet would arrange the garden as if it were a human model posing for a portrait. There are countless depictions of the place—in every season and at every hour of the day—in which the artist manages, through the skilled use of color, to evoke every bit of its charm and poetry. The water lilies became Monet's favorite subject, and he kept working on them right up to his death, even after going blind from an eye disease. Monet seems to have conceived of his garden as a work of art, as if the painter, long accustomed to observing nature and drawing inspiration from it, had sought to bring it to life as if it were a painting.

▼ Claude Monet, *The Garden at Giverny*, 1902. Vienna, Österreichische Galerie.

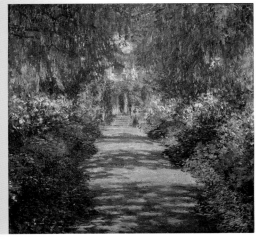

Beyond the bridge, past the soft fronds of the willow, which are rendered with long brushstrokes, is a tree with caducous leaves, whose forms are suggested by light touches of juxtaposed color.

Derived from a Japanese model, the bridge spanning the pond is the only geometrical figure among the lush vegetation.

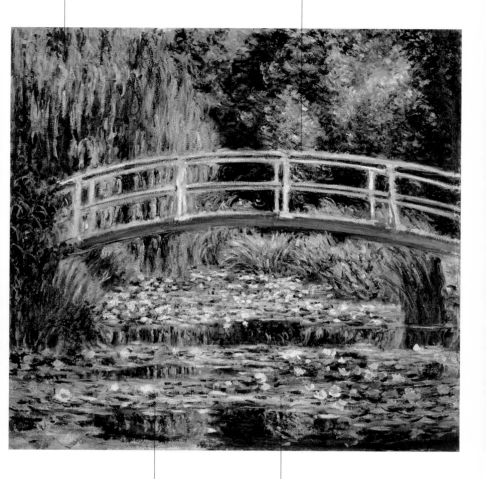

▲ Claude Monet, *White Water Lilies*, 1899. Moscow, Pushkin Museum.

The green of the vegetation dominates the lily pond; the touches of white and lilac in the foreground belong to flowers that have just bloomed.

The trees, flowers, and shrubs freely blend with one another in an infinite series of reflections and plays of light. As the years went by, the contours in Monet's paintings would become increasingly blurred, until they became pure evocations of color.

SYMBOLIC GARDENS

Sacred Woods
The Garden of Paradise
The Gardens of Christ
The Garden of Mary
The Violated Garden
The Garden of Virtue
The Garden of the Senses
Alchemical Gardens
Gardens of Emblems
Still Lifes
The Philosopher's Garden
Masonic Gardens
Gardens of the Dead
Gardens of Meditation
Round Gardens

The sacred woods of ancient Greece and Rome are the original source of our complex feelings about nature, an attitude that would influence later representations of gardens.

Sacred Woods

Greek and Roman mythology considered woods to be holy places where the gods inhabited trees, crags, streams, and springs, each of which became the object of a particular cult. In these places, the gods devoted themselves to such favorite activities as hunting or resting in the shade near cool springs. Occasionally they encountered human beings there. Woods were thus places where man might come into contact with divinity, and for this reason they aroused feelings of wonder, fear, and dismay. These sentiments were accentuated by the nature of the wood itself: wild and uncontaminated, untouched by human intervention, it was a place where nature expressed all her primordial power. The terrifying aspect of the sacred wood, derived from the Latin tradition, where the concern for the aesthetics of the site is minimal, stands in contrast to the

▼ Maurice Denis, *Muses, The Sacred Wood*, 1893. Paris, Musée d'Orsay.

Greek conception, according to which the sacred wood is a *locus amoenus*, a "delightful place" that inspires no fear. For the Greeks, moreover, nature was never a source of divine terror but was rather a place to seek harmony, grace, and everything that could be brought down to the measure of man. Under the influence of the Hellenistic and Persian ideas, Roman culture's terror of the sacred wood would eventually fade away. Once the wood was no longer protected by religious scruples, the sacred element gave way to aesthetic concerns, and gardens began to appear in what were once sanctuaries.

This image echoes the story of Actaeon, who was punished by Diana after having seen her bathing naked at a spring. The nymph's gesture may be interpreted in two ways: she may be trying to protect the goddess from the satyr's gaze, or perhaps to protect the satyr from the goddess's wrath.

Greek and Roman myth considered woods to be sacred places, where the gods devoted themselves to their favorite activities. The wood of Diana, goddess of the hunt, is a sacred wood par excellence.

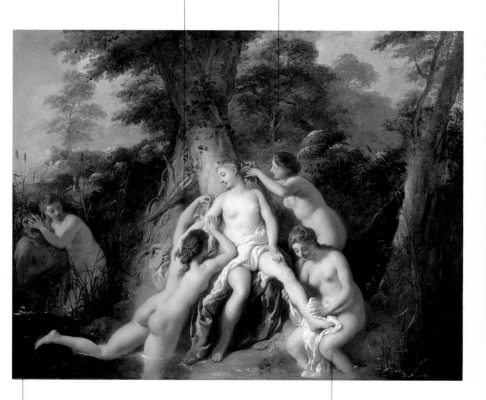

A satyr furtively tries to spy on the goddess but is surprised by a nymph, who puts a hand over his face to prevent him from seeing.

Diana is portrayed just after she has finished her bath, as the nymphs are drying and anointing her radiant skin.

▲ Jean François de Troy, *Diana and Her Nymphs Bathing*, 1722–24. Los Angeles, J. Paul Getty Museum.

The scene takes place on a park terrace, where the arrangement of trees recalls the nave of a church.

The wall on one side and the slope on the other isolate the sacred wood from the outside world, accentuating its air of exclusivity as a space accessible only to initiates.

A procession of figures clad in white, suggesting ancient priests, slowly advances toward the altar, from which a flame rises up.

In the ancient tradition, the circumscription of a natural space becomes a sacred perimeter.

▲ Arnold Böcklin, *The Sacred Wood*, 1882. Leipzig, Museum der Bildenden Künste.

An archetype of perfection, the garden of Paradise is the garden of eternity, of the beginning and end of time. It has always been a symbol of human happiness.

The Garden of Paradise

Reflecting the ancient legends of the East, the Paradise of Genesis evokes a nostalgia for the golden age, a time when man lived in direct contact with the divine. While the theme of the sacred garden, separated from the rest of the world, and the presence in it of the Tree of Life derive from Eastern traditions, the image of the Tree of the Knowledge of Good and Evil is a new element and appears for the first time in the Bible. Despite the fact that the two trees are explicitly distinguished in the texts, Christian iconography often represents them as a single tree, with the two progenitors standing on either side of it as orants. According to some scholars, the symbol of the tree is of paramount importance in the history of religion, because it is an image of the cosmic axis and an element linking the human world and the divine. The Tree of Paradise, and the fruit that hangs on its branches, thus contains both death and life within itself. A symbolic place of primordial innocence and the loss of man's original purity, the garden of Paradise has not, however, been lost forever. Its gates, guarded by the angel of the Lord, will open again at the end of time.

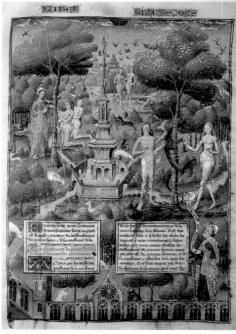

▼ *The Garden of Eden*, ca. 1480. Mâcon (France), Bibliothèque Municipale.

The Tree of Knowledge dominates the center of the garden, while the two progenitors stand on either side. Although the scriptures clearly speak of two trees, Christian iconography represents them as one.

The garden of Paradise is different from the mythic garden of the golden age. We read in Genesis that God put man in his garden so that he could tend and take care of it.

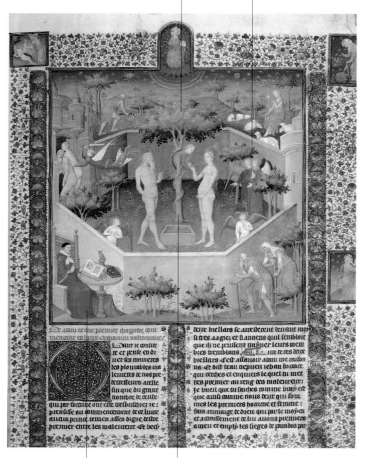

This miniature is from an illuminated edition of Boccaccio's Concerning the Fates of Illustrious Men and Women, *which recounts the story of Adam and Eve.*

▲ Boucicaut Master, *The Story of Adam and Eve*, ca. 1415. Los Angeles, J. Paul Getty Museum.

Eden is the garden of eternity. It is rich with fruit and irrigated by four rivers. At its center, the Lord has put the Tree of Good and Evil, which is also the Tree of Knowledge.

In the Gospels, the crucial moments in the life of Christ—that is, the stories of his Passion, death, and Resurrection—take place in gardens.

The Gardens of Christ

On the evening of the Last Supper, Jesus goes to pray in the garden of Gethsemane, bringing with him the apostles James, John, and Peter, who fall asleep, unaware of the drama that is about to unfold. The garden is an olive grove. Jewish tradition considers olive trees the candelabras of God, bearers of light, and according to Eastern traditions their fruit is a symbol of the essence of life. Christ thus goes into an olive grove because he is looking for a sign that might shed light on the terrible destiny he feels threatening him. And in this very garden he is arrested by the Roman soldiers, whom Judas has led to him. The symbolic meaning of the Mount of Olives is the opposite of that of the garden of Paradise and the concepts of life and fertility inherent in the biblical theme of the garden. The Mount of Olives is the garden of agony and betrayal, a kind of "anti-garden." After his crucifixion, the Son of God is buried in another garden, that of Joseph of Arimathea, in a sepulcher carved out of the rock. In this garden, the famous episode of Christ the Gardener, or *noli me tangere*, unfolds. In this story, Mary Magdalen mistakes her Lord for the *hortolanus* (κήπουροδ), or gardener. The fact that Christ appears in the guise of the gardener is closely connected to the fact that in dying he has redeemed the sin committed by Adam and Eve, which caused them to be expelled from the garden of Eden. Moreover, unlike in Eden, Mary Magdalen is not chased from the garden but leaves it of her own will, bearing within herself the divine task of telling the apostles that Christ has been resurrected. This, then, is the garden of renewal, of the triumph of life over death, the fulfillment of the promise that the garden of Eden will return at the end of time.

▼ Sandro Botticelli, *The Oration in the Garden*, 1499. Granada, Museu de la Capilla Real.

The Gardens of Christ

The image of the garden is suggested by the grass-covered rocks; the garden, moreover, is enclosed by a traditional fence of braided rushes, which we see in the background, where the artist portrays the party coming to arrest Christ.

The Gospels do not emphasize the fact that the scene takes place in a garden, because the idea of suffering is foreign to the archetypal image of the garden, a place of delight and harmony with the divine. Torn between two natures, human and divine, Christ prevents the olive garden from being a place of comfort and serenity.

▲ Martin Schongauer, *Christ on the Mount of Olives*, ca. 1485. Private collection.

The garden is presented as a desolate place, a kind of "anti-garden" without trees or flowers, but only a few clumps of grass sprouting from the rocks and a meadow all around.

Unlike the Garden of Olives, that of the Resurrection is lush with vegetation, possibly an allusion to the redemption of humankind's sins. It is a garden of renewal, in which life triumphs over death.

The image of Christ on top of his sepulchre takes up much of the scene. The Son of God is holding a cross with a banner, symbol of the Resurrection.

Flowers sprout from the bare earth, as though nature were actively participating in Christ's rebirth.

▲ Master of Wittingau, *The Resurrection of Christ*, ca. 1380. Prague, Národní Galerie.

A work of living architecture runs along one side of the garden, an arched bower of vegetation supported by caryatids. Mary Magdalen can be seen attending to the Lord's message.

The garden of Joseph of Arimathea, where the encounter between Jesus and Mary Magdalen takes place, is here transformed into a typical formal garden.

Jesus appears in the guise of a gardener, to remind us that in dying he has redeemed the sin for which Adam and Eve were banished from Paradise. Christ, the new Adam, is also the gardener of the devout soul.

▲ Lambert Sustris, *Noli me tangere*, 1540–60. Lille, Musée des Beaux-Arts.

The Christ child raises his hand in a gesture of benediction while holding in the other hand a world orb with a crucifix, which confers on him the role of salvator mundi.

Jesus is depicted in a hortus conclusus surrounded by an espalier of red roses, perhaps an allusion to his future Passion, and a brick bench covered by grass.

▲ Willem Vrelant, *Jesus with an Orb in a Garden*, ca. 1460. Los Angeles, J. Paul Getty Museum.

Normally an attribute of the Virgin Mary, the hortus conclusus is used in this case to emphasize the innocence and purity of the Christ child, who will sacrifice himself to save all of humankind.

Representations of the hortus conclusus, *the garden of the Virgin Mary and a symbol of her purity and the Immaculate Conception, became widespread in the 15th century.*

The Garden of Mary

Devotion to the Virgin Mary increased considerably over the course of the 15th century, particularly as a result of the Rosary movement that arose within the Dominican order of Cologne. This group's goal was to restore the faith through devotion to the Virgin and her rosary, and the movement spread above all through the German-speaking lands and into Italy. As a symbol of the union of human and divine nature, the Virgin is considered an intermediary between heaven and earth. Her image thus became increasingly identified with a series of attributes, most of them drawn from a famous passage in the Song of Solomon (4.12), but also from the various interpretations of such medieval scholars as Hrabanus Maurus, Albertus Magnus, and Isidore of Seville. These attributes become increasingly visible in 15th- and 16th-century paintings that honor the figure of the Virgin in the *hortus conclusus*. There are a number of variants of the classic image of Mary with her main attributes, the Christ child, and angels playing musical instruments. One of these is the "Mystical Hunt," in which the unicorn takes refuge in Mary's garden. The scene of the Annunciation is itself sometimes set in a *hortus conclusus*. In another variant, the Virgin appears with the Child under a loggia, and the garden serves as a "middle ground" between the holy scene and the surrounding urban landscape. Here the themes of the *hortus conclusus* and the courtly garden seem to merge.

▼ Master of the Paradise Garden, *The Little Garden of Paradise*, 1410. Frankfurt, Städelsches Kunstinstitut.

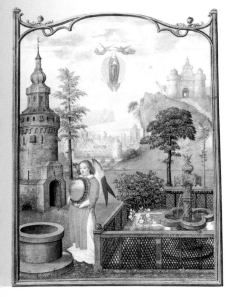

The fons hortorum, *or "garden fountain," symbolizes the purity and abundant giving of the Virgin Mary.*

The image of the hortus conclusus, an allegory of the Virgin's purity, became particularly widespread from the 15th century onward, especially after the birth of the Rosary movement.

The garden of Mary is surrounded by a splendid bower of roses. The painting gives us a classic representation of the hortus conclusus, with the Madonna and Child surrounded by angels and saints.

▲ Stefano da Verona, *The Virgin and Child in the Hortus Conclusus,* ca. 1410. Verona, Museo di Castelvecchio.

The Garden of Mary

The garden is enclosed by an imposing, turreted defensive wall. It is pink, the color created by the union of white, the emblem of the purity of the Virgin, and red, symbol of the Passion of Christ.

The Virgin is surrounded by objects symbolizing her virtue and person.

 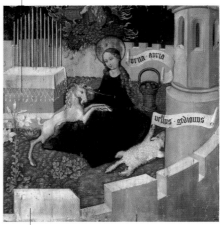

The angel Gabriel appears in the role of messenger and hunter, holding four dogs on leashes that represent, from top to bottom, Mercy, Peace, Justice, and Truth — that is, the virtues that will follow the advent of Christ on earth.

Aside from being a celebration of Mary's purity, the painting depicts the mystical hunt, that is, the allegory of the Incarnation. The theme of the mystical hunt begins to appear in conjunction with that of the Annunciation in the 15th century, particularly in German-speaking lands.

▲ Martin Schongauer, *The Mystical Hunt*, ca. 1485. Colmar, Musée d'Unterlinden.

The enclosed garden, a middle ground between the holy scene in front and the urban world behind, is represented as a typical late-15th-century garden, with raised plant beds surrounded by low brick walls.

The garden is reminiscent of a courtly garden, as underscored by the three fashionably dressed figures looking over the wall at the panoramic view.

The three shrubs are trained along super-imposed metal or wooden disks and cut to their flat shapes, in the manner of topiary.

The sacred scene unfolds in the foreground, with the Virgin Mary, the Christ child, Mary Magdalen, and the patroness as the main characters.

▲ Master of the View of Ste. Gudule, *The Virgin and Child with Saint Mary Magdalen and a Patroness*, ca. 1475. Liège, Musée d'Art Religieux et d'Art Mosan.

The open book and the closed book symbolize the New and Old Testaments, respectively.

The bower of roses and the brick bench encircle the mother and child as if to protect them, evoking the image of the hortus conclusus.

The crescent moon, just barely visible beneath the Madonna's clothes, recalls the image of the moon at the feet of the Virgin in the iconography of the Immaculate Conception.

The Madonna of Humility, portrayed sitting on the ground with the Christ child in her arms, was a popular subject in Flanders.

▲ School of Robert Campin,
The Madonna of Humility, ca. 1460.
Los Angeles, J. Paul Getty Museum.

A number of biblical episodes take place in a garden, which takes on the double signification of a garden of temptation and sin and a garden of virtue.

The Violated Garden

The book of Daniel tells the story of Susannah, a woman of rare beauty who is married to Joachim. Her husband allows two elders of Israel into his garden to discuss legal matter. There they fall in love with Susannah and conspire to take her by deceit. One day, as she is taking her daily bath in the garden, the two elders emerge from their hiding place and threaten to denounce her for adultery, a crime punishable by death, if she won't let them have their way with her. Susannah does not yield, and the two elders put their plan into action. It is foiled, however, by the providential intervention of Daniel, who succeeds in proving Susanna's innocence. Representations of Susannah's story commonly show her bathing against a background of lush garden plants. In addition to providing an excellent frame for a depiction of a female nude, the garden evokes temptation and sin, serving as backdrop for the theme of the struggle between virtue and vice. Sometimes the garden is shown surrounded by high walls, underscoring the elders' violation of the sacred space. Another biblical story of violation that takes place in a garden is that of Bathsheba, the beautiful wife of Uriah the Hittite. King David falls in love with her and, to take her as wife, sends her husband off to war to die. This story is depicted against the backdrop of a marvelous garden, which commonly features a labyrinth, to emphasize the complex amorous intrigues of the protagonists and the forbidden nature of their relations.

▼ Baldassare Croce, *Susannah and the Elders*, ca. 1598. Rome, Santa Susanna.

The Violated Garden

The luminous figure of Susannah contrasts with those of the two elders, who are portrayed with a certain humor as stiff and awkward.

In the background we see a green bower that covers the entrance to the walled garden.

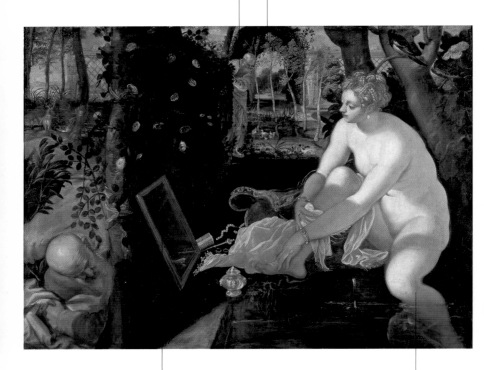

The wall of roses dividing the two spaces recalls the many images of arbors that appear behind the Virgin Mary in the hortus conclusus. It may therefore allude to Susannah's preserved chastity.

Susannah's garden is at once a garden of temptation, from the point of view of the two elders, and a garden of inviolate virtue, from Susannah's point of view.

▲ Tintoretto, *Susannah and the Elders*, 1555–56. Vienna, Kunsthistorisches Museum.

After Adam and Eve's expulsion from Paradise, man is forced to exercise his own moral rectitude in the perennial struggle between vice and virtue.

The Garden of Virtue

The garden is generally considered a place of pleasure. It can appear as an appeal to the senses through marvelous views, sounds, or scents, and it can be a place in which to exercise one's intellect. Even in antiquity, however, authors warned of the hidden dangers of gardens and the pitfalls they might contain. Later, a whole series of allegorical and symbolic figures emerged that linked the iconography of the Blessed Virgin to the garden of virtue. These figures take the form of flowers—which can express charity, humility, and chastity—and objects, such as the "sealed fountain," an image of purity. In the 16th century above all, the garden became a place for the temptation of the soul, especially after the reassertion of the Church's moral authority following the Council of Trent. At this point, the garden of virtue distinguished itself from the garden of vice mostly in terms of the activities that took place in it. Amorous promenades and conversations could lead to licentious behavior, and innocuous country games such as blindman's buff could allude to the dangers that lay hidden in such carefree amusements. In any case, the gardens of virtue and vice have assumed countless different forms and variants, some of them quite original.

▼ Swiss tapestry workshop, *The Annunciation with the Mystical Hunt and Symbols of Mary* (detail), 1480. Zurich, Schweizerisches Landesmuseum.

The Garden of Virtue

The tree-woman calls on Fortitude, Temperance, and Justice to intervene to protect the garden from a threatening cloud.

The garden is surrounded by a splendid arcade of vegetation, a specimen of the most refined art of gardening, which stands in contrast to the slovenly culture of Ignorance.

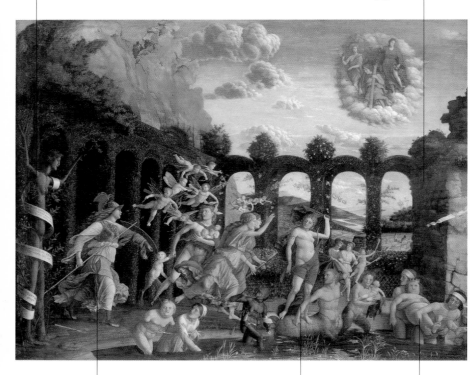

The garden of virtue has been invaded by the Vices. The resolute goddess Minerva, symbol of wisdom and learning, is chasing them away with the help of the Virtues themselves.

Venus (Lust), standing atop a lascivious centaur, prepares to dive into the swamp of vice.

Ignorance, the primary cause of vice, is cast by Avarice and Ingratitude into a slimy bog, which is supposed to be its natural environment. Other Vices follow it into the turbid swamp.

▲ Andrea Mantegna, *Minerva Chases the Vices from the Garden of Virtue*, 1497. Paris, Louvre.

The iconographical typologies of the five senses developed in the Middle Ages and would thereafter be continuously enriched by creative new ideas.

The Garden of the Senses

Initially inspired by the animals depicted in medieval bestiaries, the iconography of the five senses grew richer over time until it became a happy amalgam of several different painterly traditions. The garden has been part of this iconographical tradition from the very start, as we see in the tapestry series *The Lady and the Unicorn*. There, the senses manifest themselves in an enchanted garden world and for the first time are symbolized by woman. Compositions in this genre ended up including images of everyday life as well. Likenesses of real people, the artists' contemporaries, are engaged in what appear to be normal everyday activities, against the background of a garden that sometimes forms an integral part of the story, with clear echoes of the garden of love. Some scenes of garden revelry and feasts, especially from the 17th century onward, contain moralistic messages that warn us against the abuse of the senses, showing images of couples engaged in the pleasures of the flesh. Moreover, the garden naturally lends itself to illustrating imagery of the olfactory sense, usually personified by a woman in a garden setting. She is frequently represented smelling the flowers she holds or which are being offered to her. Images of the senses can also be less explicit and become apparent only after a careful analysis of a particular composition.

▼ Brussels tapestry workshop, *The Lady and the Unicorn, "Smell,"* 1484–1500. Paris, Musée National du Moyen Âge (Musée de Cluny).

Smell and taste are evoked by the scents of the garden and the satyr on the fountain, carrying a wine jar on his shoulders.

Hearing and sight are embodied in the organist, shown playing the instrument while gazing on the goddess.

Touch is represented by the little cherub caressing the goddess, while sight is expressed in the looks exchanged between them.

▲ Titian, *Venus and Cupid with an Organist*, 1548. Madrid, Prado.

The gentleman is holding a small bouquet of flowers and smelling them, while the girl behind the couple gazes at a carnation, symbol of marital fidelity.

The terrace opens out onto a geometrical garden with uniformly shaped flower beds enclosed by low walls. The garden itself is surrounded by dense walls of vegetation broken by vaulted openings.

The image of dogs furnishes another allusion to the olfactory sense, as does the pot of flowers that a little girl is setting on the balustrade at the bottom of the stairs.

▲ Abraham Bosse, *Odoratus*, 1635.
Tours, Musée des Beaux-Arts.

The sumptuously laid table evokes an image of taste, while hearing is personified by the young man leaning against the table, playing the lute.

The theme of the five senses is used here to convey a religiously inspired moral caution, emphasizing the generally negative connotations of the senses, which could lead one into sin.

▲ Louis de Caullery, *In the Garden of Love*, or *The Five Senses*, 1618. Nelahozeves Castle (Czech Republic), Lobkowicz Collection.

The allegory of the five senses is situated in a secluded garden of love, where the guests engage in various "courtly" activities.

The couples in the foreground, from right to left, represent the senses of smell, touch, and sight, respectively.

Alchemical images draw from the world of the garden, since this is a place requiring meticulous care that should lead, like alchemy itself, to the attainment of perfection.

Alchemical Gardens

In the alchemical garden, every color, form, and material is connected with the quest for knowledge, assumes magical and symbolic meanings, and is fodder for reflection and meditation. Steam, for example, represents the volatile soul, the alchemical material rising up into the sky, abandoning inert matter on the earth below. Dewdrops, on the other hand, are objects of study because of their nourishing properties, and they reach the earth by moving in the opposite direction from steam. In the alchemical garden, every presence—animal, vegetable, or mineral—is an allegory of the transformation of matter from the solid state of earth to the liquid state of water or the gaseous state of air, until it reaches the state of perfect harmony, that of the philosopher's stone—that is, the cosmos, the great order of the universe. Every vegetable and mineral element, moreover, has its corresponding part in man, the human body, spirit, and life. Many different kinds of plants are grown in the alchemical garden, which are selected according to a specific cosmic vision and intended to bring well-being to mankind. Among the alchemist's plants, naturally, was the mandrake root. Because of its human shape, mandrake had been since medieval times considered a magical, mysterious plant and was cultivated in the alchemical garden for the powers of divination it was thought to confer on man.

▼ *Opus alchemicus as hortus conclusus*, from Giano Lacinio, *Pretiosa Margarita Novella (The New Pearl of Great Price)* (1577–83).

Birds, symbolizing the airy element, stand for the sublimation of matter, while the seven-runged ladder (echoing the known celestial orbs and the seven metals) alludes to the stages of work the alchemist must perform.

The tree at the center is the "philosophers' tree," also sometimes called the Tree of Hermes and the "alchemists' tree."

The alchemist has climbed up to the Tree of Alchemy to collect its branches, which he offers to the philosophers below him.

The river alludes to the watery element.

▲ *Golden Tree with Crown,* miniature from *Splendor Solis,* by Salomon Trismosin, 16th century.

An emblem is a picture containing multiple symbolic and allegorical meanings. It consists of an image, a motto, and an explanation in Latin.

Gardens of Emblems

The *Emblematum liber* (*Book of Emblems*) written by the jurist Andrea Alciati in 1531 enjoyed great success and went through over one hundred editions. The *Hieroglyphica* of Horapollo and the *Hypnerotomachia Poliphili* of Francesco Colonna had a profound influence on Alciati, as did the fashion of the "device" (*impresa*), which differs from the emblem in that it features only an image and a motto. The image of a garden often appears in the emblem's field as a kind of secret place accessible only to a chosen few who have the tools necessary to decode the message contained in it. The emblem's garden is a place of flowers and trees, intricate labyrinths, and fragrant scents. It is a kind of forge in which elaborate new philosophical concepts are tested, or where, on the other hand, simple messages are conveyed whose meaning is accessible to all. Through the motto and the explanatory epigram, the garden reenters the universe of moral symbology, philosophy and literature, the sacred, the heroic, and the satirical. Depending on the relationship between text and image, its meaning either can be directly understood or may require complex interpretations presented in the form of commentaries within the treatises of emblematics. On the other hand, sometimes the garden serves simply as background, a neutral element in the complex message contained in the emblem.

▼ Emblems from the *Symbolographia* of Jacobus Boschius (Augsburg-Dillingen, 1710).

Imported to Italy from France after the French occupation in the late 15th century, the device (impresa) is composed of two parts, the motto and the image.

The image of the labyrinth with a tree at the center recalls the typology of the labyrinths of love.

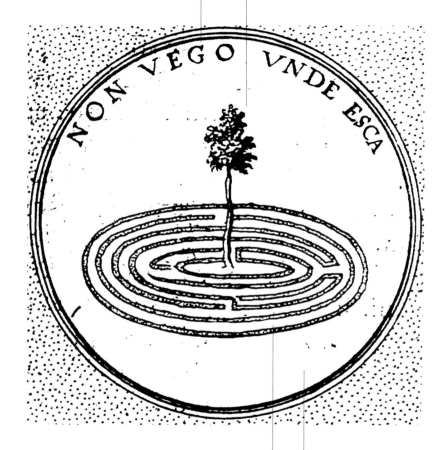

▲ *Non vego unde esca*, device (*impresa*) of Alfonso Piccolomini, from Jacobus Typotius, *Simbola divina et humana pontificum* (Prague, 1601–3).

The motto alludes to the impossibility of escaping the devil's labyrinth of deceptions unless one follows the divine law of the commandments.

The device was a medallion with a motto reflecting a certain self-image or manifesting some personal intention. One could wear the medallion or pin it to one's hat.

In the 16th and 17th centuries, images of the garden featured brilliant festoons of flowers and baskets of fruits and vegetables, but also objects associated with the theme of memento mori.

Still Lifes

The placement of a still life against a garden background, an innovation attributed to the Flemish painter Jan van Huysum, proved to be a good excuse for abandoning the traditional dark background against which the usual compositions of flowers or fruit stood out. But iconographical repertories continued to grow, and the corners of gardens began to appear in images of nature. In these images, the simultaneous presence of animals and plants took on symbolic meaning, alluding to the eternal conflict between earthly desires and Christological symbols, between good and evil. The garden still life offers documentation of the extravagant tastes of aristocratic patrons as well as the sumptuous lives of landowners. In still lifes with game, for example, hunting implements underscore the nobility's passion for the hunt. Later combinations of flowers, fruits, luxury items, and collectibles yield pictures of ostentatious abundance—the "sumptuous still lifes" that, despite this more obvious theme of opulence, almost always maintained their traditional symbolic meanings: "vanity," for example, might be expressed through objects representing life's transience, like open fob watches. These sorts of compositions, however, might also fulfill purely decorative functions and be intended only to glorify opulence and wealth, falling in with the tradition of celebratory art that emerged most notably in France under Louis XIV. We also find artists whose interest was purely documentary or botanical, whose intent was simply to portray some of the unusual species that were cultivated in botanical gardens.

▼ Pier Francesco Cittadini, *Still Life of Fruit and Sweets*, ca. 1655. Trieste, Musei Civici.

Still Lifes

Compositions of different plant species are sometimes genuine still lifes. Here the pumpkins are depicted against a background of the Medici gardens.

From 1696 onward, the Tuscan painter Bartolomeo Bimbi painted many paintings with life-size images of fruits found in the grand-ducal gardens.

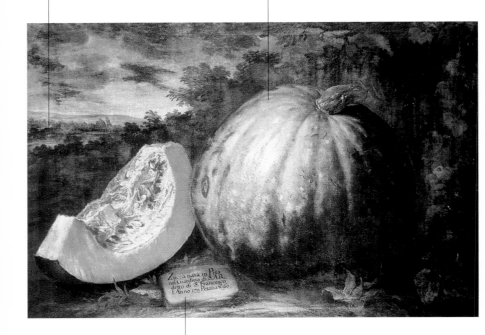

The intention was to pass on the memory of certain rare products of nature, such as this enormous pumpkin, which, as stated in the words on the stone, was found in Pisa in the garden of His Royal Highness in the year 1711. It weighed some 160 Italian pounds, or about 45 kilograms.

▲ Bartolomeo Bimbi, *Pumpkin*, ca. 1711. Florence, Museo Botanico.

Jan van Huysum was one of the first artists to paint still lifes against a garden background, abandoning the traditional dark ground.

The sumptuous composition of carefully rendered fruits and flowers stands out against the garden behind, in which we can make out a statue and two figures leaning against a stone balustrade.

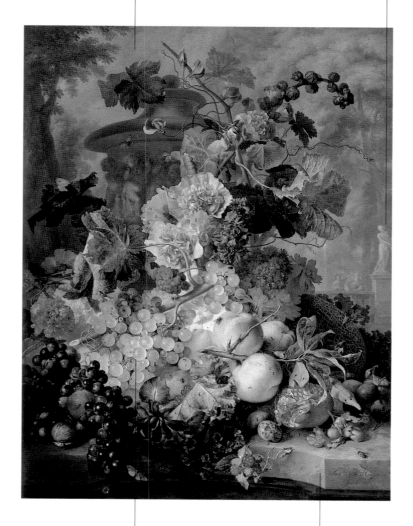

▲ Jan van Huysum, *Fruit Piece*, 1722. Los Angeles, J. Paul Getty Museum.

The presence of insects, especially the juxtaposition of flies and butterflies, suggests a representation of the eternal struggle between good and evil, accompanied by an allusion to life's brevity.

A garland of fruit, flowers, and foliage spills onto a stone balustrade. The flowers seem to sag from the weight of their magnificent blossoms.

323

The image of the garden as a place to devote oneself to thought and study dates back to antiquity and draws inspiration from the famous gardens of the Platonic Academy of Renaissance Florence.

The Philosopher's Garden

The ancient concept of the garden as a place for the recreation of the mind was revived in the age of humanism, particularly by Lorenzo de' Medici. He turned the gardens at Careggi and Poggio a Caiano into centers for the teachings of the Platonic Academy, centered around the Hermetic doctrines of Marsilio Ficino. Greek and Roman thought, viewed through the prism of Virgilian ideals, would become the foundation that would lead man to live his life in accordance with nature. This Neostoic conception, developed in the late 16th and early 17th centuries, drew particularly from the theories of the philosopher Justus Lipsius. According to this idea, the garden, a place in which wisdom and knowledge are nourished and cultivated, could not be used for idle pursuits. The garden existed by virtue of its serenity, which was propitious to the recreation of the mind and spirit. It was thus a place of knowledge, where the practice of philosophy might be freely pursued. Over the course of the 17th century, the vision of the cosmos derived from Neoplatonic and Aristotelian doctrines was abandoned and philosophers reformulated the relationship of man to nature, which was no longer to be dominated as in the Renaissance. Rather, humans were to welcome nature within themselves, adapting to it and thereby creating a new relationship. These and similar conceptions would begin to appear in landscape painting as a perfect fusion of sentiment and reason and would be further reflected in the new conceptions of the garden.

▼ Antal Strohmayer, *The Philosophers' Garden, Athens*, 1834. Private collection.

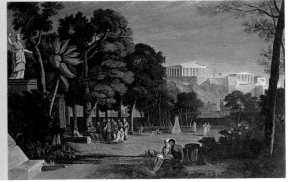

The garden's repertoire of surprises and enchantments is sometimes set aside in favor of more complex mysteries and loftier concerns.

Masonic Gardens

Over the course of the 18th century, as Masonic ideals were spreading across Europe, gardens began to take on increasingly complex meanings, becoming bearers of initiatory messages. However difficult it may be to decipher what was supposed to remain hidden, a number of specific elements relating to the stages of initiation have been identified in the repertory of signs expressed by the fabriques. These are for the most part buildings whose names reveal their philosophical bent: there are Temples of Friendship, Virtue, and Wisdom, and medieval towers and fortresses alluding to the Knights Templar, the Masons' forebears. In addition, there are symbols derived from the Egyptian world, above all the pyramid, as well as the buildings and grottoes from the Rosicrucian tradition, in which séances were organized or alchemy was practiced. Finally, there are the purposely occult buildings that intentionally dissimulate their mysterious purposes. The architectural elements making up the initiatory stage were arranged according to a predetermined ritual itinerary that involved the accomplishment of a series of tasks symbolizing the moral and spiritual evolution of the initiate. The garden's space lent itself to the creation of such symbolic and ritual itineraries, and the fabriques were obligatory stops along the way. A number of the gardens created in France in the years 1770 to 1780 belonged to members of the Masonic aristocracy, such as the Parc Monceau in Paris, which belonged to the duc de Chartres, Grand Master of the Great Orient of France; the park of Ermenonville, the property of the marquis de Girardin; and Mauperthuis, belonging to the marquis de Montesquieu.

▼ Nicolò Palma,
*Topographical Map of the
Public Villa Giulia*, 1777.

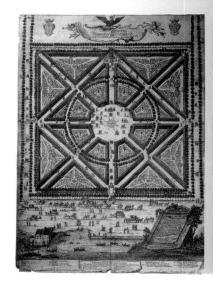

The strong contrast between light and darkness probably alludes to the simultaneous presence of the two elements. Light and darkness are the same thing, just as life is also death.

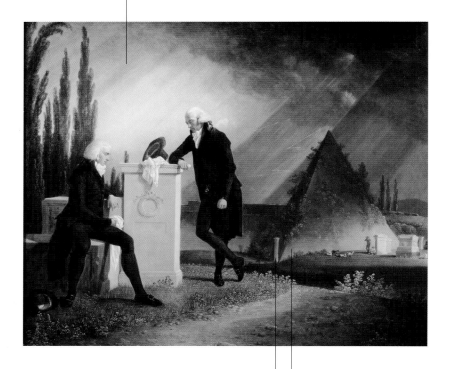

The two small columns beside the pyramid are there to remind one of the two columns on which Solomon's temple—and therefore one's inner, moral temple—was built.

A symbol of death, the pyramid is also considered an image of the afterlife and represents the door through which the soul reaches eternity. The monument is covered by acacia, which corresponds, in Masonic symbology, to the notion that ideas live on after death.

▲ Jacques Henri Sablet, *Roman Elegy*, 1791. Brest, Musée des Beaux-Arts.

The pyramid at the entrance to the garden of the marquis de Montesquieu was apparently conceived by Claude-Nicolas Ledoux.

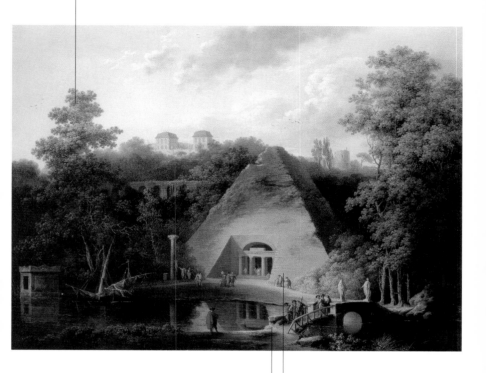

Many of the picturesque gardens created in France in the 1770s belonged to members of the Masonic aristocracy. For them, the garden became a kind of initiatory itinerary scattered with fabriques.

Symbol of death but also the afterlife, the pyramid led into a grotto, through which one entered a garden of initiation as though crossing the threshold into a new life. The symbolic journey ended in a large space in which the presence of fire and a purifying pool alluded to the trials of the Masonic initiation.

▲ Claude-Louis Châtelet, *The Pyramid of Mauperthuis*, ca. 1785. Private collection.

The column was created around 1780. Doric or Tuscan in style, it was some 50 meters wide and, had it not been made to represent a ruin, would have measured 120 meters in height.

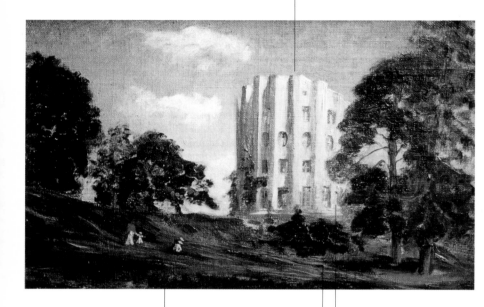

One entered the Désert de Retz through a dark cavern guarded by two menacing statues of satyrs, each holding a torch. The garden also contained a "ruin" of a Gothic church, an obelisk, a Chinese house, an icehouse in the form of a pyramid, and hothouses.

The Désert de Retz, owned by the nobleman Racine de Monville, was constructed between 1774 and 1789 in the Paris suburb of Chambourcy. Like the fanciful column, the landscapes created in the park are visions from Racine's own dreams.

Like the Chinese house, the column was actually a four-story home.

▲ *The Tower of Retz*, late 19th century.
Private collection.

In the 18th century, funerary urns, gravestones, and memorial pillars start to become essential garden ornaments, especially in English landscape gardens.

Gardens of the Dead

The custom of decorating gardens with funerary objects derives from a variety of factors, including the 18th-century ban on tombs in churches and the creation of cemeteries. In the latter, a new cult of the dead witnessed the accumulation of structures and objects devoted to their commemoration. Culturally this phenomenon derived in large part from images of Arcadia—an idealized world of rustic simplicity—that began to appear in painting and literature at the end of the Renaissance, conveying an elegiac feeling. The vision of an enchanted, timeless dimension, an island removed from the rough-and-tumble world, fell into disfavor, and people began to accept the idea that even in Arcadia there was no escape from death. The motto "Et in Arcadia ego"—meaning, ambiguously, either "I [Death] am even in Arcadia" or "I [the dead] am in Arcadia"—appears inscribed on tombs or memorial columns in the rustic landscapes depicted in a great many paintings. The habit of considering the garden as part of a meditation on death and human feeling spread further after the publication of *Night Thoughts*, by English poet Edward Young, in 1742. The book enjoyed an immediate, overwhelming success and anticipated the pre-Romantic theme of nocturnal meditations on the grave. The garden at this point was no longer a place of cheer, surprise, and play but was rather a place of memory, reminiscence, and melancholy, where symbols of death encouraged contemplation and emotion.

▼ Étienne-Louis Boullée, *Cenotaph of Newton*, 1784. Paris, Bibliothèque Nationale.

This is not merely a memento mori; indeed, the epigraph lacks the ominous ring of a dire warning of the future. The attitude of the shepherds is rather that of rapt meditation on the mortal fate of man.

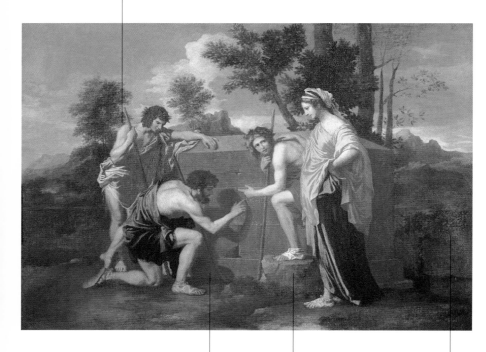

The motto on the stone, "Et in Arcadia ego," is quoted from Virgil and alludes to the fact that even in an idyllic, pastoral world such as Arcadia, one cannot escape death.

Poussin uses the allegorical representation of a moral precept to stimulate an elegiac sentiment.

The dichotomy of happiness and death features prominently in figurative art and literature from the Rococo period through Romanticism, when the garden becomes the ideal environment for conveying this feeling of boundless melancholy.

▲ Nicolas Poussin, *"Et in Arcadia ego,"* 1637–39. Paris, Louvre.

The Élysée, or garden of the tombs of illustrious men, stretched over a grassy area surrounded by cypresses, pine trees, and poplars, trees charged with symbolic meaning.

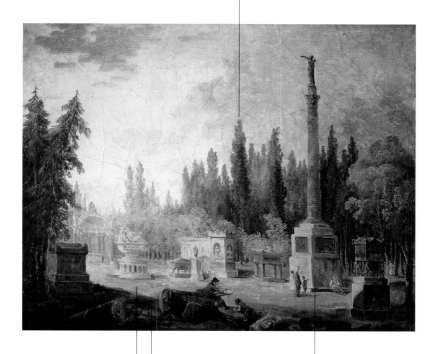

In this garden, the celebration of great men was inseparable from the meditation on death. The garden is crowded with tombs ascribed to towering figures such as Turenne, Boileau, Molière, and Descartes.

Alexandre Lenoir created his Élysée garden of French monuments at a former Augustinian monastery in Paris in 1794.

The museum, a kind of ideal ancient cemetery, brought together funerary monuments gathered from a variety of French churches in Paris and environs.

▲ Hubert Robert, *The Élysée Garden of the Musée des Monuments Français*, 1802. Paris, Musée Carnavalet.

*Rousseau's mortal
remains were moved to
the Pantheon in 1794.*

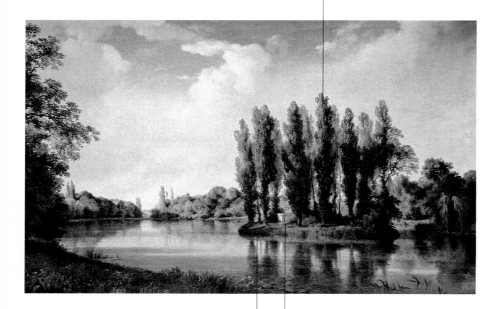

*Situated on an island at the center of
a lake and surrounded by sixteen
poplars, the tomb was visible from
afar. The monument bears a laconic
epigraph saying, "Ici repose l'homme
de la Nature et de la Vérité" (Here
lies the man of Nature and Truth).*

*Designed by Hubert Robert in 1778
to commemorate the great philoso-
pher, who died on the estate of the
marquis de Girardin, Rousseau's
tomb is a typical example of the sort
of funerary monuments created in
late-18th-century gardens.*

▲ Charles Euphrasie Kuwasseg, *The
Tomb of Jean-Jacques Rousseau,* 1845.
Fontaine-Chaalis, Institut de France,
Abbaye Royale de Chaalis.

▶ John Constable, *The Cenotaph
to Reynolds' Memory, Coleorton,*
1833–36. London, National Gallery.

The cenotaph in honor of Sir Joshua Reynolds,
painter and founder of the Royal Academy, was
erected in 1812 by Sir George Beaumont in his
gardens at Coleorton, in Leicestershire.

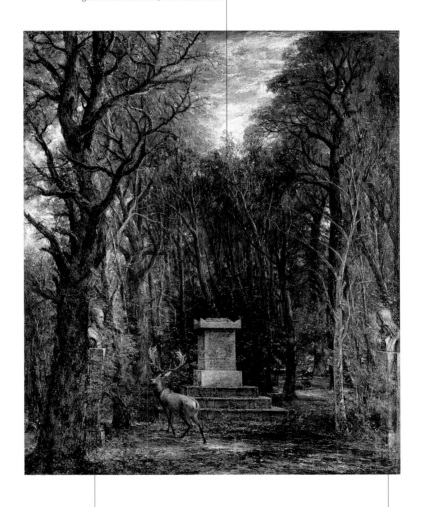

A place of memory and reminiscence,
the park puts the visitor in a state of
heightened awareness and meditation.
The image of the artist who championed
the "Grand Style" is evoked by the pres-
ence of the two famous Italian painters.

The monument is
flanked by busts of
Reynolds's two favorite
artists, Raphael, on the
right, and Michelangelo,
on the left.

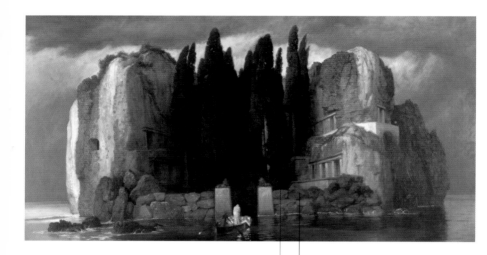

A rocky, semicircular island, on which a stand of cypresses shrouds the ancient tombs, rises up out of the water. Inspired by the tradition of sacred enclosures, the island resembles the one dedicated to Rousseau at Ermenonville.

The image depicts an unreal, disturbing natural world that conveys a sense of boundless solitude with an undercurrent of melancholy typical of the Romantic spirit.

▲ Arnold Böcklin, *The Island of the Dead*, 1886. Leipzig, Museum der Bildenden Künste.

Personifications of death wearing black over-
coats are shown lovingly tending to the plants
in their garden, probably to symbolize the
eternal cohabitation of life and death.

In his paintings, Simberg
shows a peculiar predilection
for the supernatural, death,
and devils, subjects drawn
directly from Finnish legend
and often treated ironically.

This eerie image of a
garden is probably sup-
posed to remind us that
death is part of life and
the ultimate fate of every
living being.

▲ Hugo Simberg, *The Garden of Death*,
1896. Helsinki, Museum of Finnish Art,
Ateneum.

The Chinese garden is a place of contemplation, meditation, and silence, where the decorative element is only a pretext for achieving a specific state of mind.

Gardens of Meditation

The principles on which the Chinese garden is founded are completely different from those of Western gardens, even if it, too, in its essence, strives to create landscapes of infinity. Like the Western garden, the Chinese garden may feature mountains and lakes, but these can be crossed by taking a single step. Mostly, the Chinese garden evokes a particular state of mind.

What justifies the existence of a garden is its inwardness. In a Western garden, whether a Baroque garden or landscape garden, a stage is created for man. The Chinese garden, on the other hand, does not need man in order to express itself, because what breathes life into the garden, and becomes one with it through contemplation, is the soul. The Chinese garden is first and foremost a sacred garden, a place where nature's spirituality is expressed in full, where earth, water, and sky are gods. Rocks, the bones of the earth, and water, nature's nourishment, preserve their universal meaning, even when restricted to a small space. In this view of things, a rock does not recall the image of a mountain; it *is* a mountain. This way of thinking is not without its magical side. The Chinese garden is, in short, a place organized according to the highest laws of the cosmos. Such typically light Chinese structures as bridges and pavilions stand side-by-side with the natural elements. The Japanese, for their part, took the Chinese garden and over time applied specific rules to it, creating a space in an ordered universe where the arrangement of elements and form itself are dictated not by chance but by religious considerations, as the products of a long and jealously guarded tradition.

▼ Katsushika Hokusai,
Flowering Plum, ca. 1800.
Kansas City, Nelson-Atkins
Museum of Art.

The composition seems to guide the observer's eye toward emptiness, quiet, and inner silence, leading one to contemplate the absolute.

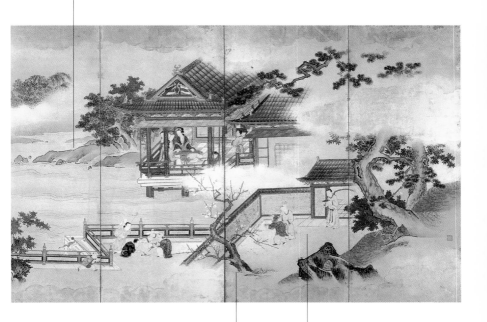

A meaningful element in this garden is the tree with a powerful trunk, and the contrast it makes with the delicacy of a plum tree in bloom.

Indoor and outdoor spaces become integrated with one another. They seem to form a single, all-enveloping environment accentuated by the narrow color spectrum, organized in nuanced gradations of gray and ochre.

▲ Kano Chikanobu, *Court Scenes*, early 18th century. Private collection.

The motif of the circle, an image of perfection with no beginning or end, has strong symbolic connotations and appears in the garden as well, especially the Baroque garden.

Round Gardens

In his treatise *De florum cultura*, published in Rome in 1633, Giovanni Battista Ferrari describes seven models of central-plan gardens, dwelling especially on the circular plan, whose purpose is to imitate the form of the universe. Using the circle's perfection, Ferrari's intention, aside from evoking Renaissance culture, is to glorify the image of the flower garden as a direct emanation of divine will. Although the most widespread garden design in the 16th and 17th centuries was the square or rectangular model, there are a few examples, however rare, of circular-plan gardens that can be associated with a vision such as Ferrari's. One of these was the garden of Prince Mauritius at The Hague, which we know from some prints by Hendrik Hondius. The garden's design unfolds around two circles, each inscribed inside a square. According to an epigram by the prince's secretary, the two circles apparently allude to the famous regret uttered by Alexander the Great, that there was but one world that he could conquer. At the same time, however, this design can be considered in light of the musical theories of the Pythagorean doctrine, according to which the image of a circle inscribed in a square alludes to the harmony of the universe, a theory also used by Alberti in architecture. Round gardens are not an uncommon sight in iconography and appear most often in images of Paradise, the *hortus conclusus*, and the gardens of Christ, particularly Gethsemane. Artists sometimes depict the latter as round, perhaps intending to mark out its confines as a sacred space mirroring the perfection of divinity and all creation, as manifested on earth in the garden of Eden.

▼ Hendrik Hondius, *The Garden of Prince Mauritius at The Hague*, from *Institutio artis perspectivae* (The Hague, 1622).

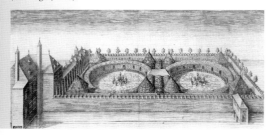

At the center of the garden stands
the Tree of Knowledge, whose
form recalls the cross of Christ.

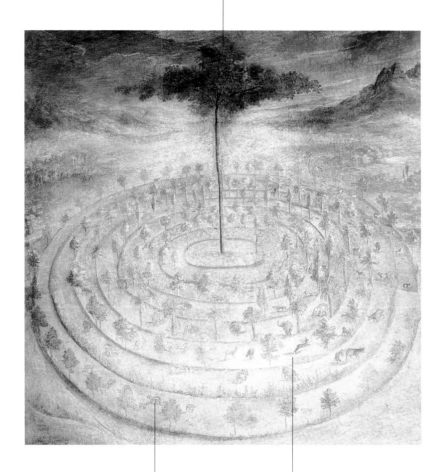

▲ *Mystical Earthly Paradise*, fresco in
the Scala Santa (Holy Staircase) from a
drawing by Giovanni Guerra, ca. 1589.
Rome, Saint John Lateran.

*Earthly Paradise is divided into
eight concentric sections, sepa-
rated by trees and hedges and
peopled with animals. The num-
ber eight is probably an allusion
to the fact that in the New
Testament, the eighth day of
Creation corresponds to the day
of Christ's Resurrection.*

*The symbolic form of this garden of
Paradise resembles the typical struc-
ture of a labyrinth, such as those
made in the pavements of medieval
churches to entrap demons. The
labyrinth may thus evoke the image
of the Earthly Paradise but may also
allude to sin, and thus to the moment
when Paradise was lost.*

Round Gardens

The episode of Christ's arrest by Roman soldiers takes place in the Garden of Olives, where he had gone to pray and seek consolation before being captured.

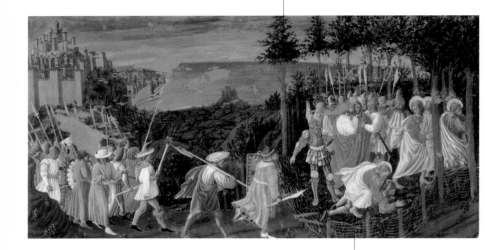

It is fairly common in iconography to see Gethsemane presented as a round garden, probably to emphasize the episode of Christ's capture as a profanation of God's Word and a denial of his kingdom, Earthly Paradise—a sacred place par excellence, sometimes depicted as circular in shape.

▲ Giovanni di Piermatteo da Camerino
Boccati, *The Capture of Christ*, 1447.
Perugia, Galleria Nazionale dell'Umbria.

The circle is not the only form that can allude to the imago mundi. The ellipse and the double-apsed rectangle do so as well.

The design of an ovate garden in Ferrari's De florum cultura *resembles that of the coffers of Borromini's dome.*

The "oval" of the dome of San Carlino draws from the decorative repertory used by Giovanni Battista Ferrari in his garden designs, particularly the Gothic motifs.

In his treatise De florum cultura, *Ferrari presents drawings of central-plan gardens informed by a system of "geometrical inlays." This system is inspired by the 16th-century Italian botanical gardens, which, according to certain scholars, served as models for some of Borromini's early works.*

▲ Francesco Borromini, View of the Interior of the Dome of San Carlino alle Quattro Fontane, Rome, 1638–41.

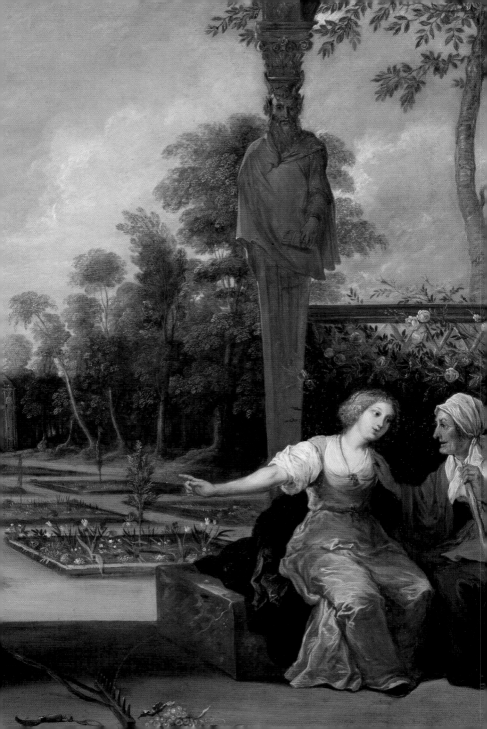

LITERARY GARDENS

The Garden of the Golden Age
The Garden of the Hesperides
The Garden of Flora
The Garden of Pomona
The Garden of Venus
Le Roman de la Rose
Dante's Gardens
Boccaccio's Garden
Petrarch's Gardens
The Gardens of Poliphilo
Armida's Garden
Paradise Lost
Sprites and Fairies in the Garden

◄ David Teniers II, *Vertumnus and Pomona* (detail), 17th century. Vienna, Kunsthistorisches Museum.

It is a place of happiness, peace, and plenty, a kind of timeless, happy island that became the archetype for utopia.

The Garden of the Golden Age

Every civilization, every epoch, has its own notion of a primordial state of happiness and plenty. Whether it is the blessed age, the golden age, or paradise, the concept is always the same: a place and time where serenity and harmony reign. Hesiod, in *Works and Days* (106–26), tells how men used to live like gods, in peace, untroubled by work or by the fear that some misfortune might befall them. They did not suffer the onslaught of old age but were always healthy and at the height of their powers, spending their time feasting and reveling. Death came to these golden men in their sleep, when Zeus would transform them into good demons. Thereafter they were hidden underground, where they became the guardians of mortals and dispensers of wealth. In his *Metamorphoses* (1.89–112), Ovid writes of the primordial golden age and associates the myth of eternal youth with that of the eternal spring, where flowers grow without seeds and the earth spontaneously produces crops. The nostalgia for a better age, for a lost golden age or the Christian Paradise, is a theme we see constantly reflected in the garden, which is considered a *locus amoenus*, a "delightful place," isolated from the world and suspended in time, a first and absolute example of utopia.

▼ Pietro da Cortona, *The Golden Age*, 1641–46. Florence, Palazzo Pitti, Galleria Palatina.

344

This painting revisits, in a mythological vein, the theme of Earthly Paradise, at the center of which stands a tree. Unlike the garden described by the poets, this garden is surrounded by walls, to keep out perils and preserve the original state of well-being.

The people of the golden age eat fruits produced spontaneously by the earth and live "free from labor and misfortune."

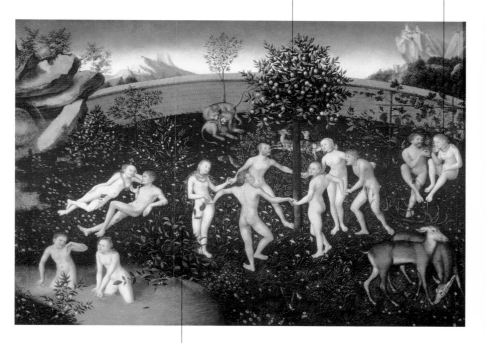

Always at the height of their powers, people would die in their sleep and turn into spirits, wandering the earth in clothes made of air. The garden of the golden age is a place of eternal youth and perpetual spring.

▲ Lucas Cranach the Elder, *The Golden Age*, ca. 1530. Munich, Alte Pinakothek.

Akin to the gardens of the golden age, that of the Hesperides is a garden of the gods located at the far end of the Western sky, in the infinities of the Ocean.

The Garden of the Hesperides

The Hesperides are the nymphs who were assigned to guard, with the help of Ladon the dragon, the garden of the gods that Earth had given as a gift to Hera on the occasion of her marriage to Zeus. In this garden grow the mythic golden apples. It is impossible not to see this garden as analogous to the garden of Adam and Eve, with its Tree of Life and its serpent. There are normally thought to be three Hesperides: Aigle, Arethusa, and Hespere, though their number varies from three to seven. Daughters of Night, they are called the "nymphs of the sunset," and their garden embodies a very ancient image of the afterlife. In it stands the jealously guarded Tree of Life, from which Hercules must pick the golden apples in order to win immortality. Access to this magnificent garden —in which Pindar, the Greek poet, imagines flowers of gold growing in great abundance—is denied to mere mortals. The garden of the Hesperides echoes the image of the garden of Eden. Man aspires to the immortality that would gain him access, symbolized by the golden fruit. Like the snake in Genesis, the dragon represents the obstacles one encounters in attempting to gain eternal bliss, while Hercules embodies the hero who overcomes every hindrance in order to attain the highest good.

▼ *Hercules in the Garden of the Hesperides*, A.D. mid-4th century. Rome, catacombs of Via Latina.

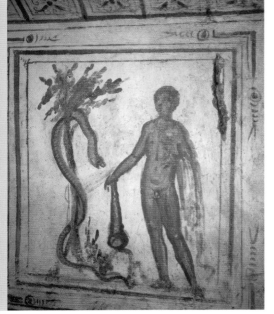

It is difficult to say exactly what sort of fruit the "golden apples" of the Hesperides were. The Greek word for them, melon, means simply "round fruit" or "fruit" of the tree in general. During the Renaissance it was widely believed, and later generally accepted, that it was a citrus fruit.

The garden of the Hesperides has characteristics reminiscent of the garden in Paradise. The dragon, the counterpart of the serpent in Genesis, alludes to the obstacles that one must overcome before reaching a place of eternal bliss.

According to tradition, the three Hesperides that keep watch over the tree with the golden apples are Aigle, Arethusa, and Hespere.

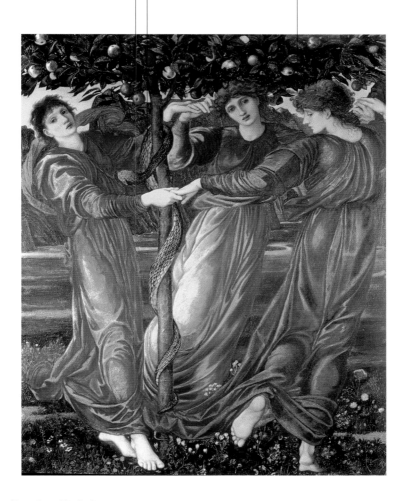

▲ Edward Burne-Jones, *The Garden of the Hesperides*, 1870–73. Private collection.

Flora, an ancient Italian deity, is the goddess of flowers. She reigns over the triumph of spring and is the preeminent protectress of flower and vegetable gardens.

The Garden of Flora

In Rome, the cult of garden fertility was embodied in the goddess Flora, a deity of Italian origin, who "presides over all that flowers." Her cult involved very ancient magical practices with sexual undercurrents. It gives us a sense of how deeply rooted in Roman culture were naturistic beliefs pertaining to the garden. Ovid recounts that Flora was in fact a Greek nymph, Chloris. While walking through the fields one spring day, Zephyr, the god of the spring wind, spotted the girl and immediately fell in love. He abducted her, later wedding her with proper ceremony. As a reward and token of his love, he allowed her to reign over flowers, gardens, and cultivated fields. Flora's garden had so many different varieties of flowers that the goddess herself could not count them all. Flora's image appears above all in representations of spring, the season she rules. She is usually portrayed against backgrounds of sumptuous gardens, surrounded by great quantities of flowers. She also appears in images whose subject matter is the elements and phenomena of nature, especially those depicting the abundance and wealth of the earth in its two complementary aspects: the utilitarian aspect, pertaining to nutrition and reproduction, and the recreational, paradisiacal aspect, which tends more to emphasize the miracle of florescence.

▼ Jan Massys, *Flora in Front of the Gardens of the Villa of Andrea Doria in Genoa*, ca. 1550. Stockholm, National Museum.

The cultivated flower garden in the foreground,
which has the typical characteristics of the
Dutch garden, is juxtaposed with a second,
more "natural" garden in the background,
consisting of meadows and small lakes.

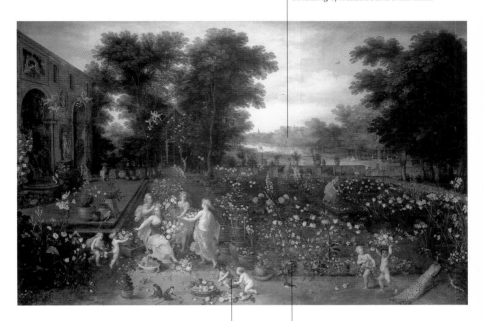

The cherubs are busy creating
flower garlands. These were
indispensable accoutrements
for the Florialia, the feasts in
honor of Flora, during which
floral garlands were hung from
temples or homes or simply
worn around one's neck.

Flowers of every species and every season
are blooming in the garden. This peculiarity
leads one to believe that the painting is in
fact supposed to represent the garden of
Flora, described by Ovid in his Fasti
(5.206–22), where Flora says: "I enjoy an
eternal spring; the year is always splendid,
the trees are always green."

▲ Jan Brueghel the Elder and Hendrick
van Balen, *The Garden of Flora*,
ca. 1620. Genoa, Durazzo Pallavicini
collection.

A mirror image of Flora, Pomona is an ancient Latin goddess worshiped as patrona pomorum, *or "lady of the fruits," protectress of orchards and vegetable gardens.*

The Garden of Pomona

Our image of Pomona—whose name derives from *pomum*, "fruit"—derived mostly from Ovid's *Metamorphoses*. There Ovid describes how the girl ignores the advances of many suitors, devoting herself entirely to gardens. Vertumnus, a god presiding over the cycle of the seasons and the fertility of the earth, cannot resist her charms and takes advantage of his ability to change his appearance to woo Pomona in a variety of guises. One day, having assumed the appearance of an old woman, he succeeds in approaching the girl and slyly enumerates the countless virtues of the young Vertumnus. Unable to make any impression, he decides to take the girl by force; once the god's true splendor is made manifest, however, the girl is won over. The story of Pomona was particularly popular in the 17th century among Dutch and Flemish painters, whose favorite scene was the one in which Vertumnus, in the guise of the old woman, talks to the young girl. A motif beloved of Flemish painters was the offerings made to Pomona to celebrate the return of the warm months and the earth's fertility.

▼ Brussels tapestry workshop, *Vertumnus Introducing Himself to Pomona as a Grape-Harvester*, 1540–60. Vienna, Kunsthistorisches Museum.

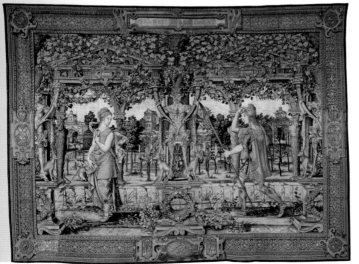

In the background we see a Dutch garden parti-
tioned into uniform plant beds, most of them
planted with flowers, and an arcaded wall of vege-
tation. The calm, fruitful garden seems to fore-
shadow the happy ending of the story.

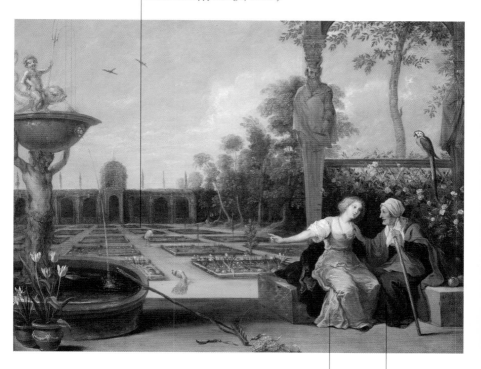

This episode, in which
Vertumnus takes on the
appearance of an old woman
to pay court to Flora, was a
favorite among 17th-century
Flemish painters. They often
set the scene against a back-
ground of magnificent gardens.

The name
Vertumnus may
derive from the
Latin vertere,
"to turn" or "to
change," and thus
probably refers to
the succession of
the seasons or the
transformation of
flowers into fruit.

▲ David Teniers I, *Vertumnus and
Pomona*, 17th century. Vienna,
Kunsthistorisches Museum.

The garden of Venus, mentioned in classical texts, is seen as the antecedent of the later garden of love, of which the goddess is the implicit guardian.

The Garden of Venus

The Greek poetess Sappho recalls the garden of Aphrodite as an "orchard of delicious apples," where "Cypris [Venus] gathers crowns" in the shade of the rosebushes. Her garden appears again in the Homeric hymn to Aphrodite, in the lines: "Aphrodite of the loving smile hastened to Troy, leaving her fragrant garden behind." The garden of Venus is described in minute detail in Francesco Colonna's *Hypnerotomachia Poliphili*. Poliphilo, the central character, sails on the "boat of love" to the garden of Venus, which is located on the island of Cythera. The garden consists of twelve concentric rings, each of which is divided into twenty sectors. The entire layout is organized in accordance with a symbolic geometry based on two numbers considered magical, ten and seven. The number ten is directly related to the pentagon and the Golden Section, and in Pythagorean doctrine it was considered to be the number of plenitude and perfection. The number seven, on the other hand, evokes the number of known planets at the time. At the center of the garden stands an amphitheater, an allusion to generative nature. The concentric sectors feature an alternation of groves, meadows, boxwood hedgerows, topiaries, and temples. Many artists have treated the subject of the garden of Venus, developing its multiple and unusual symbolic aspects. Particularly noteworthy is Watteau, who, in his *fêtes galantes*, depicts numerous journeys to the island of love.

▼ Red-figured lekythos in the style of the Meidias Painter, *Aphrodite in Her Gardens*, 420–400 B.C. London, British Museum.

The garden as depicted is faithful to the Greek text, evoking the "fragrant scents" that waft about the garden and the wondrous music created by the wings of the Cupids.

In the garden of love, many little Cupids are picking and eating the red and golden apples, while others amuse themselves in play. Venus, in the form of a statue, dominates the scene, holding a seashell, symbol of her birth.

▲ Titian, *The Worship of Venus*, 1519. Madrid, Prado.

Some art historians believe that this painting is derived from the Imagines of the Greek poet Philostratus (190 B.C.), which describes sixty-four paintings seen or imagined in a villa in Naples.

The Garden of Venus

An effigy of Venus appears among the greenery, as if to suggest the couples' final destination as they head toward the boat that will take them, like Poliphilo, protagonist of the Hypnerotomachia Poliphili, *to the island of love.*

Together with whimsy and bucolic sentiment, the predilection for country idylls and fêtes galantes—which replaced the magnificent feasts of the Baroque age—were typical features of the Rococo garden.

Watteau started a trend by creating the genre of the fêtes galantes. As a refined interpreter of the lifestyle spreading through France in the wake of the Rococo, he depicted a new society in which gallant manners, feasts, and music became the dominant fashions.

Over the course of the 17th century, Louis XIV's program of political and cultural centralization, with its center at Versailles, began to break up. The severe, propagandistic works of art of his era began to give way to lighter themes and subjects, such as intimate, frivolous, and amorous scenes between private individuals.

▲ Jean-Antoine Watteau, *Pilgrimage to the Island of Cythera*, 1717. Paris, Louvre.

Underlying the "philosophy of the garden" that began to take shape in 13th-century Europe with the rise of courtly culture was the seminal work Le Roman de la Rose.

Le Roman de la Rose

Le Roman de la Rose is actually made up of two books, the first written sometime around 1230 by Guillaume de Lorris, and the second, a continuation of the first, composed by Jean de Meun about forty years later. The work is conceived as a kind of courtly *ars amandi* (art of loving) in which the stages of amorous conquest are described in the form of allegories. All aspects and attitudes pertaining to the psychology of love are personified, and the beloved assumes the attributes of a rose. The narrator recounts, in the form of a dream, how, after entering the garden of delight—the realm of Virtue and Love— he was pierced by an arrow of Love while intently contemplating a rosebud. Falling in love with the Rose, he promises to be faithful to Love, despite the fact that Reason seeks to dissuade him. Undertaking to conquer the beloved, the protagonist is aided by Fair Welcome and succeeds in his intentions, overcoming all the obstacles set before him by Danger, Jealousy, and Foul Mouth. At last the hero manages to join his beloved, but Jealousy captures Fair Welcome and imprisons her in a castle built for that very purpose. The first book ends at this point, with the lover voicing his laments. Jean de Meun's book brings the story to a close and, after numerous twists of the plot, including the liberation of Fair Welcome, the narrator succeeds in uniting with the Rose. Artistic representations of the book primarily depict scenes from the first book— which is considered the more poetic—especially the garden of love, which in turn reproduces some of the details of the medieval secular garden.

Related Entries
Secular Gardens;
Love in the Garden

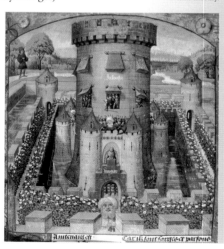

▼ Master of the Prayerbooks of ca. 1500, *The Castle of Jealousy,* illuminated manuscript, ca. 1490. London, British Library.

Le Roman de la Rose

The high wall shows that the garden of the Rose is closed and protected. It marks a clear division between outside and inside and represents a break with everyday life and obligations.

After many misadventures, the lover finally succeeds in conquering the Rose.

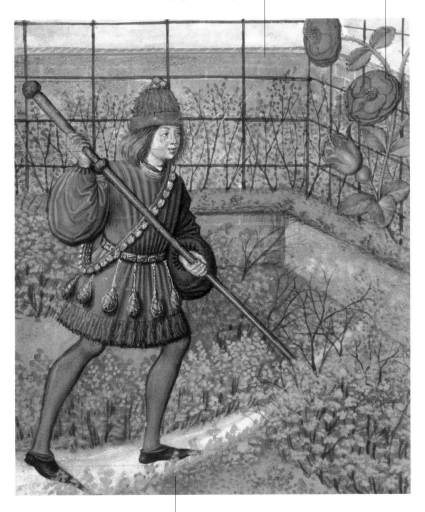

▲ Master of the Prayerbooks of ca. 1500, *The Lover Tends the Rose*, ca. 1450. Illuminated manuscript. London, British Library.

The garden of Fair Welcome is a dream garden in which the classical traditions of the *locus amoenus* are combined with features of the garden of Eden. It is where happiness, plenty, and eternal youth reign.

Dante's journey begins at the "dark forest" and ends in a veritable garden, the garden of Paradise, where, amid a profusion of flowers, the rose predominates.

Dante's Gardens

According to recent studies, *The Divine Comedy* is a religious counterpart to *Le Roman de la Rose*, in that it provides clues for understanding how the path through the garden can become a journey of initiation. Dante's poem opens with the image of a dark wood, a symbol of life overwhelmed by sin, drawn from the biblical and exegetical traditions. Accompanied by the poet Virgil, Dante goes on a journey that leads him to Paradise and redemption. Paradise is a circumscribed place covered with flowers. It is a garden of light where the blessed on their thrones form a "white rose" that exudes a scent made up of praises to God. This is the symbolic flower par excellence, an allusion to the rose of Mary. The colorful flowers give off heady scents; the senses of touch, sight, and smell commingle, as do understanding and love. Dante's Paradise garden, while recalling the medieval garden in its structure, is not a place of simple sensory pleasures such as one might have on earth. Rather, it is a fully spiritualized realm in which one rejoices not in the physical possession of things, but in the contemplation of souls and pure forms in continuous transformation.

▼ Priamo della Quercia, *Dante Attacked by Animals*, illuminated manuscript, ca. 1440–50. London, British Library.

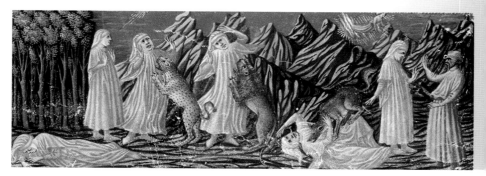

Some interpret the garden described on the third day of Giovanni Boccaccio's Decameron *as a transition from the thematics of the medieval garden to those of the Renaissance garden.*

Boccaccio's Garden

The *Decameron* is a celebrated collection of stories by Giovanni Boccaccio, set during the Black Plague of 1348. A group of young nobles decides to flee the pestilence and take refuge in a villa in the countryside outside of Fiesole, in the hills above the city of Florence. On the third day, the group moves into a garden that is enclosed by a high wall, centrally planned, and surrounded by bowers and rosebushes. At the center of the garden is a lawn dotted with countless flowers, in the middle of which stands a white marble fountain, quite refined in form, with a statue spouting abundant water that then flows into numerous artificial channels. In this image of the sophisticated forms of the fountain and its tributaries, we already glimpse the humanist spirit. While dominated by an aesthetics in which the medieval influence is still very much alive, the garden appears mostly free of symbolic and allegorical content. It is represented more in earthly, naturalistic terms and is unified in its conception and design, foreshadowing the

▼ Illustration of a story from *The Decameron*, by Giovanni Boccaccio, ca. 1370. Paris, Bibliothèque Nationale.

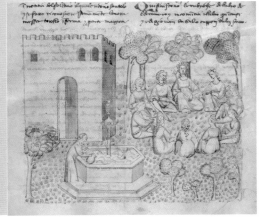

spirit of Renaissance gardens. The Bibliothèque Nationale in Paris owns a pen-and-bistre illustration of this garden made by Boccaccio himself. In it we can see the company seated in a circle on a flower-strewn lawn, as well as a hexagonal fountain surmounted by a small statue of Venus, below which four small zoomorphic heads disgorge water.

The story of Simona and Pasquino is illustrated against the background of a fine pergola of grapevines, "which showed great promise of producing many grapes that year, and being all in bloom sent forth a strong scent through the garden."

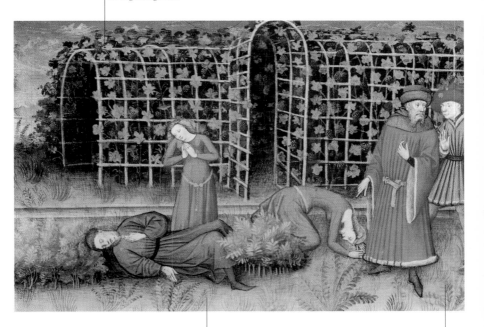

In this tragic story, Pasquino dies by rubbing a sage leaf across his teeth. Simona, charged with poisoning her lover, manages to move the trial to the garden, where she too takes sage leaf and dies.

Though still dominated by medieval tastes, Boccaccio's garden is already shedding its symbolic contents in favor of a more naturalistic representation.

▲ *Story of Simona and Pasquino*, from *The Decameron*, by Giovanni Boccaccio, ca. 1432. Illuminated manuscript. Paris, Bibliothèque de l'Arsenal.

The continuation of the story is
depicted in the background, where
the two nuns, counting on Masetto's
muteness, use him to satisfy their lust.

The form of the plant beds,
simple carpets of grass, is
only lightly indicated.

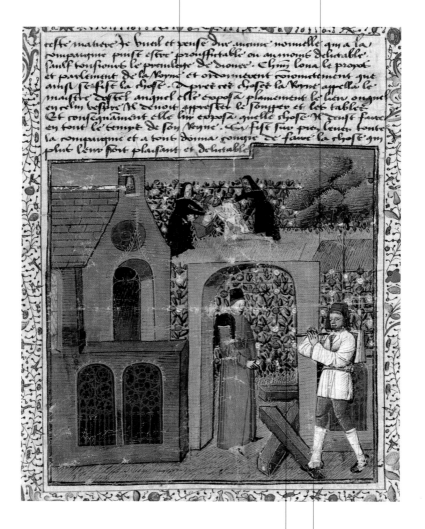

▲ *Masetto, the Nuns' Gardener*,
miniature, 15th century. Paris,
Bibliothèque Nationale.

The convent's garden is surrounded by
tall trellises of climbing roses. The nuns'
bad behavior makes the garden's allu-
sion to the roses of the Virgin Mary
something of a joke.

Masetto pretends to
be deaf and dumb so
that he will be hired
as a gardener for the
convent.

Francesco Petrarca, known as Petrarch, was one of the first poets to draw inspiration from walking in the garden, where he meditated on his life, the past, and his inner world.

Petrarch's Gardens

The author of the *Canzoniere* (Songbook) was the first passionate gardener of the modern age. He was also the first to think of the labor involved in gardening, like a poet's labor, as a way of imitating the ancients. By imitation, of course, we mean not mechanically copying but creating a new model whereby the study of the ancients could be adapted to one's inner world and personal sensibility. The poet, who spent much of his life in and around the papal court at Avignon, took part in making a garden out of a field near the source of the river Sorgue, in the Vaucluse, which was often flooded by the tumultuous river. The gardens of the Vaucluse, a place the poet himself called the "Transalpine Helicon," were dedicated to Apollo and Bacchus and represented not only an echo of antiquity but also an attempt to reclaim the divine powers of the landscape, where "great fountains of water burst up suddenly from hidden sources, prompting man to erect altars to them." The first garden, dedicated to Apollo, and perhaps the one dearest to Petrarch, was shady, peaceful, and secluded, lending itself well to study and concentration. The garden dedicated to Bacchus, which was closer to the poet's home, was more manicured and had a stretch of rapids running through it. The Vaucluse was an important place for Petrarch. He called it variously his "home" (*patria*), "Helicon," and "Athens and Rome"—at once an inspiration and a bit of antiquity, a place where "even an inert mind can lift itself up to lofty thoughts."

▼ Manuscript by Petrarch, with sketch of the Vaucluse landscape, ca. 1350. Paris, Bibliothèque Nationale.

The importance of gardens to Petrarch emerges in his writings, where the poet recalls how, in the shade of a garden, beside a "gurgling stream," the weary spirit gains new strength.

Petrarch was one of the first humanist writers to seek reflection and inspiration in the serenity of a garden.

▲ Arnold Böcklin, *Francesco Petrarca*, 1863. Leipzig, Museum der Bildenden Künste.

Printed in Venice in 1499, Francesco Colonna's Hypnerotomachia Poliphili, *the story of a battle for love in a dream, summarizes the features of the Renaissance garden.*

The Gardens of Poliphilo

Not exactly an easy read, the *Hypnerotomachia Poliphili* recounts the dream of Poliphilo, who is in love with the nymph Polia, and his imaginary journey. The protagonist follows an esoteric itinerary, the meaning of which has been interpreted in a variety of interesting ways. Drifting through an exotic land-scape, amid fragments of ancient ruins, Poliphilo loses his way and arrives at a magnificent palace. From there he glimpses the first of a series of gardens in which nature is replaced by artificial elements to create highly suggestive environments. In this first garden, every plant is made of the purest glass. The box trees have glassy foliage that is supported by golden branches molded into topiary shapes. Between each pair of box trees there is a tall cypress. The second garden Poliphilo encounters is an intricate labyrinth consisting of seven circular paths and seven towers, with a series of navigable waterways. The labyrinth symbolizes the seven ages of human life, and the "death-dealing dragon" at its center alludes to death, which can take one by surprise at any stage of life. The third garden is made entirely of precious woven silk. The box and cypress trees are also made of silk, and from their golden branches hang splendid gems in the guise of fruits. These artificial gardens serve as counter-parts to the garden of Venus on the island of Cythera. The gardens Poliphilo describes are immersed in an enchanted, inaccessible universe, but a universe that is nevertheless subject to rules dictated by reason.

▼ *The Garden of Venus on Cythera*, illustration from the *Hypnerotomachia Poliphili* (Venice, 1499).

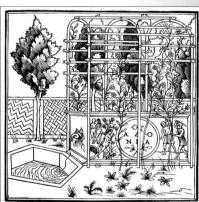

fopra il fonte. Nelquale aptamente era infixo uno ferpe aureo ficto obrepere fora duna latebrofa crepidine di faxo. Cum inuoluti uertigini ,di conueniente craffitudine euomeua largamente nel fonoro fonte la chiariffima aqua. Onde per tale magifterio il fignifico artifice, il ferpe hauea fufo inglobato, per infrenare lo impeto dellaqua. Laquale per libero mea to & directo fiftulato harebbe ultra gli limiti del fonte fparfo.

Sopra la plana del præfato fepulchro la Diuina Genitrice fedeua puerpera exfcalpta, nõ fencia fúmo ftupore di ptiofa petra Sardonyce tri colore, fopra una fedula antiqria , nõ excedéte la fua feffiõe della fardoa ue na, ma cũ fcredibile fuéto & artificio era tutto il cythereo corpufculo della uéa lactea del onyce, qfi deueftito, p cõ folante era relicto uno uelami ne della rubra uenacælante lo arcano della natura, uelando parte di una coxa, & il refiduo fopra la plana defcendeua. Demigrando pofcia fopra p

Accompanied by Logistica and Thelemia—symbols of reason and will, respectively—Poliphilo is about to enter the crystal garden.

The ars topiaria, *whose origins date back to classical antiquity, was revived in the Renaissance garden and later spread to gardens all over the world. It became one of the distinguishing marks of the "Italian-style" garden.*

Some have considered the Hypnerotomachia Poliphili *a veritable manual for the Italian humanist garden. It often served as an inspiration for artists.*

▲ *The Garden of Crystal*, engraving from the French edition of the *Hypnerotomachia Poliphili* (1564).

The peculiarity of this garden is that, after entering
it by boat, one can no longer turn back and ends
up in the coils of the dragon at the center.

The "labyrinth of water" is
actually a spiral path con-
sisting of seven circles and
adorned with seven towers.

The path that runs inside
the walls of this garden is
made of water, symbol of
human life.

▲ The Labyrinth of Water, engraving
from the French edition of the
Hypnerotomachia Poliphili (1564).

Armida's garden is imbued with a sense of transience and the knowledge that even a dream of joy, taken to the extreme, is fated to be extinguished.

Armida's Garden

In Torquato Tasso's epic poem of the First Crusade, *Jerusalem Delivered* (1580), the garden of the sorceress Armida is posited as the mythic counterpart of staid Jerusalem, symbol of duty and heroic, religious exploits. Here one finds joy and delight of the senses, a just reward for one's exacting, heroic deeds. It does not however, resemble the realm of eternal Paradise. Armida's garden is pervaded by an awareness of its own frailty and its inability to satisfy the need for happiness that resides in every man's heart. We already note, here, a shift in attitude toward the garden. It no longer embodies geometric principles or even a salutary Edenic ideal; rather, it is a place of fleeting, fragile happiness, governed, like everything else of this world, by the inexorable laws of transience. One must travel a series of tortuous paths to reach Armida's garden. The places and decorations there appear natural, as though nature itself had sought amusement by imitating art, which in fact imitates nature. The ideas laid out in this work, and elsewhere in Tasso's oeuvre, have been interpreted as a sort of foreshadowing of the English landscape garden.

▼ Eduard Müller, *The Garden of Armida*, 1854. Private collection.

"So with the rude the polished mingled was / That natural seemed all and every part, / Nature would craft in counterfeiting pass, / And imitate her imitator art" (Jerusalem Delivered, 16.10, translation by Edward Fairfax). This description has led some to see Tasso as a herald of the English landscape garden.

The round temple evokes the temple of love.

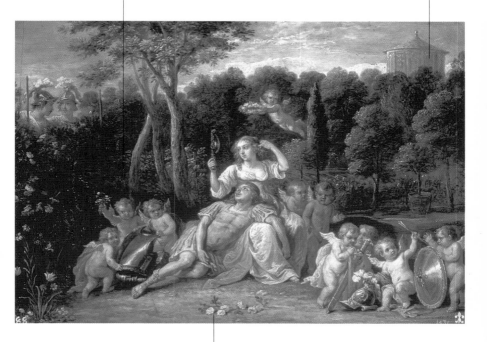

The roses in the foreground allude to the passage in which Tasso exhorts one to gather the roses of love in the morning of life, or youth, which quickly fades.

▲ David Teniers II, *The Garden of Armida*, 1650. Madrid, Prado.

The description of Eden in John Milton's Paradise Lost *has been seen as prefiguring the model of the English landscape garden.*

Paradise Lost

The novelist, essayist, and all-around man of letters Horace Walpole played a determining role in developing the principles behind the landscape garden, and he claimed that John Milton's description of Eden in *Paradise Lost* (1674) was a "warmer and more just picture of the present style than Claude Lorrain could have painted from Hagley or Stourhead." In Milton's description, the garden of Paradise created by God spreads across this "delightful land" (4.643), where flows a broad river whose course continues underground. Multiple streams well up spontaneously, running through the garden in many broad coils, while flowers and plants thrive that are "not nice art / In beds and curious knots, but Nature boon / poured forth profuse on hill and dale and plain" (4.241–43). Milton's Eden is a succession of flowing contours, natural lakes, open valleys, and green hills, light, shadows, and wondrous perspectives and contrasts. The typology of the landscape garden thus seems to have existed long before the time of its actual birth; it had already appeared in literature as the archetype of all gardens, Paradise.

▼ Henry Fuseli, *The Shepherd's Dream*, 1793. London, The Tate Gallery.

The world of fairies and their retinue of fanciful creatures—denizens of woods and gardens—has its roots in medieval literature and folk legends.

Sprites and Fairies in the Garden

The folk belief in fairies was absorbed into medieval literature, in defiance of firm religious injunctions condemning it as a pagan cult. Chaucer's *Canterbury Tales*, in particular, establish a typology later used by Shakespeare in *A Midsummer Night's Dream* and *The Tempest*. It was above all in the Victorian era, however, that sprites and fairies became a true fashion, a kind of reaction to the staid, rational, self-satisfied world of the English middle classes of this period. Together with the rise of spiritualism and the occult, the world of elves, fairies, and dwarves became a passion among the English, one that was stoked by the publication of the Grimm brothers' *Fairy Tales*, the Shakespeare revival, and the fashion for ballets on the theme of love between mortals and sylphs or nymphs. Victorian artists from Burne-Jones to Turner delighted in depicting these fanciful worlds, drawing inspiration primarily from Shakespeare but soon concocting scenes based on their own imaginations and obsessions. The painters of fairies were visionary dreamers right from the start. Blake believed in fairies and claimed to have witnessed one of their funeral ceremonies in his own backyard. Fuseli for his part considered dreams an important source of inspiration, and he developed various dubious techniques for stimulating dreams, such as eating raw meat before going to sleep. In his drawings inspired by *A Midsummer Night's Dream*, he invented a fantasy world that would inspire and influence his students and successors. Some artists, such as Richard Dadd and John Anster Fitzgerald, actually specialized in paintings of fairies.

▼ John Everett Millais, *Ferdinand Lured by Ariel*, 1849. Washington, The Makins Collection.

Sprites and Fairies in the Garden

The name Oberon is probably derived from a French translation of Alberic, the King of the Elves in Teutonic legend.

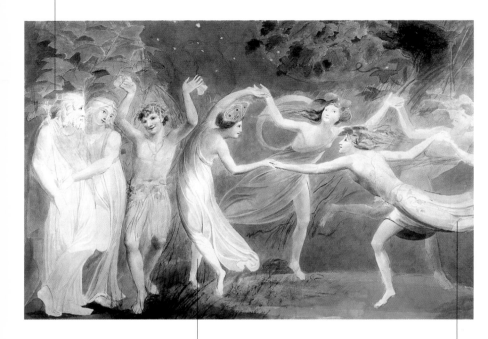

Blake gave his fairies transparent butterfly wings, probably drawing inspiration from the winged cherubs and images of Psyche—a personification of the soul—in the paintings adorning ancient Greek vases and the frescoes of Pompeii.

At once benign figures who help heroes in their exploits, and seers, malevolent sorceresses, and bearers of bad luck, fairies probably date back to Celtic culture.

▲ William Blake, *Oberon, Titania, and Puck with Fairies Dancing*, ca. 1785. London, Tate Gallery.

The fairies have conflicting feelings toward the robin, because of the bird's link to the world of humans.

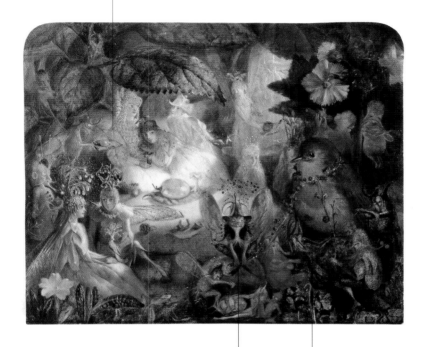

The tiny, monstrous creatures accompanying the fairies were clearly inspired by the paintings of Pieter Bruegel the Elder and Hieronymus Bosch.

According to ancient legend, killing or capturing a robin brings bad luck. It was believed that the little birds buried those who died or were killed in the woods.

▲ John Anster Fitzgerald, *The Captive Robin*, ca. 1864. Private collection.

APPENDIXES

Index of Subjects
Index of Artists
Bibliography

◀ Jean-Honoré Fragonard, *The Swing* (detail), 1767. London, Wallace Collection.

Alchemical Gardens 317
Ancient Egypt 10
Ancient Greece 11
Ancient Rome 13
Armida's Garden 366
Artificial Garden, The 229

Baroque Gardens 58
Belvedere, see The Papal Garden
Boccaccio's Garden 358
Bomarzo 55

Cardinal's *Barco*, The
 (Villa Lante) 53
Chiswick, see Nature as Model:
 Chiswick 90

Dante's Gardens 357
Democratic Holland 76

Ermenonville 101
Everyday Life 234
Exotic Plants 217

Fabriques and Follies 200
Fashionable Promenades 272
Festivities in the Garden 257
Flowers 172

Games, Sports, and Activities 264
Garden of Defiance, The (Vaux-le-
 Vicomte) 61
Garden of Flora, The 348
Garden of Mary, The 304
Garden of Paradise, The 297
Garden of Pomona, The 350
Garden of the Czar, The (Peterhof) 74
Garden of the Golden Age, The 344
Garden of the Hesperides, The 346
Garden of the Senses, The 313
Garden of Venus, The 352
Garden of Virtue, The 311
Garden of Wonders, The 159
Garden Paths 155
Garden Stage, The 186
Gardens of Christ, The 299

Gardens of Emblems 319
Gardens of Meditation 336
Gardens of Poliphilo, The 363
Gardens of the Dead 329
Gardens outside City Walls 45
Greenhouses 205
Grottoes 144

Hortus 127
Hortus Palatinus 68
Hubert Robert's Gardens 287

Islamic Gardens 18

Labyrinths 163
Landscape Gardens 88
Living Architecture 138
Love in the Garden 248

Malmaison 106
Masonic Gardens 325
Medici Gardens 39
Monastic Gardens 21
Monet's Giverny 290
Mountains 148

Nature as Model: Chiswick 90
New York's Central Park 120

Orient in the Garden, The 210

Papal Garden: Belvedere, The 47
Paradise Lost 368
Parterres 194
Petrarch's Gardens 361
Philosopher's Garden, The 324
Poet's Garden: Twickenham, A 92
Political Garden: Stowe, The 96
Portrait in the Garden, The 278
Public Park in London, The 115
Public Park in Paris, The 112

Renaissance Gardens 32
Renaissance Treatises 35
Repton's Gardens 99
Rococo Gardens 83

Roman de la Rose, Le 355
Round Gardens 338
Royal Palace at Caserta, The 72
Ruins 225

Sacred Woods 294
Schönbrunn 70
Science in the Garden 240
Secret Gardens 142
Secular Gardens 24
Sitting in the Garden 167
Sprites and Fairies in the Garden 369
Statues 150
Still Lifes 321
Stourhead 93
Stowe, see The Political Garden:
 Stowe
"Sublime" Garden, The 109

Technology in the Garden 185
Topiary 130
Trees 213
Treillage 135
Tulipomania 79

Urban Residences 43
Urns and Vases 222

Versailles 63
Viktoriapark in Berlin 118
Villa d'Este 49
Violated Garden, The 309

Walls 124
Water 178
Wilhelmshöhe 104
Work in the Garden 242

Index of Artists

Allegrain, Etienne 132, 205, 274–75
Allingham, Helen Paterson 176
Allinson, Adrian Paul 129
Apollonio di Giovanni 229
Ayvazvky, Ivan Konstantinovich 75

Bailly, Jacques 165
Balen, Hendrik van 349
Balla, Giacomo 230
Bampfylde, Coplestone Warre 94
Battaglioli, Francesco 188
Baur, Johann Wilhelm 179
Bazhenov, Vassily Ivanovich 74
Bellotto, Bernardo 71, 156, 182–83, 198
Béraud, Jean 271
Biagio d'Antonio 38
Bimbi, Bartolomeo 322
Blake, William 370
Boccati, Giovanni di Piermatteo da Camerino 340
Böcklin, Arnold 296, 334, 362
Bol, Hans 180
Borromini, Francesco Castelli, known as 341
Bosse, Abraham 315
Botticelli, Sandro Filipepi, known as 299
Boucher, François 83, 212
Boucicaut Master 298
Boullée, Étienne-Louis 329
Bramantino, Bartolomeo Suardi, known as 130
Bruegel, Pieter, the Elder 244
Brueghel, Jan, the Elder 349
Brueghel, Jan, the Younger 82
Bruggen, Coosje van 184
Burne-Jones, Edward 347

Caillebotte, Gustave 247
Caliari, Benedetto 191
Campin, Robert, school of 308
Canaletto, Giovanni Antonio Canal, known as 272
Carmontelle, Louis de 201, 202–3, 245

Caullery, Louis de 316
Caus, Salomon de 68, 148
Celloles, Jacques de 264
Châtelet, Claude-Louis 204, 327
Chikanobu, Kano 337
Cittadini, Pier Francesco 321
Cleve, Hendrick van, III 30, 47
Cleve, Joos van 254
Collins, Charles 222
Constable, John 333
Corot, Jean-Baptiste-Camille 49
Cossa, Francesco del 167
Cotelle, Jean 66, 187
Cranach, Lucas, the Elder 345
Critz, Thomas de 219
Croce, Baldassare 309
Crook, Pam 134
Cungi, Camillo 206
Currier and Ives 120

Danckerts, Hendrick 218
Daniell, William 210
Debucourt, Louis-Philibert 273
Della Quercia, Priamo 357
Denis, Maurice 294
Donatello, Donato di Niccolò di Betto Bardi, known as 151
Duchamp, Marcel 231

Eyck, Barthélemy d' 28–29

Fagen, Graham 228
Filarete 35, 36
Fitzgerald, John Anster 371
Flitcroft, Henry 93
Fouquières, Jacques 69
Fragonard, Jean-Honoré 52, 255, 259, 269, 372
Francesco di Giorgio Martini 37
Fuseli, Henry 368

Gainsborough, Thomas 216, 282
Garneray, Auguste 108, 207
Gendall, John 226
Giambologna, Jean de Boulogne, known as 145, 149

Girardon, François 152
Gogh, Vincent van 170, 172, 256
Gozzoli, Benozzo 45
Guerra, Giovanni 339
Gysels, Peeter 77

Hackert, Jakob Philipp 72
Haghe, Louis 208
Havell, William 158
Hintze, Johann Heinrich 119
Hogarth, William 90, 223
Hokusai, Katsushika 336
Hondius, Hendrik 338
Hooch, Pieter de 236, 281
Hummel, Johann Erdmann 105
Huysum, Jan van 323

Janson, Johannes 195
Joly, André 162

Kauffmann, Angelica 283
Kessel, Jan van, the Elder 76
Knutson, Johann 169
Kuwasseg, Charles Euphrasie 332

Lancret, Nicolas 192, 238
Lavery, Sir John 266–67
Le Tavernier, Jean 27
Lee, Frederick Richard 181
Lega, Silvestro 239
Leonardo da Vinci 138
Leprince, Jean-Baptiste 112
Lequeu, Jean-Jacques 141
Levitsky, Dmitri 220
Lippi, Filippino 43
Lorrain, Claude 89, 95, 215

Magnasco, Alessandro 262–63
Manet, Édouard 270
Mantegna, Andrea 139, 312
Martin, Jean-Baptiste 67
Martin, Pierre-Denis 59, 185
Massys, Jan 348
Master of Margaret of York 243
Master of the Cité des Dames and workshop 124

Master of the Fitzwilliam MS. 268 25
Master of the Geneva Boccaccio 127
Master of the Jouvenel Codex 168
Master of the Maréchal de Brosse 22
Master of the Paradise Garden 304
Master of the Prayerbooks of ca. 1500 355–356
Master of the View of Ste. Gudule 307
Master of Wittingau 301
Meidias Painter, style of 352
Melling, Anton Ignaz 86, 107
Merian, Matthäus, the Elder 197
Millais, John Everett 369
Miller, William Rickarby 121
Monet, Claude 290, 291
Montauban, Renaud de 137
Moreth 101
Müller, Eduard 366

Netscher, Theodorus 217
Nickelen, Jan 104
Nickolls, Joseph 92

Oldenburg, Claes 184
Oosten, Izaac van 173
Oudry, Jean-Baptiste 79

Palma, Nicolò 325
Passe, Crispijn van de, I 80
Patel, Pierre Antoine 64–65
Paxton, Joseph 117
Perino del Vaga 48
Petrarch 361
Pietro da Cortona 344
Piper, John 96
Pissarro, Camille 128
Pot, Hendrik Gerritsz. 81
Poussin, Nicolas 88, 330
Poynter, Edward John 221

Raffaellino da Reggio 54, 155
Raschka, Robert 56, 70
Re, Marcantonio dal 186
Redouté, Pierre-Joseph 106
Renoir, Pierre-Auguste 276
Repton, Humphry 99, 100, 175, 214

Ricci, Marco 110, 116
Rigaud, Jacques 97
Robert, Hubert 102, 103, 147, 287, 288, 289, 331
Robins, Thomas, the Elder 211
Rolland, Benjamin de 278
Rousseau, François 85
Rowlandson, Thomas 98
Rubens, Peter Paul 253, 279
Rysbrack, Pieter Andreas 189

Sablet, Jacques Henri 284, 285, 326
Saint-Phalle, Niki de 154
Sargent, John Singer 277
Schenck, Pieter 58
Schleuen, Johann David 84
Schongauer, Martin 300, 306
Segal, George 171
Sellaio, Jacopo del 44
Silvestre, Israël 61
Simberg, Hugo 335
Smith, John 109
Sommer, Johann Friedrich 153
Sommer, Philipp Jakob 153
Starnina, Gherardo 21
Stefano da Verona 305
Strohmeyer, Antal 324
Sustris, Lambert 302

Teniers, David, I 351
Teniers, David, II 342, 367
Terreni, Giuseppe Maria 260–61
Tintoretto, Jacopo Robusti, known as 310
Tintoretto, school of 163
Titian 314, 353
Troost, Cornelis 237
Troy, Jean François de 295
Turner, Joseph Mallord William 224

Uccello, Paolo 46
Ukhtomsky, Konstantin Andreyevich 209
Utens, Giusto 40, 41, 160–61

Valckenborch, Lucas van 166

Venne, Adriaen van de 268
Viger, Jean Louis Victor 286
Vrancx, Sebastian 140, 235
Vredeman de Vries, Hans 131
Vrelant, Willem 292, 303

Waldmüller, Ferdinand Georg 122, 227
Walther, Johann Jakob 78, 146
Warhol, Andy 177
Waterhouse, William 142
Watteau, Jean-Antoine 193, 248, 354
Wyld, William 113

Ziegler, Johann 213
Zucchi, Paolo 32

Bibliography

Acidini Luchinat, Cristina, ed., *Giardini dei Medici* (Milan, 1996).

Alfrey, Nicholas, Stephen Daniels, and Martin Postle, *Art of the Garden: The Garden in British Art, from 1800 to the Present Day*, exh. cat. (Tate Gallery, London, 2004).

Amari, Monica, ed., *Giardini regali*, exh. cat. (Codroipo [Udine], Villa Manin di Passariano, 1998).

Appiano Caprettani, Ave, *Il giardino dipinto. Dagli affreschi egizi a Botero* (Turin, 2002).

Baldan Zenoni-Politeo, Giuliana, and Antonella Pietrogrande, eds., *Il giardino e la memoria del mondo* (Florence, 2002).

Battisti, Eugenio, *Iconologia e ecologia del giardino e del paesaggio* (Florence, 2004).

Bénetière, Marie-Hélène, *Jardin: Vocabulaire typologique et technique* (Paris, 2000).

Bowe, Patrick, *Gardens of the Roman World* (Los Angeles, 2004).

Calvano, Teresa, *Viaggio nel pittoresco* (Rome, 1996).

Cardini, Franco, and Massimo Miglio, *Nostalgia del paradiso. Il giardino medievale* (Rome, 2002).

Cataldi Gallo, Marzia, and Farida Simonetti, eds., *Il giardino di Flora. Natura e simbolo nell'immagine dei fiori*, exh. cat. (Genoa, Loggia della Mercanzia, 1986).

Cayeux, Jean de, *Hubert Robert et les jardins* (Paris, 1987).

Cazzato, Vincenzo, Marcello Fagiolo, and Maria Adriana Giusti, eds., *Teatri di verzura. La scena del giardino dal barocco al novecento* (Florence, 1993).

Cowell, Frank, *The Garden as a Fine Art from Antiquity to Modern Times* (London, 1978).

Curtil, Jean Claude, *Les Jardins d'Ermenonville racontés par René Louis marquis de Girardin* (Saint-Rémy-en-l'Eau, 2003).

Donati, Angela, *Romana pictura. La pittura romana dalle origini all'età bizantina*, exh. cat. (Rimini, Palazzo del Podestà, 1998).

Fagiolo, Marcello, ed., *La città effimera e l'universo artificiale del giardino* (Rome, 1980).

———, ed., *Natura e artificio* (Rome, 1981).

———, *Roman Gardens* (New York, 1997).

Fagiolo, Marcello, Maria Adriana Giusti, and Vincenzo Cazzato, *Lo specchio del Paradiso. Giardino e teatro dall'Antico al Novecento* (Cinisello Balsamo, 1997).

Fahr-Becker, Gabriele, ed., *The Art of East Asia* (Cologne, 1999).

Fleurs et jardins dans l'art flamande, exh. cat. (Ghent, Musée des Beaux-Arts, 1960).

Fryberger, Betsy Geraghty, ed., *The Changing Garden: Four Centuries of European and American Art*, exh. cat. (Iris and B. Gerald Cantor Center for Visual Arts, Stanford, 2003).

The Garden Book, by the editors of Phaidon Press (London, 2000).

Grimal, Pierre, *I giardini di Roma antica* (Milan, 1990).

Haddad, Hubert, *Le Jardin des peintres* (Paris, 2000).

Hobhouse, Penelope, *Plants in Garden History* (London, 1992).

———, *The Story of Gardening* (London, 2002).

Hunt, John Dixon, *The Picturesque Garden in Europe* (London, 2002).

Huxley, Anthony, *An Illustrated History of Gardening* (London, 1998).

Il giardino dipinto nella Casa del Bracciale d'Oro a Pompei e il suo restauro, exh. cat. (Florence, Sala d'Arme di Palazzo Vecchio, 1991).

Jellicoe, Geoffrey, Susan Jellicoe, Patrick Goode, and Michael Lancaster, eds., *The Oxford Companion to Gardens* (Oxford, 1986).

Kern, Hermann, *Through the Labyrinth: Designs and Meanings over 5,000 Years*, A. Clay, trans. (Munich and New York, 2000).

Ketcham, Diana, *Le Désert de Retz: A Late Eighteenth-Century French Folly Garden* (Cambridge, Mass., and London, 1994).

Kluckert, Ehrenfried, *European Garden Design from Classical Antiquity to the Present Day*, R. Toman, ed. (Cologne, 2000).

Laird, Mark, *The Formal Garden: Traditions of Art and Nature* (London, 1992).

Les Frères Sablet (1775–1815): Peintures, dessins, gravures, exh. cat. (Rome, Centre Culturel Français de Rome, 1985).

Likhachev, Dmitri Sergeevich, *La poesia dei giardini* (Turin, 1996).

Maresca, Paola, *Giardini incantati, boschi sacri, e architetture magiche* (Florence, 2004).

Martineau, Jane, ed., *Victorian Fairy Painting*, exh. cat. (Royal Academy of Arts, London, 1997).

Masoero, Ada, ed., *Nel giardini di Balla: Futurismo 1912–1928*, exh. cat. (Milan, Galleria Fonte d'Abisso, 2004).

Mosser, Monique, and Georges Teyssot, eds., *The History of Garden Design: The Western Tradition from the Renaissance to the Present Day* (London and New York, 2000).

Panofsky, Erwin, *Meaning in the Visual Arts* (1955; Chicago, 1982).

Panzini, Franco, *Per i piaceri del popolo: L'evoluzione del giardino pubblico in Europa dalle origini al XX secolo* (Bologna, 1993).

Pays d'illusion, terre d'expérience, exh. cat. (Paris, Caisse Nationale des Monuments Historiques et des Sites, 1977).

Petruccioli, Attilio, *Dar al Islam. Architetture del territorio nei paesi islamici* (Rome, 1985).

———, ed., *Gardens in the Time of the Great Islamic Empires: Theory and Design* (New York and Leiden, 1997).

Pirrone, Gianni, *L'isola del Sole. Architettura dei giardini di Sicilia* (Milan, 1994).

Pizzoni, Filippo, *Gardens: A History in Landscape and Art* (New York, 1999).

Praz, Mario, *Il giardino dei sensi. Studi sul manierismo barocco* (Milan, 1975).

Racine, Michel, ed., *Créateurs de jardins et de paysages en France de la Renaissance au XXIème siècle* (Arles, 2001).

Rogers, Elizabeth Barlow, *Landscape Design: A Cultural and Architectural History* (New York, 2001).

Settis, Salvatore, *Le pareti ingannevoli, la Villa di Livia e la pittura di giardino* (Milan, 2002).

Shoemaker, Candice A., ed., *Encyclopedia of Gardens: History and Design* (Chicago, 2001).

Strong, Roy, *The Renaissance Garden in England* (London, 1979).

Sur la terre comme au ciel. Jardins d'occident à la fin du moyen-âge, exh. cat. (Musée Nationale du Moyen-Âge, Paris, 2002).

Tagliolini, Alessandro, *Storia del giardino italiano* (Florence, 1991).

Tagliolini, Alessandro, and Margherita Azzi Visentini, eds., *Il giardino delle Esperidi: Gli agrumi nella storia, nella letteratura e nell'arte* (Florence, 1996).

Taylor, Patrick, ed., *The Oxford Companion to the Garden* (Oxford, 2006).

Teichert, Wolfgang, *I giardini dell' anima* (Como, 1995).

Turner, Tom, *Garden History: Philosophy and Design, 2000 B.C.–2000 A.D.* (New York and London, 2005).

Van Zuylen, Gabrielle, *The Garden: Visions of Paradise* (London, 1995).

Vercelloni, Matteo, *Il paradiso terrestre: Viaggio tra i manufatti del giardino dell'uomo* (Milan, 1986).

Vercelloni, Virgilio, *European Gardens: An Historical Atlas* (New York, 1990).

Vezzosi, Alessandro, ed., *La fonte delle fonti: iconologia degli artifizi d'acqua* (Florence, 1985).

———, ed., *Il giardino d'Europa: Pratolino come modello nella cultura europea*, exh. cat. (Milan, Palazzo Medici Riccardi, 1986).

Wittkower, Rudolf, *Palladio and Palladianism* (New York, 1974).

Woods, May, *Visions of Arcadia: European Gardens from Renaissance to Rococo* (London, 1996).

Zoppi, Mariella, *Storia del giardino europeo* (Bari, 1995).